(1) Orthodox Eastern Church and art

THEOLOGY OF THE ICON

(2) Icons--Cult

LEONIDE OUSPENSKY

Theology of the Icon

ST. VLADIMIR'S SEMINARY PRESS
CRESTWOOD, NY 10707
1978

Library of Congress Cataloging in Publication Data

Ouspensky, Léonide.
Theology of the icon.

Translation of Essai sur la théologie de l'icone dans
l'Eglise orthodoxe.
Bibliography: p.
1. Theology, Eastern Church. 2. Icons—Cult.
3. Orthodox Eastern Church and art. I. Title.
BX323.08513 230'1'9 77-11882
ISBN 0-913836-42-7

ISBN 0-913836-42-7

© 1978

St. Vladimir's Seminary Press

PRINTED IN THE UNITED STATES OF AMERICA
BY
ATHENS PRINTING COMPANY
NEW YORK, N.Y.

Table of Contents

Author's Foreword ... 7

Introduction ... 9

I The Symbolism of the Church 21

II The Origin of the Christian Image 39

III The First Icons of Christ and the Virgin 59

IV The Art of the First Centuries of Christianity and its Symbolism .. 81

V Sacred Art in the Constantinian Era 101

VI The Quinisext Council: Its Teaching on the Image 113

VII The Pre-Iconoclastic Period 125

VIII The Iconoclastic Period: An Abridged History 135

IX The Iconoclastic Teaching and the Orthodox Response ... 145

X The Meaning and Content of the Icon 179

Select Bibliography .. 231

Author's Foreword

This work is neither a history of sacred art nor a study specializing in one of its aspects. It is the summary of a course on iconology given at the Pastoral Courses of Theology of the Exarchate of the Patriarchate of Moscow in Western Europe, in Paris. Like all courses, it is to a large extent a work of compiled information. It develops the ideas briefly set forth in *The Meaning of Icons*, written by the author with V. N. Lossky and published in 1952 by Urs Graf Verlag in Bern.

This study, which roughly follows a historical plan, tries to define the place and the role of art in the Church and to present it in the light of the liturgy, of conciliar decisions and of patristic writings. Due to the widespread interest in the icon which exists today, this study is published so as to analyze the Orthodox teaching on sacred art, as well as the expression of the Orthodox doctrine and spiritual experience in sacred art.

For technical reasons, we have only been able to include a limited number of illustrations, so that the photographs and sketches in this work illustrate only the most basic ideas.

Introduction

A LARGE number of works about Christian sacred art exist in various languages. This art has been studied from the historical, esthetic, sociological and archeological points of view. All of these aspects are indeed components of sacred art. But they represent only its external side and are not concerned with its very essence, that is, that which this art conveys. At the same time, many works are dedicated to explaining the external and explicit connection of the image to the Holy Scriptures and to the other liturgical texts. Other works, finally, explain this art from a theological and philosophical point of view. But what does the Church itself think of the art which it has created? What are its teachings on this subject? How was sacred art understood by the holy councils and the Fathers who were concerned with it? All of this has not been the object of special attention. Moreover, as we shall see, certain authors go so far as to deny the Church's participation in the creation of its art. But can one imagine that the Church would neglect figurative art, at least as a strong means of influencing man? Figurative art was abundantly used in the paganism which surrounded the Church from the first centuries, and, later, by the Christian state. It is certain that the Church could not have ignored it. Its entire outlook on the image is a witness to this fact, and it is precisely with this that we shall begin our study.

It is well known that the veneration of holy icons plays a very important role in the Orthodox Church. The veneration of the icons of Christ, of the Virgin, of the angels and of the saints is a dogma of the Christian faith formulated at the Seventh Ecumenical Council and proceeds from a basic doctrine of the Church: its confession of the Son of God who became man. His icon is a witness to the true and non-deceptive incarnation of God. In the course of its history, the Church triumphed

9

over heresy many times. But of all its victories, only the victory over iconoclasm, the victory of the icon, was solemnly proclaimed as the "Triumph of Orthodoxy," a victory which we celebrate each year on the first Sunday of Lent. This demonstrates the importance which the Church attributes to the image, and not just to any image, but to the specific image which it wrought in its fierce struggle against paganism, against iconoclasm and against other heresies, to the image which was paid for with the blood of a large number of martyrs and confessors.

Why does the Church attribute such a great importance to the icon? The icon is not just a simple image, nor a decoration, nor even an illustration of Holy Scripture. It is something greater. It is an object of worship and an integral part of the liturgy. The Church sees in its holy image not simply one of the aspects of Orthodox teaching, but the expression of Orthodoxy in its totality, the expression of Orthodoxy as such. The icon is one of the manifestations of the holy Tradition of the Church, similar to the written and oral traditions. As we shall see in our study, the "icon," according to the teaching of the Church, corresponds entirely to the "word" of Scripture. "That which the word communicates by sound, the painting shows silently by representation," says St. Basil the Great.[1] And the Fathers of the Seventh Ecumenical Council repeat these words and specify that "through these two mediums which accompany each other... we acquire the knowledge of the same realities."[2]

It is absolutely impossible to imagine the smallest liturgical rite in the Orthodox Church without icons. The liturgical and sacramental life of the Church is inseparable from the image. Even before entering the sanctuary to celebrate the Divine Liturgy, the priest recites a prayer of purification before the royal doors (the central portal of the iconostasis) and a declaration of faith before the "local" icons. The icon is an object of worship embodying divine grace and forming an integral part of the liturgy. Often and with good reason, the icon is called "theology in images." It is understandable that the basis of sacred art, its meaning and its content, can only be a subject

[1]Hom. 19, on the 40 martyrs, PG 31: 509 A.
[2]Mansi 13: 300 C.

of theology similar to the study of the Holy Scripture. There-
fore, one can neither understand nor explain sacred art outside
of the Church and its life. Such an explanation would always
be partial and incomplete. In relation to sacred art itself, it
would be false.

In fact, sacred art not only reflects the life of the Church
in all its complexity and in all its depth. It is an integral part
of this life, just as a branch is a part of a tree. An object of
worship, the icon is not merely provoked or inspired by the
liturgy: Together they form a homogenous whole. The icon
completes the liturgy and explains it, adding its influence on
the souls of the faithful. The contents and the meaning of the
icon and of the liturgy are the same, and this is why their form,
their language, is also the same. It is the same symbolism, the
same sobriety, the same depth in content. This is why, like
everything in the Church, sacred art has a double dimension:
Its very essence is unchangeable and eternal since it expresses
the revealed truth, but at the same time it is infinitely diverse
in its forms and expressions, corresponding to different times
and places. Our study will therefore be, on the one hand and
foremost, a theological study. On the other hand, on the his-
torical and archeological level, we will use the facts provided
by secular archeologists or historians of art.

The content and the meaning of sacred art determines
one's attitude towards it. To understand this point more clearly,
let us compare the attitudes of the Orthodox Church and the
Roman Catholic Church towards sacred art. The Roman Cath-
olic Church confesses, as does Orthodoxy, the dogma of the
veneration of icons. But its attitude towards sacred art differs
considerably from the Orthodox attitude. Let us take as an
example the decision of the Council of Trent, which has until
now been the basis of all the regulations issued by the Vatican
in the field of art. All these regulations have a negative tone:
They pronounce what sacred art should *not* be. Here is the
decision of the Council of Trent (1563, the twenty-fifth and
last session) : "The Holy Council upholds that no image should
be placed in the churches which is inspired by a false dogma
and which can mislead the simple people; it wills that all
impurity be avoided and that the images should not have any

provoking attributes. To assure the regard to these decisions, the Holy Council prohibits any improper image from being placed anywhere, even in the churches which are not subject to the visit of the ordinary, unless the bishop has first approved it."[3] This rule is repeated, some parts of it literally, in the new regulations on the subject (June 30, 1952). Here are the orders of a 1947 encyclical letter of Pius XII: "The field must be left absolutely open for the art of our time when it shows the respect and honor due to the buildings and the sacred rites. In such a way, it will enter into the wonderful concert which famous men have sung to the catholic faith in past centuries . . ."[4] The Pope adds that "everything which is not in accord with the holiness of the place" must be removed from the sanctuaries. As we see, neither the decision of the council nor the papal encyclical letter of 1947 nor the other directives of the Roman Church set any criterion or indicate any connection with Tradition. They only indicate what should *not* be in sacred art, and this in not very clear terms. What is an "improper image"? What traits can be considered "provoking"? All of this remains unclear. Even in the West, this vagueness stirs up sharp criticisms which underline the negative aspect of the rules pertaining to sacred art. Some have said concerning the regulations of 1952 that they preserve only a minimum of "tradition": just enough to keep the faithful from confusing a church steeple with a factory chimney. Otherwise they sanction all of the mistakes of the past and of the present and proclaim that sacred art must search for a "new style." To participate in "the wonderful concert of famous men," as it is put by Pius XII, the Roman Church therefore appeals to the most famous of contemporary painters to decorate its churches, without being in the least concerned with whether they belong to the Church or not, or even if they are believers or atheists. How can there even be a question of intercourse between the image and the word of Scripture when the person who decorates a church or paints a sacred image is an atheist or when he belongs to another religion? One could in such a case speak

[3]Quoted from E. Mâle, *L'art religieux après le Concile de Trente* (Paris, 1932), p. 1.
[4]F. R. Regamey, *L'art sacré du XXᵉ siècle* (Paris, 1952), p. 432

only of a formal illustration of the letter of the Scriptural text or, what would be even worse, of a personal interpretation by the painter, the application of his own ingenuity to a scriptural subject. Even to preach a sermon—something much less important in the Church than an image—one would not invite someone of a different religion or an atheist simply on the grounds that he is a brilliant speaker. But this is being done in the field of art. This shows the extent to which the very meaning of the sacred image has been lost in the Roman Catholic Church.

This vagueness in the directives communicates the chaotic state of sacred art itself, which has now reached a critical point. In fact the Roman Catholic Church has been forced to accept secular art which often has a very doubtful spiritual content, or else to do without art altogether. For example, here is what was written in an article which appeared several years ago in a French magazine: "The Church [speaking of the Roman Church] finds itself today in the same situation as any individual. It must accept the criteria of pure esthetics . . . Therefore the Church, unless it succumbs to sentimental bad taste, should either come to terms with the solutions reached by artists outside itself or else refrain from resorting to art."

The Orthodox Church, on the other hand, gives a positive teaching. It stipulates that artists paint icons as they were painted by the ancient and holy iconographers (see, for example, the Council of One Hundred Chapters in 1551). At first glance, this directive may appear to be very imprecise. But its entire significance becomes clear if one remembers the masterly expression of St. Paul, quite relevant in its sobriety and power: "Be imitators of me," he wrote, "as I am of Christ" (I Cor. 11:1). To paint icons as they were painted by the ancient and holy iconographers means to follow Tradition and denotes a particular attitude towards sacred art. "Use colors according to Tradition," says St. Simeon of Thessalonica. "This is true painting, as Scripture is its books . . ."[5] It is not a matter of copying the ancient iconographers. St. Paul did not imitate Christ by copying His gestures and His words, but by integrating

[5]*Dialogue against heresies*, ch. 23, PG 155: 113 D.

himself into His life, by letting Him live in him. Similarly, to paint icons as they were painted by the ancient iconographers does not mean to copy the ancient forms, since each historical period has its own forms. It means to follow the sacred Tradition, to live in the Tradition. But the power of Tradition is the power of the Holy Spirit and of continuity in the spiritual experience of the Church, the power of communion with the spiritual life of all the preceding generations back to the times of the apostles. In Tradition, our experience and our understanding are the experience and understanding of the Apostle Paul, of the holy iconographers and of the entire Church: We no longer live separately, individually, but in the body of Christ, in the same total body as all of our brothers in Christ. This is in fact the case in all areas of spiritual life, but it is particularly true in that of sacred art. The contemporary iconographer must rediscover the internal outlook of the iconographers of old and be guided by the same living inspiration. He will then find true faithfulness to Tradition, which is not repetition but a new, contemporary revelation of the internal life of the Church. Indeed, an Orthodox iconographer faithful to Tradition always speaks the language of his time, expressing himself in his own manner, following his own way. We see, therefore, how the decisions of the Roman Church are vague in spite of their prolixity, and how the basic guidelines of the Orthodox Church are precise and concrete in their laconism.

We spoke briefly of the icon in the life of the Church and we explained in a few words the importance which the Church ascribes to its sacred art. But if we now turn to the practice of the Church, we will frequently see a great discrepancy between the traditional teaching about the image and the image itself. We often see in our churches a large number of heteroclite, secular or semi-secular images which have little in common with the icon. These are, in fact, usually images of a secular art having merely a religious subject. Anything can be found, even masonic symbols such as an eye in a triangle, called the "all-seeing eye." In most of our churches, the true icons are lost amidst a multitude of representations foreign to Orthodoxy and which, so as not to be called simply Roman Catholic, are euphemistically characterized as "paintings in

the Italian style" or icons "of the Italian genre.'
hand, icons which are truly Orthodox are calle
the Byzantine style," "Novgorodian," *etc.* One
style in scientific analyses, in historical or archeolo
but to use this idea in the Church to characterize
absurd as to discuss the "style" in which the Creed or the Great
Canon of St. Andrew of Crete is written. It is clearly a meaning-
less statement. In the Church there is only one criterion: Ortho-
doxy. Is an image Orthodox or not? Does it correspond to the
teaching of the Church or not? Style as such is never an issue
in worship.

Many faithful believe that one can pray before any image,
Orthodox or Roman Catholic, as long as there is an image, since
it is only of secondary importance. This is why they bring all
kinds of images into churches. Those who think in this way do
not know that during the iconoclastic period of the eighth and
ninth centuries it is precisely this struggle for an authentic Or-
thodox image which called forth from the Church a large num-
ber of martyrs and confessors. Of course, one can pray before
any image. One can also pray without any images at all, or even
without a church. One can and one must pray always and every-
where. But this certainly does not mean that one can dispense
with the church and the image or that the external appearance
of the church and of the images in it are an indifferent matter.
One must not forget that when one enters a church, it is not
only to pray in it. We also receive the teaching of Orthodoxy,
and this beneficial teaching is our guide throughout our whole
life, including our prayers. It often happens in our churches
that the sacred word is our guide and teaches us in a certain
way, while the image, being heterodox, teaches us and guides
us in a completely different way. How is this possible? We have
preserved the Orthodox veneration of the image. But under
the influence of Catholicism and Protestantism, we have be-
come indifferent to the very contents of the image. This is why
we can no longer distinguish between the Roman Catholic
image, which expresses, as we shall see, the Roman teaching,
and the authentic Orthodox image. We accept everything and
take a passive attitude toward the realm of sacred art.

Let us give several examples. There exists an opinion ac-

cording to which nothing which has been used by the Church can be discarded. Human error is normal, but a theory based on an error and the erroneous practice which it produces are inadmissible in the Church. If this were not the case, we would not, for example, have any reason to reject the synodal regime in the Russian Church. Indeed, the regime lasted for many centuries and the period was illumined by great saints, like St. Seraphim of Sarov, St. Mitrofan of Voronezh, St. Tikhon of Zadonsk and others. This same reference to practice is invoked in preserving iconographic subjects borrowed from heterodox art, based solely on the imagination of the artist, and which not only did not correspond to the Gospel but, on the contrary, contradicted it. These subjects are not rejected, since it is believed that the mere fact of their existence in our Church for two or three centuries is proof that they have become Orthodox. But time is not a criterion of truth. If a falsehood has been accepted for two hundred years, this does not mean that it has become a truth. And if it happens that the ecclesiastical authorities have been mistaken, then the Church always, in the end, corrects their error. Thus, a local council of Moscow in 1553-1554 accepted a representation borrowed from the West—the image of God the Father—under the pretext that this image had already been introduced into the practice of the Church. But in 1667, the Great Council of Moscow considered the question from a different angle, asking the question of whether this image corresponded to the Orthodox teaching. It reached the conclusion that it did not. The decision of the previous council was annulled, and this representation was forbidden.

On the other hand, there exist, even among the Orthodox, people who are disturbed by the Orthodox icon, believing as do some archeologists and art historians that liturgical art is "medieval," "out-dated," "idealistic," *etc.*, and who are afraid of being left behind the times. But the opinion of scholars and philosophers of esthetics cannot, as such, be an authority for the faithful. Often ignorant of the very basis of sacred art and applying secular standards to it, this opinion could only be unilateral and partial. It is amazing that those persons who are disturbed by the presence of icons are not, however,

disturbed by the fact that our liturgy goes back to the same times as does the icon and, to a great extent, even as far back as the Old Testament. But in spite of its antiquity, the liturgy retains its fundamental importance, and very few consider it to be "out-dated."

But the plague of our times is estheticism. There is a dictatorship of "taste." Personal taste is usually accepted as the only criterion for the appreciation of a sacred image. One speaks of "good taste" and "bad taste." But in the Church, taste can be neither good nor bad, and should not be used as a criterion. By what right should one person's taste be considered good and another's bad? By its very definition, taste is something subjective and changeable. For a sacred image, just as for the sacred writings, a relative and variable criterion cannot be valid. The notion of taste may be applicable to the artistic value of the image, but not to its value as a liturgical image. If one bases one's understanding exclusively on individual, esthetic or some other kind of appreciation, one reaches the point which St. John of Damascus feared when he wrote: "If each person could act according to his desire, little by little, the entire body of the Church would be destroyed."[6] It is precisely in defending icons during the iconoclastic period in the eighth century that St. John of Damascus wrote these words.

The Orthodox Church has always fought to defend its sacred art against secularization. Through the voice of its councils, its hierarchy and its faithful, it fought to retain the purity of the sacred image against the penetration of foreign elements characteristic of secular art. The Church did not fight for the artistic quality of its art, but for its authenticity, not for its beauty, but for its truth. It has retained unchanged the sacred tradition in art, the understanding of its dogmatic contents and of the spiritual significance of sacred art. We are constantly reminded of it in the liturgy. It is, in particular, the stichera and canons of the feasts of the various icons (for example, that of the Holy Face on August 16, and especially the liturgy of the Triumph of Orthodoxy) which dis-

[6] *Third Treatise in the Defense of Holy Icons*, ch. 41, PG 94: 1356.

cover the meaning of the image in all its depth. But, in times of spiritual decadence like our own, the voice of the Church is a voice which is not heard. Shamelessly, we listen without hearing the words which the Church proclaims, and we look without seeing, like those of whom Christ speaks in His Gospel.

One must admit that the existing confusion in the Orthodox Church concerning sacred art is, to a large extent, a consequence of the education received by the clergy, which does not stress the priest's responsibility for the purity of the icon. Indeed, before his ordination, every priest promises to "obey all the rules established by the councils." But the learning which he acquires in religious institutions does not prepare him to be able to keep such a promise in the realm of sacred art. One is not taught anything about the theology of the image, though at the same time a future priest is taught archeology and art history. But these subjects cannot be useful unless they are limited to an auxiliary role. By themselves, without a theological basis, they give the future priest a false idea of what an image is in the Church. This is why, when a student becomes a priest, he is often incapable of distinguishing between an icon and a secular image, or even certain icons from others, and of interpreting the representations of the principal feasts. How can he, under these circumstances, distinguish in an image the real from the false and explain to others the contents of the image? One usually replies that art is a special field, that to understand it one must be a specialized expert. Yes, certainly this is true when one is concerned with the historical or artistic aspect of the image. But if one is concerned with the contents, such a point of view is absolutely false. The icon, in fact, is art, but it is above all liturgical art, a part of the liturgy. Thus, just as the celebrant should not be required to be a historian or a lover of literature in order to understand sacred Scripture, so also the understanding of the sacred image requires neither precise knowledge of art history nor the refinement of an esthete. A priest should simply know how to "read" an icon as well as the liturgy.

But whether we are priests or laymen, we are all members of the Church. We are all called to witness its truth in a world which does not understand it. This is why it is essential that

each one of us be conscious of this truth in whatever form it is expressed, verbally or in images. The Orthodox teaching of the image was formulated several times, in response to errors and misunderstandings. These errors and misunderstandings repeat themselves, and our century has discovered nothing new in this field. The Orthodox Church has retained intact an immense richness not only in the realm of liturgy and patristic thought but also in that of sacred art, and we who enjoy the riches of this treasure should know about it and be witnesses to it. Those who confess Orthodoxy should be careful not to bring into the world a truth mixed with falsehood. Let us not forget that, just as thought in the realm of religion has not always reached the level of theology, so artistic creation has not always reached the level of authentic iconography. This is why one cannot consider every image, even one that is very old and very beautiful, as an infallible authority, especially if it originated in a time of decadence such as our own. Such an image may correspond to the teaching of the Church or it may not. It can deceive instead of teach. In other words, the teaching of the Church can be falsified by the image as much as by the word. In the conditions existing today, we are facing a painful situation which leads to conflicts and polemics and often throws the faithful and particularly the painters into total confusion. Each one of us should be able, at every instant, to confess his faith by word and through the image.

I

The Symbolism of the Church

BEFORE WE begin our discussion of the icon, it is necessary to consider briefly the whole of which it is a part: the church building and its symbolic significance.

What is symbolism? Symbolism expresses indirectly, through images, that which cannot be expressed directly in material or verbal forms. Being a mysterious language, symbolism also hides truths which it reflects from those who are not initiated and makes them understandable to those who know how it approach them. Everyday language frequently confuses the ideas of "sign" and "symbol," as if they were identical. In fact, there is a necessary spiritual distinction between them. A sign only portrays reality; a symbol always qualifies it in a certain way, bringing forth a superior reality. To understand a symbol is to participate in a presence; to understand a sign is to translate an indication. Let us take the example of the cross. In arithmetic, it is a sign of addition; as a road sign, it announces the crossing of two roads. But in religion, it is a symbol which expresses and communicates the inexhaustible contents of Christianity.

In the Church, symbolism plays a very important role because the entire Church is, in a way, both material and spiritual. That which is material is directly accessible to us; that which is spiritual is indicated through symbols. The symbolism of the Church cannot be effectively studied outside of the liturgy because it is a liturgical symbolism and it is through the liturgy that the Fathers explained it. Separated from the divine services, symbolism loses its meaning and becomes a series of sterile abstractions.

The word "Church" (in Greek ἐκκλησία) means "con-

vocation" or "reunion." The Church "is thus named because it convokes all men and unites them with one another," says St. Cyril of Jerusalem.[1] Other Fathers (for example, St. Athanasius the Great, St. John Chrysostom, St. Augustine) express this same thought. The verb καλέω means "to summon"; ἐκκαλέω means "to convoke" from somewhere. Those who are called together are the apostles and the disciples of Christ, the new Israel. In the Old Testament, the people of Israel were distinct from the world so that they could announce to it the divine incarnation and prepare the world for the coming of the Messiah. The new Israel—the Church—in turn brings the presence and the promise of the Kingdom of God to the fallen world; it prepares this world for Christ's Second Coming.

The word "Church" also designates the Body of Christ, His Kingdom made up of the communion of the faithful, and also the place of worship. In our prayers for the consecration of churches, the place of worship is, indeed, called the "house comparable to the heavens," "the image of the house of God." It is consecrated "to the image of the most holy Church of God, that is, of our very body which Thou deigneth to call Thy temple and the members of Thy Christ by the mouth of Thy glorious Apostle Paul," that is, to the image of the Church, the Body of Christ, according to the words of St. Paul (Eph. 1:23 and Col. 1:18). Thus a church is an image, an icon, of the Church, the Body of Christ. It expresses symbolically that which cannot be expressed directly, because neither words nor direct images can represent the one, holy, catholic and apostolic Church, the object of our faith but invisible in its fulness.

The foundation of Christian life has always been the same, both in the first centuries of our era and today. It is the birth of a new life, an intimate union with God which is essentially fulfilled in the sacrament of the eucharist. A church, as the place where this sacrament is fulfilled and where men, united and revived, are gathered together, is different from all other places and buildings. It is characteristic that, among

[1]*Catechetical Orations* 18, 24, PG 33: 1044.

the various names which the first Christians gave to their temple, such as "church" or "the house of the Church," the most frequent designation was "the house of the Lord." [2] This name itself already underlines the difference between a church and all other buildings and expresses its specifically Christian meaning.

This meaning is connected with the heritage of the Old Testament. The tabernacle of the Old Testament, a prefiguration of the New Testament churches, was built according to the image shown to Moses on Mount Sinai. God Himself indicates both its general plan and its disposition, in the smallest detail. The history of the Church shows us that the first Christians had not broken with the past. On the contrary, they believed themselves to be the direct heirs of the Old Testament. The Christians were the new Israel, the fulfillment of the prophecies. The Apostles and the Fathers constantly emphasize the traditional character of the new faith. The Apostles and the first Christians generally went to the synagogues and to the temple in Jerusalem and participated in Jewish worship. It is only after they were forbidden access to these places that they built Christian sanctuaries, and they did so in strict accord with the revealed character of the place of worship, with the very principle according to which the tabernacle and the Jerusalem temple had been built. But they also gave this principle its true meaning, as expressed in the New Testament and as the fulfillment of the prophecies. This is why one cannot doubt that the essential significance of a church, so directly connected with the very essence of Christianity, was understandable to everyone in the first centuries of our era, even though it was not immediately manifested in external or conceptual forms.

We learn from history and archeology that the Christians of the first centuries did not only have catacombs and places of prayer in private homes, as we know from the Acts of the Apostles and the Epistles,[3] but that they also built churches

[2]H. Leclercq, *Manuel d'archéologie chretienne*, vol. 1 (Paris, 1907), pp. 361-2.

[3]Acts 12:12, 20:7-8; Rom. 16:4; I Cor. 16:19; Col. 4:15.

above ground.[4] These churches were destroyed in the times
of the persecutions; then they were rebuilt. But in spite of
the existence of these churches, neither the Fathers of the first
centuries, nor writers in general, describe the liturgy exten-
sively or dwell upon its meaning and the symbolism of the
church. There are two reasons for this silence: (1) There was
no need to write about that which everyone understood, that
which everyone lived. (2) The Christians did not want to
initiate the pagans into their sacraments, to lay bare their faith
and their hope. The truths of the faith were confessed by life
itself and needed no formulation.

There exist, nevertheless, some indications, dating back
to the first centuries, showing how early Christians under-
stood their place of worship. According to the *Didascalia* and
the Apostolic Constitutions, a church should remind the faith-
ful of a boat, and have three doors to evoke the Holy Trinity.
We know that the Fathers frequently used the image of the
boat and, particularly, that of Noah's ark to symbolize the
Church. Noah's ark was seen as a prefiguration of the Church:
Just as this ark was a refuge during the flood, so the Church,
guided by the Holy Spirit through the tides of life, is a
salutary refuge for Christians. Even today, we continue to call
the central part of our churches "the nave," from the Latin
navis, ship. Symbolic images of Noah's ark can be found in
ancient monuments, in the form of a square box,[5] sometimes
with a dove flying above it. Archeological diggings show that
many churches in the first centuries were built in a square
shape, that is, in the image of the ark. At first sight, this
analogy may appear to be artificial, just as the indication of
the Holy Trinity with three doors. But, for the small Chris-
tian communities, surrounded by a more or less hostile pagan-
ism, the Church was indeed an ark, where salvation could be
found in the sacraments.

As for the symbolism of the three doors, it is necessary to
remember that the teaching on the Holy Trinity is not only a
teaching of the Church on the one God in three persons; it is

[4]H. Leclercq, *op. cit.*, vol. 1, pp. 378 ff.; Sisto Scaglia, *Manuel d'arché-
ologie chrétienne* (Turin, 1916), pp. 143-144.
[5]H. Leclercq, *op. cit.*, vol. 1, p. 395.

also the very basis of the life of the entire Christian community. The Holy Trinity is, in fact, the prototype of the love in which, even today, the entire Christian community lives, whether it is a monastery, a parish or any other group. This is why, even today, everything in our churches reminds us of the Trinity: the three parts of the church, the three fingers with which we cross ourselves, *etc.*

From the fourth century on, Christian authors begin to explain the symbolism of the church in more detail. Two particular circumstances made such explanations necessary:

(1) In the fourth century, under St. Constantine, the Church received the right to a legitimate existence in the Roman Empire. This historical event of capital importance led to the triumph of the Church and had very important consequences for its art. Construction and adornment of the churches was developed to a point unknown until that time. The famous church historian Eusebius of Caesarea speaks at length and very enthusiastically about these constructions. A large multitude of recent converts filled these new churches. Most of them needed spiritual guidance and direct explanation of the Christian faith. One of the ways this instruction was accomplished was through the symbolism of the churches and of worship, which was now explained in detail.

(2) In the fourth century, Christian worship took more precise and determined forms. The liturgies of St. John Chrysostom and St. Basil the Great date back to this time. The rapid progress in the definition of rites and the decoration of churches can be seen in a description by Eusebius of the reign of St. Constantine: "A clear and luminous day, without even the smallest cloud, illuminates with rays of divine light the churches of Christ in the whole universe ... Churches are again rebuilt to a great height and have a much better appearance than the ancient, destroyed churches ... Feasts of renovation and consecration of new churches are beginning to be celebrated in the town ... The worship which is celebrated by the priest and the sacred rites become more perfect, the customs of worship become more beautiful." [6] Certain an-

[6] *Ecclesiastical History* X, I and II, PG 20: 845 A, 845 C and 848 B.

cient liturgies (for example, the Syriac text of the liturgy of St. James) contained commentaries for the instruction and guidance of the faithful. These commentaries were part of the liturgical text and were read by the deacon during the celebration. It is believed that these commentaries were introduced at the end of the third or in the beginning of the fourth centuries, that is, at the time when they were made necessary by the large number of new converts in the Church. This makes us think that today, too, such commentaries would not be superfluous, at least during a sermon, after the liturgy.

What is the basis of the symbolism in churches? Christian life is based on two essential realities. One is the redeeming sacrifice of Christ, the need to participate in this sacrifice, to partake of communion in it in order to be saved. The other essential truth is the goal and the result of this sacrifice: the transfiguration of man, and with him, of the whole visible world, resulting in peace between God and the world. This second truth is the main subject of Church symbolism: the forthcoming universal Kingdom of God. It is precisely this orientation towards the future, this building up of the future, which distinguished Christian worship from all others.

Worship can be celebrated in different languages and take many forms. Similarly, a church can be shaped like a cross, a basilica or a rotunda. It can be built according to the tastes and the ideas of any epoch or of any civilization, but its meaning was, is, and will always be the same. Each people leaves its characteristic traits in the construction of churches. But this diversity of forms only serves to emphasize the unity of meaning, the confession of the same truth.

In a homily on the consecration of a church in Tyre at the beginning of the fourth century, Eusebius already devotes a rather detailed passage to the symbolism of the building. His fundamental thought is that, in a church, what we see is identical to what we hear. The building corresponds to the worship which we celebrate in it. It is the house of God, for God lives in it with the faithful, the receivers of His Spirit. It is the heavens on earth, it is already the earth of the time to come, when God will be all in all. The beauty of a church reveals, in a way, the beauty of the celestial Jerusalem which

God prepares for those who love Him.[7] But Eusebius does not limit himself to commenting on the church as a whole. He already provides several explanation of its parts: the sanctuary, separated by a barrier, the nave and the narthex. Eusebius knew how to reflect the mentality of his time and how to describe the events which he had witnessed.

It is particularly in the seventh and eighth centuries that the symbolism of the churches acquires its most complete theoretical expression. The most systematic commentaries can be found in the *Mystagogy* of St. Maximus the Confessor (seventh century), who also left us a remarkable study of the liturgy, in the writings of St. Sophronius, Patriarch of Jerusalem (seventh century), in those of St. Germanus, Patriarch of Constantinople (d. 740), an important confessor of Orthodoxy during the iconoclastic period, and in the works of St. Simeon, Archbishop of Thessalonica (fifteenth century). The seventh and eighth centuries, when symbolism became so popular, are also the time of vigorous liturgical creativity, the time of the great hymnographers, St. Andrew of Crete, St. Cosmas of Maium and St. John of Damascus.

When one studies these commentaries, one must never forget that they do not express the subjective opinion of the authors. The symbolism of the Church is objectively based on the essence of Christianity. It expresses a well-defined reality, the liturgical life, that is, one of the principle aspects of Tradition. This is why St. Simeon of Thessalonica begins his *Book on the Church* with the words: "With love, we pass on to you that which we have taken from the Fathers. For we offer nothing new, but only that which has been passed on to us, and we have changed nothing but we have retained everything, like a creed, in the state in which it has been given to us. We worship exactly as Christ Himself did and as did the apostles and the Fathers of the Church."[8] This presents a striking parallel with theological thought, in which the Fathers also tried to avoid all individual and subjective valuation. "I pray God so as not to think or to pronounce on Him, as did

[7]*Ecclesiastical History*, X, 4, PG 20: 873.

[8]PG 155: 701 A-B.

Solomon, anything which comes from me personally," writes
St. Gregory of Nazianzen.[9]

St. Maximus the Confessor and St. Sophronius see in the
church, the image of the spiritual and visible worlds, the image
of that which we perceive spiritually and that which we per-
ceive with our senses. They particularly emphasize the cosmic
importance of a church, as an image of the entire created but
transfigured world.

St. Germanus speaks of the Church as the Body of Christ
and of the church as a place of worship in the same terms
and in the same sentence, thus emphasizing that the latter is
but an image of the former. He says: "The Church is the
heavens on earth, where God, who is higher than the heavens,
lives." He continues: "It is reminiscent of the crucifixion, the
burial and the resurrection of Christ; it is more glorified than
the tabernacle of the Covenant," which obviously refers to the
place of worship. "It was prefigured in the patriarchs, based
on the apostles . . . it was announced by the prophets, adorned
by the hierarchs, sanctified by the martyrs, and its altar is
founded on their holy relics." Having clearly emphasized the
analogy between the Church, the Body of Christ, and a
church as the place of worship, St. Germanus goes on to ex-
plain the meaning of the place of worship: "The church is a
divine house where the mysterious and vivifying sacrifice is
fulfilled; it contains the interior sanctuary, the holy cave, the
sepulcher, the meal which saves and vivifies the soul; it is
the place where you will find the pearls of the divine dogmas
which the Lord taught unto His disciples."

St. Simeon of Thessalonica also emphasizes this signif-
icance of the church and specifies, among other things, that
the most solemn rite of the consecration of a church presents
it to us as "a mysterious heaven and the Church of the first-
born." It is obvious that the Church about which the Fathers
speak is not only the terrestrial Church in its present state, but
it is also the celestial Church which is intricately connected
with it, in other words, the Kingdom of God which will come
in its power when God will be "all in all" (Eph. 1:23). This

[9]Hom. 20, *On the Trinity*, PG 35: 1069 C.

is what the Church expresses. St. Simeon of Thessalonica calls a church paradise and the gifts of paradise, for it contains not the tree of life, but life itself, which acts in the sacraments and is communicated to the faithful.

Thus, a church is a very complicated reality, having a meaning rich in contents. It is a sacred place where the members of the Church, through the sacraments, commune in the divine life. Being the first fruits of the Kingdom to come, it is both a part of this Kingdom, as it already exists on the earth, and an anticipation of its coming in glory. It is an image of the divine Kingdom, towards which the Church leads the world.

But patristic commentaries do not limit themselves to explaining the actual building of the church. They also clarify the meaning of each of its parts. The patristic conception of the church and of its parts is well summarized in a contemporary work, Archbishop Benjamin's *Novaia skriial* ("New Table of the Law"). The church can be divided into three parts (the sanctuary, the nave and the narthex), according to the plan of the tabernacle of Moses and the temple of Solomon. Just as the people of Israel, the Church of the Old Testament, prefigured the Church of the New Testament, so also the tabernacle and the temple prefigured the sacred places of the New Covenant, which had preserved the same plan (Fig. 1). St. Simeon of Thessalonica is reminded of the Holy Trinity by this tripartition, of the three orders of the celestial hierarchs and of the Christian people themselves who are divided into three categories: the clergy, the faithful, and the penitents and catechumens.

The sanctuary is reserved for the clergy. It is the most important part of the church, where the sacrament of the eucharist is performed, and corresponds to the holy of holies in the tabernacle. Symbolically, the sanctuary represents the house of God, "the heaven of the heavens," according to St. Simeon of Thessalonica. According to the words of St. Germanus, it is "the place where Christ, King of all things, rules with the apostles." The sanctuary is usually in the eastern part of the building, so that the whole church faces east. This orientation also has a symbolic significance. On the one hand, the lost

paradise was "in the East." On the other hand and more im-
portantly, the coming of the Kingdom is often identified with
the sunrise: Christ is glorified as "the orient from on high."
This Kingdom of God to come is often seen, particularly in
the first centuries of Christianity, as "the eighth day" of crea-
tion. The coming of this "day without end," which we await
and prepare for, its rising as it were, is symbolized by the sun-
rise in the east. This is why St. Basil stipulates, in his canon
90, that our prayers should always be oriented towards the
east, where the sun rises.

The central part of the church, the nave, corresponds to
the "holy" of the tabernacle, which was separated from the
courtyard by a veil. Every day, the Jewish priests would enter
it to bring the sacrifices. In the Church of the New Testament,
it is the faithful laymen, "the royal priesthood, the holy
people," according to the expression of St. Paul, who enter
into this part and pray to God. This part of the church is
therefore for those men who are enlightened by the faith and
who are preparing themselves to partake in the grace of the
eucharistic sacrament. Having received this grace, they are
redeemed and sanctified; they are the Kingdom of God. If
the sanctuary represents that which goes beyond the created
world: the house of God Himself, then the nave of the church
represents the created world. But it is a world which is jus-
tified, sanctified and deified; it is the Kingdom of God, the
new earth and the new heavens. This is how the Fathers de-
scribe this part of the church. Here, for example, is what St.
Maximus the Confessor says: "Just as, in man, the carnal and
spiritual principles are united, even though the carnal prin-
ciple does not absorb the spiritual, nor does the spiritual prin-
ciple absorb the carnal into itself, but rather spiritualizes it,
so that the body itself becomes an expression of the spirit, so
also in a church, the sanctuary and the nave communicate: the
sanctuary enlightens and guides the nave, which becomes its
visible expression. Such a relationship restores the normal
order of the universe, which had been destroyed by the fall
of man. Thus it reestablishes what had been in paradise and
what will be in the Kingdom of God." [10]

[10]*Mystagogy*, caps. 8-21, PG 91: 672.

The narthex, finally, corresponds to the courtyard of the tabernacle, the external part which contained the people. Today, the sanctified people stand in the nave, and it is the catechumens and penitents who remain in the narthex, that is, those who are only preparing themselves to enter the Church and those whom the Church places in a special category and who are not permitted to partake in the communion of the holy gifts. This is why, once the sacrament is fulfilled, those who do not partake of it are asked to leave, some because they are not yet members of the Church and others because they have fallen away or are considered unworthy. Thus, the very plan of a church makes a clear distinction between those who participate in the Body of Christ and those who do not. The latter are not driven out of the church and can remain until a certain moment. But they cannot participate in the internal, sacramental life of the Church. They are neither completely outside the church, nor a part of it. They are, so to speak, on the periphery, at the limit between the church and the world. The narthex, according to the Fathers, symbolizes the unredeemed part of the world, the world lying in sin, and even hell. It is always at the opposite end of the church from the sanctuary, that is, at the west.

A "temporal" significance, which changes during the different moments of worship, is added to the "spatial" and permanent significance of a church. The Church also uses images in order to show that a church, a place of worship, is an image of the one, holy, catholic and apostolic Church, that it is the real first fruits and the image of the Kingdom of God to come, and in order to make this image more precise, by suggesting the presence of this Kingdom to come. The iconographic subjects are distributed according to the meaning of each part of the church and its role in worship. If the symbolism of the liturgy was explained by the fathers during the pre-iconoclastic period, in contrast it is after the iconoclastic period that the relationship between the decoration of the church and this symbolism was made more specific. The decoration acquired the forms of a clear and precise theological system.

We will speak here only in very general terms of the classical plan of decoration, which prevailed from the ninth cen-

tury, that is, from the post-iconoclastic period when the system
of decorations of churches was definitively established, until
the end of the seventeenth century. Obviously, this stability
and uniformity exists only in the general shape of the decora-
tion, not in its details.

In the sanctuary, the first row of paintings, beginning from
the bottom, represents the Fathers, authors of liturgies, and
with them, the other holy hierarchs and the deacons in their
rank of concelebrants. Above these, the eucharist itself is
represented in the form of the communion of the apostles,
in the two forms of bread and wine. Above the eucharist, the
image of the Mother of God is placed directly behind the
altar. Her place close to the sacrament corresponds to Her
place in the eucharistic canon, where she is mentioned as the
head of the entire Church, immediately after the fulfillment
of the eucharistic mystery. At the same time, the Mother of
God personifies the Church itself, because She contained in
Herself the creator of the world whom the whole world can-
not contain. This is why, in this part of the sanctuary, She
is usually represented in the *oranta* position, that is, interced-
ing before God for the sins of the world, which is simul-
taneously Her role and the role of the Church. This representa-
tion of the Virgin in *oranta* in the very place where the sac-
rifice is fulfilled reflects a very special meaning. The uplifted
hands are a gesture which completes the sacrifice. This is why
the priest also makes this same gesture during the liturgy.
This position of uplifted hands is not a formal requirement,
but it has become deeply rooted in the liturgy, as it is bound
with the sacrifice and is the image of prayer itself.

Because the sanctuary is the place where the unbloody
sacrifice established by Christ is offered, the image of Christ
is placed above that of the Virgin. It is He who is Himself the
offered sacrifice and the Sanctifier who offers, and His image
has a uniquely eucharistic significance here. Finally, Pentecost
is represented in the vault. This image indicates the presence
of the Holy Spirit by whose virtue the sacrament of the eucha-
rist is fulfilled.

This very brief survey permits us to see the capital im-
portance of the sanctuary: It is the place which sanctifies the

entire church. When the Royal Doors are opened during the liturgy, it is as if the heavens themselves were opened a bit, permitting us to catch a glimpse of their splendor.

The nave of the church, as we already know, symbolizes the transfigured creation, the new earth and the new heavens, and at the same time, the Church. This is why the leader of the Church, Christ the Pantocrator, is painted on the cupola. The Church had been announced by the prophets and established on the apostles; they are represented immediately under the image of Christ. There are followed, in the four corners, by the four evangelists, who announced the good news and preached the Gospel in the four parts of the world. The columns which support the building are decorated with the images of the pillars of the Church: the martyrs, the hierarchs and the ascetics. The most important events of sacred history are found everywhere on the walls, particularly those events which the liturgical feasts celebrate, the "pearls of divine dogmas," in the words of St. Germanus of Constantinople. Finally, on the western wall, the Last Judgment is presented: the end of church history and the beginning of the age to come.

Thus, the decoration of Orthodox churches does not depend on individual conceptions of artists. The iconographic themes are distributed according to the meaning of the church as a whole and the meaning of each of its parts.

The Church of the Old Testament, as well as all other religions, used symbols. This symbolism prefigured the coming of Christ. But Christ has come, and, nevertheless, the symbolism inherited from Israel continues to exist in the new Church, being an indispensable part of its worship, penetrating the entire liturgy with its words, its gestures and its images. This symbolism is an initiation to the mysteries which are fulfilled in the Church and the revelation of a reality which is always present in it and which cannot be expressed directly. This reality is the Kingdom of God, whose authentic first fruits are present as a spiritual, material and physical reality in the eucharist, the central sacrament of the Church. For "it is impossible for us to raise ourselves to the contemplation of

spiritual objects without some kind of intermediary, and to
lift ourselves, we need something which is close and familiar
to us," says St. John of Damascus.[11] In other words, worship
and everything which is a part of it, is a path towards our
sanctification, towards our deification. Everything in a church
is oriented towards this goal. After the fall, the Old Testa-
ment was the first step, but it was not yet a direct preparation
for the age to come; it was only the preparation for the sec-
ond stage, that of the New Testament. That which was, in
the Old Testament, the future, has now become the present,
and this present, in turn, prepares and leads us to that which
is still to come, the celestial Jerusalem. Here is how St. John
of Damascus understands the Epistle to the Hebrews:

> Notice that the law and everything that was estab-
> lished by the law, as well as the whole worship which
> we now offer up, are sacred things made by man
> which, with the intermediary of matter, we lift to-
> wards the immaterial God. The law and everything
> that was established by the law (that is, the entire
> Old Testament) was a prefiguration of our pres-
> ent worship. And the worship which we presently
> offer up is an image of the things to come. These
> things (that is, reality itself) are the celestial, im-
> material Jerusalem which is not made by the hand
> of man, according to the words of the Apostle, "for
> here we have no lasting city, but we seek the city
> which is to come" (Heb. 13:14), that is, the celestial
> Jerusalem of which God is the "builder and maker"
> (Heb. 11:10). Indeed, everything that was estab-
> lished both by the law and by our present worship
> only exists in relation to the celestial Jerusalem.[12]

A church is, therefore, the prefiguration of the peace to
come, of the new heavens and the new earth where all crea-
tures will gather around their creator. The construction and

[11]*First Treatise in the Defense of Holy Icons,* cap. 2, PG 94: 1233.

[12]*Second Treatise in the Defense of Holy Icons,* cap. 23, PG 94: 1309,
passim.

decoration of churches is based on this image. The fathers do not stipulate any style of architecture; they do not indicate how the building should be decorated and how icons should be painted. Everything flows from the general meaning of the church and follows a rule of art which is analogous to the rule of liturgical creativity. In other words, we have a very clear, albeit general formula which guides the architect and the artist, while leaving him the freedom of the Holy Spirit. This formula is always passed on from generation to generation by the living tradition of the Church, the tradition which dates back not only to the apostles but even to the Old Testament. If we live in this tradition, we can understand the Church as it was understood by our holy Fathers and we will decorate it accordingly. If we move away from this tradition, we can introduce into our churches elements which do not correspond to the Church's very nature, but which reflect only our everyday life. Thus, we secularize the church.

The very meaning of the church, its *raison d'être*, requires it to be different from all other buildings. According to the words of Jesus Christ Himself, His Church is a Kingdom "which is not of this world." However, the Church lives in the world and for the world, for its salvation. This is the goal of its existence. Being the "Kingdom which is not of this world," it has its own nature which is distinct from the world. And it can fulfill its goal only by remaining faithful to its specific nature, to itself. Its way of life, its actions and methods, are different from those of the world. Its art, in particular, does not resemble the art of the world. It expresses different kinds of truths and has other goals. If it mingles with secular art, it no longer corresponds to the goal which it must serve.

From the first centuries, the Christian Church established the interior aspect of its temples, the character of the sacred images, the hymns, the sacerdotal vestments, *etc.* All of this forms a harmonious whole, a perfect unity and a liturgical fulness in the Church and in the liturgy. This unity, this convergence towards the same goal, implies that each of the elements which make up the divine service is subordinate to the general meaning of the church and, consequently, that it renounces all ambition of playing its own role, of being of

value by itself. Images and hymns express, each in their own way, the same transfigured universe and prefigure the same peace to come.

United by this common goal, these different elements which enter into worship realize this "unity in diversity" and this "richness in unity" which express, both as a whole and in every detail, the catholicity of the Orthodox Church, its *sobornost'*. They create the beauty of the church which is so different from the beauty of the world because it reflects the harmony of the age to come. As an example, one can remember the Russian chronicler's account of the conversion of St. Prince Vladimir. When messengers he had sent to Constantinople as part of his program of comparing the different religions had returned, they told of how, when they were participating in a liturgy at St. Sophia, they no longer knew whether they were on earth or in heaven. Even if this is only a legend, it corresponds perfectly to the Orthodox understanding of beauty. The imperial palace was also beautiful, but it did not leave the same impression on the messengers of St. Vladimir.

All of this is, of course, not new, but the obvious experience of one who lives in the Church. The Church never loses this Tradition, and reminds us of it constantly by the liturgy, by the voice of its councils, its hierarchs and its faithful. Thus, in 1945 the Patriarch of Moscow, Alexis, called us to Tradition by writing the following to the clergy of Moscow:

> So as to indicate what true beauty is in the church, in worship, and, in particular, in liturgical music, not according to my personal taste but in the very spirit of the Church, I wish to give the following directions, which are indispensable for all priests and for all churches.
>
> In a church, everything is different from that which we constantly see around us and in our homes. The images are not the same as those we have in our homes. The walls are painted with sacred images; everything shines brightly; everything raises the spirit and removes it from the usual thoughts and impressions of this world. And when we see in a church

something which does not correspond to its greatness and its meaning, it shocks us. The holy Fathers, who not only established the rite and the worship, but also the external aspect and the internal arrangement, thought of everything. They foresaw and ordered everything so as to create in the faithful a special spiritual state, so that nothing impedes their flight toward the heavens, toward God, toward the celestial world whose reflection a church should be. If in a hospital everything is directed toward treating the maladies of the body, and conditions are created which correspond to the needs of the sick person, so in a spiritual hospital, a church of God, one should also provide all the things that are needed.[13]

In his message, the late patriarch particularly emphasizes music which, just like the image, is one of the grave questions of our day. "To sing liturgical hymns in the shrill manner of worldly songs or of the passionate tunes of opera is to deprive the faithful of any possibility of concentrating, as well as of grasping the contents and the meaning of the hymns." However beautiful these songs and these tunes may be in themselves, they do not fulfill the purpose of church singing. The same can be said about images. Of course, each one of us has his habits and his tastes. But we must learn to transcend them and to sacrifice them in church. Moreover, the role of a church is not at all to satisfy the habits and tastes of some individual; it consists in directing him or her on the saving path of Christ.

The symbolism of the church shows us the foundation on which the symbolic language of worship and, in particular, of the icon is based—this language which we have unfortunately forgotten. All of the testimonies of the Fathers and of the ecclesiastical writers which we have mentioned are only a few expressions of that by which the Church lives from its beginning and by which it will live until the second coming of Christ.

The direct image is a characteristic trait of the New Testa-

[13]Paschal Message to the Rectors of the Churches in Moscow, Calendar of the Patriarchate of Moscow for 1947 (in Russian).

ment. This New Testament image will not disappear until the coming of the reality which it prefigures: the Kingdom of God. But as long as we are still on the way, as long as the Church is still only building this Kingdom to come, we will continue to live in the realm of the image. It is through the image that the Church shows us the way towards our goal.

We could not participate in the building up of the Kingdom of God, we could not ask in all good conscience: "Thy Kingdom come," if we did not have an idea of what this Kingdom will be. The symbolism of an Orthodox Church and, in particular, of an icon is an authentic reflection, though of course a very weak one, of the glory of the age to come. In the words of St. Simeon the New Theologian: "God can be known to us in the same way as a man can see an endless ocean by standing at the shore at night with a dimly lit candle. Do you think he can see much? Not much, almost nothing. And nevertheless, he sees the water well. He knows that there is an ocean in front of him, that this ocean is huge and that he cannot see it all at once. The same is true of our knowledge of God."[14]

[14]Oration 61, *Works* (Moscow, 1892—in Russian), p. 100.

II
The Origin of the Christian Image

WE HAVE discussed at some length the symbolism of the Church in order to discover the basis of the symbolic language of the icon. While studying the latter, one must always remember that the sacred image integrates itself into a harmonious synthesis, into an organic whole, which creates Orthodox worship, outside of which its contents and meaning cannot, we repeat, be understood. Only the assurance of this spiritual totality will allow us to gain a correct perspective of that which is the subject of our book—the icon.

The word "icon" originates from the Greek word εἰκών, meaning "image" or "portrait." When the Christian image was being created in Byzantium, this word was used to mean all representations of Christ, the Virgin, a saint, an angel or an event from sacred history, whether this image was painted or sculpted,[1] mobile or monumental, and whatever the technique used. Now this term is used by preference to designate portable works of painting, sculpture, mosaic and the like. This is the meaning given to the icon in archeology and history of art. In the Church, we also make a distinction between a wall-painting and an icon. A wall-painting, whether it is a fresco or a mosaic, is not an object by itself, but is a part of the architecture, while an icon painted on a board is itself an object of art. But in principle, their meaning is the same. They are distinguished not by their significance but by their use and purpose. Thus, when we speak of icons, we will have in mind all sacred images, whether they are paintings on boards,

[1] One must note that, contrary to current opinion, the Orthodox Church never forbade the use of statues; such a negative prescription would have no basis in the teaching of the Church.

frescos, mosaics or sculptures. In any case, the English word "image," just as the Russian word *obraz*, embraces all these meanings.

Several present-day scholarly opinions about icons must be discussed first. Such a review is indispensable because, among works on sacred art, one can come across scholarly points of view on the origin of this art which are very different and often contradictory. In any case, one will often find contradictions with the Church's point of view, which is unique and invariable: The Church affirms and teaches that sacred images existed from the beginning of Christianity.

The opposing point of view appeared particularly in the eighteenth century. The English scholar Gibbon (1737-1791), author of *The History of the Decline and Fall of the Roman Empire*, maintained that the first Christians had an insurmountable aversion to the use of images. According to him, this aversion was a consequence of their Jewish origin. Gibbon believed that the first icons appeared only in the beginning of the fourth century. This opinion was accepted by many, and Gibbon's ideas unfortunately have been upheld, in one form or another, until the present day. We will give some characteristic examples.

Here is what a famous scholar, Louis Bréhier, writes in his book entitled *L'art chrétien*: "Christian art is born outside of the Church and, at least in the beginning, developed almost against its will. Christianity, springing from Judaism, was naturally, like the religion from which it arose, hostile to idolatry." Having referred to some ancient authors in favor of his point of view, Bréhier concludes: "The Church did not create Christian art. In all probability, it did not retain an indifferent and uninterested attitude towards it for long; in accepting it, the Church most probably restricted it in certain ways, but it was created upon the initiative of the faithful."[2] We find the same ideas in the works of other scholars of our times,[3] and, what is most significant, in an official encyclope-

[2]*L'art chrétien* (Paris, 1928), pp. 13 and 16.

[3]For example, in Charles Diehl's *Manuel d'art byzantin* (1925), vol. 1, p. 1 and p. 41; in A. Michel, *Histoire de l'art* (1926), vol. 1, chap. 1, p. 3; in Cabrol,

dia of the Roman Catholic Church, entitled *Ecclésia*.[4]

For an Orthodox, Bréhier's reasoning can only be meaningless. What primarily amazes a believer, Orthodox or Catholic, is the confusion between an idol and a Christian image. We know that, in fact, the Church, throughout its history, drew a very clear line between the two. The proofs of this are not lacking in the works of the writers of antiquity, nor in the lives of the saints of the first centuries, nor in the *Ecclesiastical History* of Eusebius, nor in later sources. When, for example, pagan Russia was converted to Christianity, the first thing which St. Vladimir did was to destroy the idols and to propagate icons.

In the second place, what shocks an Orthodox is the opposition which Bréhier sets up between the Church and the believers when he says that it is not the Church but the believers who created Christian art. It is the clergy and the believers together who make up the body of the Church, and the hierarchy does not have a monopoly on grace. This is how Christians of the first centuries looked upon the Church and this is how the Orthodox of today look upon it. To understand the clergy as being the unique holder, the unique guardian, of the truth, that is to say, to identify the clergy with the Church, is to apply a later Roman Catholic point of view to Christianity of the first centuries. To adopt such an anachronism is to exclude from the start any chance of making a valid judgment on early Christian sacred art.

In fact, scholars are well aware of the existence of frescos in the catacombs (particularly in Rome and Alexandria) dating back to the first centuries. These catacombs were not only cemeteries, but also gathering places and places of worship. They were therefore known not only by the faithful, but also by the hierarchy. It is difficult to believe that the clergy, while celebrating before frescos, did not see them, and, if Christianity was hostile to art, did not take any step towards ending this mistake.

All of these scholarly interpretations lead up to the con-

in the famous *Dictionnaire d'archéologie chrétienne et de liturgie* (Paris, 1915 ff).

[4](Paris, 1927), p. 611.

clusion which an eminent scholar, Louis Réau, reaches from the words of Pope St. Gregory the Great about sacred images as being "the only book accessible to the illiterate." "Thus Christian art," writes Réau, "is at its origin only a concession to the ignorance of the faithful. Its remarkable development can be explained by this almost general ignorance."[5] This statement shows the complete incomprehension of the meaning and purpose of Christian iconography.

All of these theories are based on the texts of some writers of antiquity who are, in these cases, qualified as "Fathers of the Church" and who were supposedly opposed to sacred images. First of all, if this opposition had been real, it would prove the existence and the role of images, since one does not fight against something which does not exist or has no importance. Furthermore, most of the texts can be interpreted in a different way. The most important of these writers are: Tertullian (160-240/250), Clement of Alexandria (150-216), Origen (185/186-254/255), Eusebius of Caesarea (265-339/340) and others who are less well-known, such as Minutius Felix (second or third centuries), Arnobius (255/260-327) and Lactantius (240/250-?). First of all, if one refers to these authorities and uses an ecclesiastical term like "Fathers of the Church," it is important not to deviate from its proper meaning. It fact, among these authors, not one is strictly speaking a "Father of the Church," and not one is venerated as a saint, even if the Church shows respect to their memory. Many of them are not even recognized by the Church as being truly Orthodox. Thus, Origen was posthumously condemned, and Eusebius had a leaning towards the Arian heresy. As for Tertullian, in spite of all of his greatness as an apologist and a confessor, he ended his life in a Montanist sect. Therefore, even if they fought against images, their writings cannot be considered to be the voice of the Church, but only expressions of personal opinion. Actually, the only one to have a genuine iconoclastic tendency is Eusebius. As for the others, in protesting against images, they had idols in mind and not Christian images. Thus, Clement of Alexandria writes:

[5]*L'Art du Moyen Age* (in the collection L'Evolution de l'humanité, Paris, 1935), pp. 2-3.

"Art deceives and fascinates, bringing one if not to love, then at least to respect and to venerate statues and paintings. The same holds true for painting: This art is praiseworthy, but let no one mistake it for the truth."[6]

Such is the text which is supposedly directed against Christian images! But Clement speaks only of those images which "fascinate and deceive," presenting themselves as the truth. That is, he fights against false and deceiving images. One can misinterpret him only if one confuses idolatry and the veneration of icons! But here is another text by Clement of Alexandria: "We are permitted to have a ring to make a seal. The images which are engraved on it and which we use as a seal should preferably be a dove, a fish, or a ship with unfurled and rapid sails; one can even represent a lyre as did Polycrates or an anchor as did Seleucus; finally, one could represent a fisherman at the seashore, the sight of which would remind us of the apostle and the children drawn out from the waters" (*i.e.*, the newly baptized).[7] All of these images are Christian symbols and, if the text quoted earlier appeared to condemn images, this one recommends their use. It is obvious that two very different kinds of images are being spoken of—images that are desirable and useful to Christians, and others which are false and inadmissible. Besides, Clement himself specifies this by criticizing Christians who, on their seals, engrave images of pagan gods, on their swords and arrows images of the goddess of war, on their goblets images of Bacchus, *etc.*,—all representations which are not compatible with Christianity. All of this bears witness to a prudent and vigilant attitude towards images on the part of Clement.

But there is another text which is invariably quoted to prove the Church's opposition to images.[8] It must be admitted that it is more convincing than Clement's. This is the canon 36 of the local council which took place in Elvira, in Spain, around the year 300: "It seemed good to us that paintings should not be found in churches and that which is venerated and adored not

[6]*Protrepticos*, chap. 4, PG 8: 156 C.
[7]*Paedagogos*, 1, 3, c. 11, PG 8:633.
[8]L. Bréhier, *op. cit.*, p. 61; A. Michel, *op. cit.*, vol. 1, p. 176; C. Diehl, *op. cit.*, vol. 1, p. 360, and others.

be painted on the walls." (*Placuit picturas en ecclesia esse non debere, nequod colitur et adoratur in parietibus depingatur.*) However, if we try to penetrate the meaning of this text, we will see that its meaning is not as indisputable as is believed, and that it does not give sufficient reasons for an iconoclastic interpretation. The members of the council speak only of wall-paintings, that is, of monumental decoration of the church building, but they say nothing of other types of images. And we know that in Spain at this particular time, there existed a large number of images on sacred vases, on sarcophagi, *etc.* Why does the Council not mention them? One can surmise that the council's decision was determined by practical reasons and not because it denied the idea of a sacred image. In this case, the decision would have been formulated completely differently and would not have mentioned only wall-painting.[9] This is why this text can be interpreted not as prohibiting the use of images, but rather as an attempt to preserve sacred objects from profanation by the Jews or pagans. Let us not forget that the Council of Elvira, whose date cannot be exactly determined, was contemporary with the persecutions of Diocletian. In any case, this last interpretation seems to be more justified, more logical and more convincing than the former.[10]

Apart from the opinions which have been already mentioned, some scholars hold the view that although we do not know of any Christian images which date back to the origins of Christianity, images may have existed then but were few in number. Those who support this point of view rely on the same authors of antiquity as the scholars who disregard tradition; however, they usually interpret the texts in a completely different way. Thus, N. Pokrovsky, a Russian historian of Christian art, using the authors quoted above as well as St. Justin and Athenagoras, reaches the following conclusion: "The apologists say nothing about a Christian opposition in principle against images, but only testify that images were very few in number in their times."[11] And this is true. If Christians

[9]See also L. Ouspensky and V. Lossky, *The Meaning of Icons*, (Olten, Switzerland, 1952), pp. 25 ff.
[10]Hefele, *Histoire des Conciles*, vol. I, part 1 (Paris, 1907), p. 240.
[11]N. Pokrovsky, *Pamiatniki khristianskoi ikonografii i iskusstva*, (ed. 2, St. Petersburg, 1900), p. 16.

had not favored sacred representations, we would not have monuments of Christian art from the first centuries found exactly in those places where these Christians met. At the same time, the enormous diffusion of images in the course of the following centuries would be incomprehensible and inexplicable if they had not existed before. According to the writings which we possess, not a single author, with the exception of Eusebius of Caesarea, is really hostile to the principle of sacred art. And even if a relatively hostile outlook can be found among certain Christians, it remains in opposition to the tradition of the entire Church, as St. John of Damascus writes in defense of icons.[12]

Another Russian scholar, N. P. Kondakov, even invokes the witness of Origen, often considered to be in part an iconoclast, in favor of images:[13] "Origen taught his contemporaries that religion should be the subject of art, that art should bring man closer to the ideal which was assigned to him by the Creator. He condemns those who forget Tradition, which speaks of the beauty of the face of Christ, and recalls His transfiguration, which the apostles were able to contemplate." [14]

The conclusions which certain scholars reach about the writings of the authors of antiquity in order to justify their biases can, undoubtedly, lead to misunderstandings. But, on another level, secular scholarship can be a great help to the Church. Studying sacred art from the point of view of style and of its purity, scholars discover in the minutest detail all the borrowed characteristics and all the deformations which ruin the purity of a given "style." Sometimes, thinking that they are speaking of style, they in fact discover elements foreign to Orthodoxy. They point out, for example, the deformations lingering from the art of antiquity and maintaining themselves in the art called "Byzantine." In Russian or Balkan art, they discover in detail the deformations which are a consequence of western influences. It is therefore possible to use all of these scholarly facts to purify the sacred art of Orthodoxy.

If the writings of ancient Christian writers and the few

[12]*First Treatise in the Defense of the Holy Icons*, chap. 24, PG 94:1257.
[13]See L. Bréhier, *op. cit.*, p. 14.
[14]*Ikonografia Khrista* (St. Petersburg, 1905), vol. 1, p. 3.

images remaining from the first centuries do not allow us
to conclude that the Church was opposed to the veneration of
images, the opposite is also true: Even if we have no knowl-
edge of formal iconoclasm, we cannot conclude that icono-
clasm did not exist from early times. Given the circumstances
in which the first Christians lived, we can conclude that among
them ideas hostile to images did exist. Iconoclasm could be as
old as the veneration of images. As we have said, in the
fourth century Eusebius of Caesarea was hostile to images,
and he was certainly not alone in this attitude. Since the first
centuries of our era, the Christian communities have been
surrounded by pagan influences. It is normal to suppose that
certain Christians, in particular those who came from Judaism,
reacted against all the negative experience of paganism and
tried to preserve their religion against the contamination of
idolatry. Supporting their belief with the prohibition voiced
in the Old Testament, some of them may have repudiated
the very possibility of a sacred image in Christianity, as did
Eusebius. All of this is very understandable, but cannot be
considered to be decisive.

The point of view of the Church is categorical, clear and
precise. In its liturgical tradition, the Church affirms that the
first icon of our Lord dates back to the time when He lived
in this world, and that the first icons of the Virgin were
painted not much later, *i.e.* shortly after Pentecost. But if
Church tradition insists that the image existed since the begin-
ning of Christianity, we do not know what these first repre-
sentations were like. We cannot sanction the tradition of the
Church with concrete and precise facts, but we can do so
indirectly with portraits. It is true that, with our present
knowledge, it is impossible to trace a clear line of demarca-
tion between an image, as an object of liturgical worship, and
a simple portrait. But the existence of portraits can indirectly
prove the existence of images used in worship. The portraits
of early Christian times are therefore very important to us,
if only as documents. They help us to realize to what extent
our present icons faithfully reproduce the historical traits
of the saints of that time. The existence of these portraits
is based on historical evidence and archeological facts.

Here is historical evidence which is valuable because it comes from Eusebius of Caesarea, a sympathizer of iconoclasm. He writes in his *Ecclesiastical History* about an ancient monument found in Paneas (Caesarea Philippi), a town lying near the source of the Jordan. It is the statue erected by the hemorrhaging woman whom we read about in the Gospels (Math. 9:20-23; Mark 5:25-34; Luke 8:43-48). "This woman," says Eusebius, "who was healed by the Savior ... was born in Paneas, where her house can be seen. Remarkable evidence of the goodness of the Savior towards her lives on. On a raised stone pedestal, erected by the door of the house, a bronze image can be seen of this kneeling, supplicating woman, whose arms are stretched out in front of her. Before her is another statue of the same metal of a standing man, decently dressed in a diploid and making a welcoming gesture with his hand towards the supplicant ... It has been said that this statue is an image of Jesus. It has survived until today; we have seen it, passing through Paneas." The evidence of Eusebius is confirmed by other writers, such as Macarius of Magnesia in about 360 or 370. Nevertheless, the emperor Maximus, according to Asterius of Amasea (end of the fourth and beginning of the fifth centuries), destroyed this monument, while Philostorgius (fourth century) and Sozomenus (fifth century) attribute this destruction to Julian the Apostate. The remains of the statue were gathered by the faithful and carried to an oratory where John Malalas saw them in the seventh century. "These statues can still be seen," he says, "in the town of Paneas, not where they had stood originally on the central plaza, but in the holy oratory. I found them there."[15] The monument itself did not survive. Nevertheless, it is believed that a lateral bas relief of a sarcophagus from the fourth century preserved at the museum of the Lateran reproduces this monument[16] (Fig. 2).

But let us return to Eusebius. Having described the monument raised by the healed woman, he continues: "One should not be surprised if the pagans have preserved in their memory

[15]Quoted from H. Leclercq, *Manuel d'archéologie chrétienne*, vol. 2 (Paris, 1907), p. 248.

[16]*Ibid.*, p. 250.

the favours which they received from the Savior. It was their custom to leave behind to posterity signs of gratitude to those who had obliged them and we have learned (ἰστορήσαμεν) that the images of the apostles Peter and Paul and of Christ Himself have been preserved with colors on paintings."[17] Book VII (cap. 18), in which Eusebius talks about these portraits, was completed before 312; therefore, his evidence goes back to the end of the third or to the first years of the fourth centuries. This means that the portraits date back to an earlier epoch, maybe even back to the time when Christ and the apostles lived, just as the famous statue of the hemorrhaging woman. Some of these portraits still exist. The museum of the Vatican preserves, for example, a medallion from the second or third century on which St. Peter and St. Paul are represented (Fig. 3).

From these historical and archeological facts, one can conclude that the art of portraiture was very widespread in the Roman Empire in the times of Christ. This art reached its height in the first century and was continued, though declining in value, to the second and third centuries.[18] An example of its penetration into the widest social strata of the population is found in the remains of a letter on papyrus which was found in Egypt. It was written in the second century in Greek, in Italy, by a notary public from the dictation of a young recruit of the Roman army, an Egyptian soldier. Among other things, he informs his father that he is sending his portrait to his family.[19] Since, at that time, the art of portraiture was so common, it would be difficult to believe that Christians, in particular those who had once been pagans, would have made an exception.

Even in the Judaism of those days, there were trends towards accepting images. The prohibitions of the Old Testament only slowed down the development of art among the

[17]PG 20: 680B-D.

[18]V. Finders Petrie, *Roman Portraits* (London, 1911), pp. 12-124, and M. Alpatov, *Vseobshchaia istoriia iskusstv,* vol. I, chap. 7 (Moscow and Leningrad, 1948).

[19]J. H. Bredstead, *Ancient Times: A History of the Early World* (Boston, 1916), p. 631.

Jews, but it could not make them renounce art altogether nor banish all the representations in the synagogues. From the first century, rabbis tried to make more lenient interpretations of the prohibition of Exodus (20:4) to justify the fact that some synagogues were decorated with biblical scenes and images of prophets. These images were not widespread, but we know of several synagogues which are decorated with wall-paintings of human figures.[20] Moreover, representations exist on coins and on small objects (see the engraving from the second or third centuries in the Cabinet des Medailles in the Bibliothèque Nationale of Paris), and a whole series of Bibles illustrated at different times can be found in various museums of Europe.[21] On the other hand, some Christian heretics and, notably, gnostic sects, like the disciples of Carpocratus, used portraits of persons whom they worshiped, not only those of Christ, but also those of Pythagoras, Homer, Plato, Aristotle, *etc.*

All of this brings us to the following conclusion: Even without considering church tradition, nothing permits us to believe that Christians did not have images and did not use them in their religious practice. We saw that Clement of Alexandria advised that, among other things, human representations be engraved on the rings which served as seals. Tertullian speaks of representations of the Good Shepherd on chalices.[22] Symbolic representations of Christ dating back to the first century, and images of the Virgin dating back to the second century, were discovered in the Roman catacombs. Eusebius knew of many portraits of Christ, St. Peter and St. Paul which had been preserved till his time. And Eusebius cannot be suspected of exaggeration, since he did not approve of this fact.

From what we know about Christian art of the first centuries, we can conclude that, even if a tendency hostile to

[20]For example, the frescos at Dura Europos (245-246), the mosaics on the pavements in the synagogue of Ain-Douq (third century) near Jericho, in Beth Alfa, that of Tell-Hum near Alexandria, a Jewish catacomb in Rome, *etc.* (V. Lazarev, *op. cit.*, pp. 277-278; L. Brébier, *op cit.*, pp. 19-20 n. 16).

[21]V. E. Namenyi, *L'esprit de l'art juif* (1957).

[22]*De pudicitia*, cap. 7, PL 2: 991C; cf. cap. 10, 1000C.

images did exist, there is also a prevailing movement favorable to images. The image is indeed a basic characteristic of Christianity, since it is not only the revelation of the Word of God, but also of the Image of God, manifested by the God-Man. The Church teaches that the image is based on the incarnation of the second person of the Trinity. This is not a break, nor even a contradiction with the Old Testament, as the Protestants understand it, but, on the contrary, it clearly fulfills it, for the existence of the image in the New Testament is implied by its prohibition in the Old. Even though this may appear to be strange, the sacred image, for the Church, proceeds precisely from the *absence* of the image in the Old Testament. The forerunner of the Christian image is not the pagan idol, as is sometimes thought, but the absence of direct iconography before the incarnation, just as the forerunner of the Church is not the pagan world, but the Israel of old, the people chosen by God to witness His revelation. The prohibition of the image which appears in Exodus (20:4) and in Deuteronomy (5:12-19) is a provisional, pedagogic measure which concerns only the Old Testament, and is not a prohibition in theory. " 'Moreover I gave them statutes that were not good' (Ezek. 20:25) because of their callousness," says St. John of Damascus, explaining this prohibition by a biblical quotation.[23] Indeed, the prohibition of all direct and concrete images was accompanied by the divine commandment to establish certain symbolic images, those prefigurations which were the tabernacle and everything which it contained.

The teaching of the Church on this subject is clearly explained by St. John of Damascus in his three *Treatises in the Defense of Holy Icons*, written in response to the iconoclasts, who limited themselves to the biblical prohibition and confused the Christian image with the idol. Comparing the Old Testament texts and the Gospel, St. John shows that the Christian image, far from contradicting the prohibition of the Old Testament, is, as we have said, its result and conclusion, since it arises from the very essence of Christianity.

His reasoning can be summarized as follows: In the Old

[23]*Second Treatise*, cap. 15, PG 94: 1301C.

Testament, God manifests Himself directly to His people only by sound, by word. He does not show Himself, and remains invisible. Israel does not see any image. In Deuteronomy (4:12), we read: "The Lord spoke to you out of the midst of the fire; you heard the sound of words, but saw no form; there was only a voice." And a bit further (4:15), we read: "Therefore take good heed to yourselves. Since you saw no form on the day that the Lord spoke to you at Horeb out of the midst of the fire." The prohibition comes immediately afterwards (4:16-19): "Beware lest you act corruptly by making a graven image for yourselves, in the form of any figure, the likeness of male or female, the likeness of any beast that is on the earth, the likeness of any winged bird that flies in the air, the likeness of any thing that creeps on the ground, the likeness of any fish that is in the water under the earth. And beware lest you lift up your eyes to heaven, and when you see the sun and the moon and the stars, all the host of heaven, you be drawn away and worship them and serve them . . ." Thus, when God speaks of creatures, He forbids their representation. But when He speaks of Himself, He also forbids the making of His image, stressing the fact that He is invisible. Neither the people, nor even Moses saw any image of Him. They only heard His words. Not having seen God's image, they could not represent it; they could only write down His divine word, which is what Moses did. And how could they represent that which is incorporeal and indescribable, that which has neither shape nor limit? But in the very insistence of the biblical texts to emphasize that Israel *hears* the word but does not *see* the image, St. John of Damascus discovers a mysterious sign of the future possibility of seeing and representing God coming in the flesh. "What is mysteriously indicated in these passages of Scripture?" he asks. "It is clearly a prohibition of representing the invisible God. But when you see Him who has no body become man for you, then you will make representations of His human aspect. When the Invisible, having clothed Himself in the flesh, becomes visible, then represent the likeness of Him who has appeared . . . When He who, having been the consubstantial Image of the Father, emptied Himself by taking

the form of a servant (Phil. 2:6-7), thus becoming bound in quantity and quality, having taken on the carnal image, then paint and make visible to everyone Him who desired to become visible. Paint His birth from the Virgin, His baptism in the Jordan, His transfiguration on Mount Tabor ... Paint everything with words and with colors, in books and on boards." [24] Thus the very prohibition of representing the invisible God implies the necessity of representing God once the prophecies have been fulfilled. The words of the Lord, "You have seen no images; hence do not create any," mean "create no images of God *as long as you have not seen Him.*" An image of an invisible God is impossible, "for how can that which is inaccessible to the eye be represented?" [25] If such an image were made, it would be based on imagination and would therefore be a falsehood and a lie.

One can therefore say that the scriptural prohibition of representing God is connected with the overall destiny of the Israelites. The purpose of the chosen people was to serve the true God. Theirs was a mission consisting in preparing and prefiguring that which was to be revealed in the New Testament. This is why there could only be symbolic prefigurations, revelations of the future. "The law was not an image," says St. John of Damascus, "but it was like a wall which hid the image. The Apostle Paul also says: 'The law was but a shadow of the good things to come instead of the true form of these realities' (Heb. 10:1)." [26] In other words, it is the New Testament which is the true image of reality.

But what about the prohibition of images of *creatures* ordered by God to Moses? It has clearly only one purpose: to forbid the chosen people to worship creatures in place of the Creator. "You shall not bow down to them or serve them" (Exod. 20:5 and Deut. 5:9). Indeed, given the leanings of the people towards idolatry, creatures and all images of creatures could easily be deified and worshiped. After the fall of Adam, man, together with the entire terrestrial world,

[24]*First Treatise*, cap. 8, PG 94: 1237D—1240A; and *Third Treatise*, cap. 8, PG 94: 1328D.

[25]*Third Treatise*, cap. 4, PG 94: 1321.

[26]*First Treatise*, cap. 15, PG 94: 1244.

became subject to corruption. This is why the image of man corrupted by sin or the image of terrestrial beings could not bring man closer to the only true God and could only lead him in the opposite direction, that is, to idolatry. It was fundamentally impure.

In other words, the image of a creature cannot be a substitute for the image of God, which the people had not seen when the Lord spoke on Horeb. In the face of God, the creation of a substitute is always an iniquity. Hence these words: "Beware lest you act corruptly by making a graven image for yourselves, in the form of any figure, the likeness of any beast that is on the earth" (Deut. 4:16).

But this prohibition is clearly a step to protect the specific ministry of the chosen people from corrupt practices. This clearly emerges from God's command to Moses to build, according to the image shown to him on the mountain, the tabernacle and all that it was to contain, including the gilded cherubim cast in metal (Exod. 25:18, 26:1 and 31). This commandment first of all signifies the possibility of expressing spiritual reality through art. Furthermore, it was not just a matter of representing cherubim in general or anywhere, since the Jews would have been able to come to idolize these images as easily as those of all other creatures. Cherubim could be represented only in the tabernacle, as servants of the true God, in a place and a posture which brought forth this particular function.

This exception to the general rule shows that the prohibition of images was not an absolute one. "Solomon, who received the gift of wisdom, when he made representations of the sky, made images of cherubim, lions and bulls," says St. John of Damascus.[27] The fact that these creatures were represented near the temple, that is, where the only true God was worshiped, excluded any possibility of adoring them.[28]

To build the tabernacle according to the model shown

[27]*First Treatise*, cap. 20, PG 94: 1252.

[28]It is interesting to note that though the ancient Jews did not renounce sculptured images in the tabernacle and in the temple of Solomon, the Jews of today rigorously uphold the word of the Law and abstain from venerating sculptured images (V. E. Namenyi, *op. cit.*, p. 27).

on the mountain, God chose special men. It was not simply a matter of natural gifts and of the ability to follow Moses' instructions: "I have filled him [Bez'alel] with the Spirit of God, with ability and intelligence, with knowledge and all craftsmanship"; and further, speaking of all those who would work with Bez'alel: "I have given to all men ability, that they may make all that I have commanded you" (Exod. 31:3 and 6). It is clearly shown here that art which serves God is not like any other art. It is not only based on the talent and wisdom of men, but also on the wisdom of the Spirit of God, on an intelligence granted by God Himself. In other words, divine inspiration is the very principle of liturgical art. Here the Scripture draws a line between liturgical art and art in general. This specific character and this divine inspiration are not only characteristic of the Old Testament, but also belong to the very principle of sacred art. It certainly remains valid in the New Testament.

But let us return to the explanations of St. John of Damascus. If, in the Old Testament, the direct revelation of God was made manifest only by word, in the New Testament it is made manifest both by word and by the image. The Invisible became visible, the Nonrepresentable became representable. Now God does not only address man by word and through the prophets. He shows Himself in the person of the incarnate Word. He "liveth among men." In the Gospel according to St. Matthew (13:16-17), says St. John of Damascus, the Lord, the same Lord who spoke in the Old Testament, speaks honoring His disciples and all those who lived in their image and followed their footsteps: "Blessed are your eyes, for they see, and your ears, for they hear. Truly, I say to you, many prophets and righteous men longed to see what you see, and did not see it, and to hear what you hear, and did not hear it."[29] It is obvious that when Christ says to His disciples that their eyes are fortunate to see what they see and their ears to hear what they hear, he is referring to that which has never been seen or heard, since men always had eyes to see and ears to hear. These words of Christ also did not apply

[29]*Second Treatise*, cap. 20, PG 94: 1305-1308; cf. *Third Treatise*, cap. 12, PG 94: 1333.

to His miracles, since the prophets of the Old Testament also performed miracles (Moses, Elias, who resurrected a dead person, stopped the rain from falling, *etc.*). These words mean that the disciples directly saw and heard Him whose coming had been foretold by the prophets: the incarnate God. "No one has ever seen God," says St. John the Evangelist, "the only Son, who is in the bosom of the Father, He has made Him known" (John 1:18).

Thus the distinctive trait of the New Testament is the direct connection between the word and the image. This is the reason why the Fathers and the councils, when speaking of the image, never forgot to stress: "That which we have heard, we have seen. That which we have heard, we have seen in the city of the all-powerful God, in the city of our God" (Ps. 47[48]:9). That which David and Solomon saw and heard was only prophetic prefigurations of that which was realized in the New Testament. Now, in the New Testament, man receives the revelation of the Kingdom of God to come and this revelation is given to him by the word and the image of the incarnate Son of God. The apostles saw with their carnal eyes that which was, in the Old Testament, only foreshadowed by symbols. Here is how St. John of Damascus explains it: "God, who has neither body nor form, was never represented in days of old. But now that He has come in the flesh and has lived among men, I represent the visible appearance of God."[30]

This divine incarnation, the fact that God assumed human flesh, has sanctified both man and the entire terrestrial world which Adam had led into sin. Thus matter itself gains an enormous significance. St. John of Damascus continues: "I do not adore matter, but I adore the Creator of matter, who became matter for me, inhabiting matter and accomplishing my salvation through matter."[31] Here lies the heart of the difference with the vision of the Old Testament: In the Old Testament the prophets saw with their spiritual eyes an incorporeal image revealing the future (Ezekiel, Jacob, Isaiah). Now man sees with his carnal eyes the realization of their

[30]*First Treatise*, cap. 16, PG 94: 1245.
[31]*Ibid.*, and *Second Treatise*, cap. 14, PG 94: 1300.

revelations, the incarnate God. St. John the Evangelist expresses this powerfully in the first words of his first epistle: "That which was from the beginning, which we have heard, which we have seen with our eyes, which we have looked upon and touched with our hands."

St. John of Damascus continues:

> Thus the apostles saw with their carnal eyes God who became man, Christ. They saw His passion, His miracles, and heard His words. And we too, following the steps of the apostles, ardently desire to see and to hear. The apostles saw Christ face to face because He was present corporeally. But we who do not see Him directly nor hear His words nevertheless listen to these words which are written in books and thus sanctify our hearing and, thereby, our soul. We consider ourselves fortunate and we venerate the books through which we hear these sacred words and are sanctified. Similarly, through His image, we contemplate the physical appearance of Christ, His miracles and His passion. This contemplation sanctifies our sight and, thereby, our soul. We consider ourselves fortunate and we venerate this image by lifting ourselves, as far as possible, beyond this physical appearance to the contemplation of divine glory.[32]

Therefore, if we comprehend the spiritual through the words which we hear with our carnal ears, contemplation with our carnal eyes likewise leads us to spiritual contemplation.

This commentary of St. John of Damascus does not express his personal opinion, nor even a teaching that the Church has added, as it were, to its early doctrine. This teaching is an integral part of Christian doctrine itself. It is part of the very essence of Christianity, just as is the teaching about the two natures of Christ or the veneration of the Virgin. St. John of Damascus only systematized and formulated in the eighth century that which existed from the beginning. He did so in response to a situation which demanded more

[32]*Third Treatise*, cap. 12, PG 94: 1333 and 1336.

clarity, just as he also systematized and formulated the general teaching of the Church in his work *On the Orthodox Faith.*

All of the prefigurations of the Old Testament announced the salvation to come, this salvation which is now realized and which the Fathers summarized in a particularly pregnant statement: "God became man so that man could become God." This redeeming act is therefore centered on the person of Christ, God who became man, and, next to Him, on the first deified human being, the Virgin. On these two central figures converge all the writings of the Old Testament, expressed through human history, animals or objects. Thus Isaac's sacrifice, the lamb and the iron serpent prefigured Christ, and Esther, mediator of the people before God, the golden vase containing the divine bread, Aaron's staff, *etc.* prefigured the Virgin. The realization of these prophetic symbols is accomplished in the New Testament by the two essential images: that of our Lord, God who became man, and that of the Most Holy Mother of God, the first human being to attain deification. This is why the first icons, appearing simultaneously with Christianity, represent Christ and the Virgin. And the Church, asserting this by its tradition, bases on these two images—the two poles of its belief—all its iconography.

The realization of this divine promise made to man also sanctifies and illumines creatures of the past, humanity of the Old Testament, by uniting it with redeemed humanity. Now, after the incarnation, we can also speak of the prophets and patriarchs of the Old Testament as witnesses of the humanity redeemed by the blood of the incarnate God. The images of these men, like those of the New Testament saints, can no longer lead us to idolatry, since we now perceive the image of God in man. According to St. John of Damascus: "We received from God the capability of judgment, and we know what can be represented and what cannot be expressed by representation. 'So that the law was our custodian until Christ came, that we might be justified by faith. But now that faith has come, we are no longer under a custodian' (Gal. 3:24-25,

see also Gal. 4:3)."[33] This means that we do not represent
the vices of men; we do not make images to glorify demons.
We make representations to glorify God and His saints, to
encourage goodness, avoid sin and save our souls.

From all that we have said, the following conclusion can
be reached: The image, far from contradicting Christianity,
is its indispensable attribute. The Church declares that the
Christian image is an extension of the divine incarnation, that
it is based on this incarnation and that, therefore, it is the
very essence of Christianity, from which it is inseparable.
This basic relationship is the source of the tradition according
to which the Church, from the beginning, preached Christiani-
ty to the world by both word and image. This is precisely
why the Fathers of the Seventh Ecumenical Council were able
to say: "The tradition of making icons existed from the time
of the apostolic preaching,"[34] and also: "Iconographic art was
not invented by painters; it is, on the contrary, a confirmed
law and a tradition of the catholic Church."[35] This is why
images were accepted in the Church and—silently, as a self-
evident reality—occupied the place which belongs to them, in
spite of the Old Testament prohibition and some episodic
opposition.

[33]*Third Treatise*, cap. 8, PG 94: 1328.
[34]Mansi 13: 252B.
[35]Mansi 13: 252C.

III
The First Icons of Christ and the Virgin

THE TEACHING of the Church, according to which images are an integral element of the Christian Gospel from its very beginning, is also expressed in the tradition which asserts that the first icon of Christ appeared during His life on earth. In the West, this image was called "the Holy Face." In the East it is called "the image not made by the hand of man" (in Greek, ἀχειροποίητος). According to this tradition, Christ Himself sent His image to Abgar V Ukhama, prince of Osroene, a small country between the Tigris and the Euphrates, situated at this time between the Roman and the Parthian empires. Its capital was the city of Edessa, now Orfu or Rogaïs. It should be noted that the chronicle of this city mentions the existence of a Christian church which was considered ancient in the year 201 when it was destroyed by a flood. The kingdom of Edessa was the first state in the world to become a Christian state (between 170 and 214, under the rule of Abgar IX).

The history of the first image of Christ is acknowledged, first of all, by the texts of the liturgical service honoring the Holy Face (August 16). Here, for example, is a sticheron in tone 8 from Vespers: "Having represented Thy most pure image, Thou didst sent it to the faithful Abgar who desired to see Thee, who according to Thy divinity art invisible to the cherubim." Another sticheron from Matins in tone 4 says: "Thou didst send letters traced by Thy divine hand to Abgar, who asked for the salvation and health which comes from the image of Thy divine face."

A more detailed account of the story appears in the

59

Menaion of the month of August. It can be summarized as
follows: The king of Edessa, Abgar, was a leper. He heard
of the miracles of Christ and sent to Him his archivist, Han-
nan (Ananias), with a letter in which he asked Christ to
come to Edessa to heal him. Hannan was a painter, so Abgar
charged him to make a portrait of the Savior in case Christ
refused to come. Hannan found Christ surrounded by a big
crowd and could not approach Him. Therefore he climbed
up on a rock from which he could see Him better. He tried
to make a portrait of the Savior, but could not "because of
the indescribable glory of His face which was changing
through grace." Seeing that Hannan wanted to make a por-
trait of Him, Christ asked for some water, washed Himself,
wiped His face with a piece of linen, and His features re-
mained fixed on this linen. This is why this image is also
known under the name of "Mandylion." (The Greek word
μανδύλιον comes from the semitic word *mindil*, a hand-
kerchief.) Christ gave it to Hannan and told him to take it,
with a letter, to the person who had sent him. In the letter,
Christ refused to go Himself to Edessa, since He had a mis-
sion to fulfill. He promised Abgar that once this mission was
finished, He would send one of His disciples to him. When
he received the portrait, Abgar was healed from the worst of
his sickness, but several marks remained on his face. After
the ascension, the apostle St. Thaddeus, one of the seventy, went
to Edessa and completely healed the king, converting him to
Christianity. On the miraculous portrait of Christ, Abgar
wrote these words: "O Christ God, he who trusts in Thee will
not die." He removed an idol from a niche above one of the
town gates, replacing it with the holy image. Abgar did
much to spread Christianity among his subjects. But his great-
grandson returned to paganism and wanted to destroy the
image of the Holy Face. The bishop of the town therefore
walled it into the niche, after having placed a burning lamp
before it. Thus the image was saved.

Before the fifth century, ancient authors made no refer-
ence to the image of the Holy Face. The first time we hear it
mentioned is in the fifth century, in the document called *The
Doctrine of Addai*. Addai was a bishop of Edessa (d. 541)

who, in his work (if this work is an authentic one), undoubt-
edly used either a local tradition or documents which we do
not know about. The most ancient undisputed author who
mentions the icon sent to Abgar is Evagrius (sixth century);
in his *Ecclesiastical History*[1] he calls the portrait "the icon
made by God," Θεότευχτος εἰκών. In any case, the image
itself re-appeared in 544 or 545, when the Persian king
Chosroës besieged the town of Edessa. The bishop Eulalius
through a dream discovered the place of the niche where the
icon was hidden. He uncovered it and saw the lamp still
burning before it. By virtue of the image, the town was
spared. The image was not only intact, but it had also been
imprinted on the inner side of the tile which concealed it.
In memory of this event, there appeared two different icons
of the Holy Face, one where the face of the Savior is repre-
sented on a piece of linen (Fig. 4) and another where the
Holy Face is represented as it was imprinted on the tile,
κεράμιον, in Russian *chrepie*. The original icon, *i.e.* the
linen on which the face of the Lord is imprinted, was pre-
served in Edessa for a long time as the most precious treasure
of the town. In 630 the Arabs seized Edessa but did not
forbid the veneration of the Holy Face, which was well
known in the West and in honor of which, in the eighth cen-
tury, Christians in many lands celebrated a feast, following
the example of the Church of Edessa. During the iconoclastic
period, St. John of Damascus mentions the miraculous image,
and in 787 the Fathers of the Seventh Ecumenical Council
refer to it many times. Leo, a reader of the Cathedral of St.
Sophia in Constantinople who was present at the Seventh
Ecumenical Council, recounts how he himself venerated the
Holy Face during his stay in Edessa.[2] In 944 the Byzantine
emperors Constantine Porphyrogenitus and Romanus I bought
the holy icon from Edessa at the price of 200 Saracen prisoners,
12,000 denarii of silver and the promise that the imperial
armies would never touch Edessa and the lands surrounding
it. A popular revolt resulted. Nevertheless the Holy Face

[1] IV, cap. 27, PG 86: 2745-2748.

[2] Mansi 13: 169, 190 ff., 192; A. Grabar, *Nerukotvorny Spas Ianskogo
Sobora* (Seminarium Kondakovianum, Prague, 1930), p. 24.

was pompously transported to Constantinople and placed in the church of the Virgin of Pharos; Emperor Constantine Porphyrogenitus praised it in a sermon as the guardian of the empire. The liturgy of the feast celebrated on August 16, the Transfer of the Holy Face to Constantinople, probably dates back, at least in part, to this time.

About the image imprinted on the tile, we only know that it was found in Hierapolis (Mabbug) in Syria. Emperor Nicephorus Phocas (963-969), following the example of Romanus I, made use of the expedition of his armies in Syria (in 965 or 968) to transport this image to Constantinople. After the pillage of Constantinople by the Crusaders in 1204, traces of the two images are lost. It is thought that the Crusaders brought the Holy Face to Western Europe, some say to Paris, others to Rome. Nothing definite is known.[3]

The image of the Holy Face was, of course, frequently reproduced. Some witnesses speak of a reproduction made by the king of Persia. Until recently, the oldest remaining representations were thought to be certain miniatures of the eleventh century and frescos of the twelfth century (the church of the Holy Savior of Nereditsa).[4] But recently an encaustic icon of the Holy Face has been discovered in Georgia dating back to the sixth or seventh century, *i.e.*, to the epoch when the miraculous image was still in Edessa.[5]

From the ninth century, there remains an interesting icon made in four parts which can now be found in the monastery of St. Catherine on Mount Sinai. The upper part of the icon represents, on one side, the apostle Thaddeus, and on the other side, king Abgar receiving from the hands of Ananias the linen with the Holy Face.[6]

[3]Tradition has it that there is another icon of Christ which was "not made by the hand of man," an icon named after the place where it appeared, the town of Kamuliana in Cappadocia. This image was transported to Constantinople in 544 and played an important role in the life of the Byzantine Empire. However in the eighth century it seems to have been forgotten. It is thought that it was destroyed by the iconoclasts. In any case, it is not mentioned in our liturgical texts.

[4]A. Grabar, *op. cit.*, p. 21.

[5]Amiranachvili, *Istoria gruzinskogo iskusstva* (Moscow, 1950), p. 126.

[6]G. and M. Sotiriou, Εἰκόνες τῆς Μονῆς Σινᾶ. Reproduction t. I, (Athens, 1956), tab. 34, text t. II (Athens, 1958), pp. 49-51.

In France there exists a famous icon of the Holy Face which is now preserved in the sacristy of the cathedral of Laon. It was sent from Rome to France in the thirteenth century (1249) by Jacobus Pantaleo Tricassinus, chaplain of Pope Innocent IV and the future Pope Urban IV, to his sister, the abbess of the convent of Cistercians of Monasteriolum (Montreuil-les-Dames, diocese of Laon). It is thought that this icon is of Balkan origin, perhaps Serbian, dating back to the beginning of the twelfth century. But in the Middle Ages there was another image of the Holy Face, which was called "Veronikë" *(vera icon)*. It is thought that it was sent as a gift to Pope Celestine III by the great Zhupan of Serbia, Stephen II Nemania (1151-1195). It was venerated by the entire West. Pilgrimages were organized, and pilgrims returning from Rome had the Roman insignia, two keys and the effigy of the Holy Face, on their hats. A special prayer attributed to Pope Innocent III was written in its honor. In the beginning of the fourteenth century, a psalter of Arras attested that one gained forty days of indulgences for reciting it—"chi apres commence lorison du veronike. Et quicunkes le dit, il a XL jours de pardon de par l'apostiole'" (that is, the pardon of the Pope, guardian of the "Veronikë" and bestower of the indulgence to which one was entitled for venerating this distinguished icon). Two antiphons were written in honor of this icon, one in the thirteenth century, the other in the fourteenth century. In 1527 this image was stolen and destroyed by the German and Spanish soldiers of Charles V. In the fifteenth century, when the story of St. Veronica came into being, the Holy Face of St. Peter of Rome was replaced by the theme of St. Veronica holding the linen on which the Holy Face was imprinted. The story of St. Veronica has several versions. The most famous is the one which is usually represented in the "way of the cross" introduced by the Franciscans (Fourth Station): When Christ was being led to the Golgotha, a woman named Veronica wiped

[7]"Hereafter begins the prayer of the 'Veronikë'. And whosoever recites it receives 40 days of pardon through the apostolic father."

His sweat with a piece of linen on which His image remained imprinted.[8]

The study of the liturgical service honoring the Holy Face provides rich information about the meaning of the image in the medieval Church. This feast is called "the transfer from Edessa to the city of Constantine of the image of our Lord Jesus Christ 'not made by the hand of man,' the image which is called the holy linen." The office of this day, however, does not only limit itself to the simple memory of the transference of the image from one place to another. The essential point of this service is the dogmatic foundation of image veneration.

The image "not made by the hand of man" is primarily Christ Himself, the incarnate Word revealed in the "temple of His body" (John 2:21). This is why the icon of Christ is an irrefutable witness of the divine incarnation. It is not an image created according to a human conception; it represents the true face of the Son of God who became man, and originates, according to tradition, from an immediate contact with His face. It is this first image of God who became man that the Church venerates on the day of the Holy Face.

As we have seen, the stichera quoted above together with the other liturgical texts emphasize the historical origin of the image. As always, the Church brings us back to the historical reality, just as in the Creed the Church speaks of the Crucifixion "under Pontius Pilate." Christianity is not concerned with a "universal Christ," a personification of the internal spiritual life, nor with an abstract Christ, a symbol of some grand idea. It is essentially concerned with a historical person who lived in a definite place, at a precise time. "Having saved Adam," we hear in a sticheron of the feast, "the Savior, indescribable in His essence, lived on earth among men, visible and distinguishable" (second sticheron in the first tone during Little Vespers).

The scriptural readings of the day are of particular importance to our study. All of these readings reveal the mean-

[8]On the subject of the Holy Face of St. Peter of Rome and the image of St. Veronica, see Paul Perdrizet's article in *Seminarium Kondakovianum*, vol. 5 (Prague, 1932), pp. 1-15.

ing of the event which is being celebrated. Emphasizing these biblical prefigurations, they exalt their realization in the New Testament and underline their eschatological significance. The choice of the texts reveals precisely what we have already learned from the works of St. John of Damascus, *i.e.* how the Church understands the Old Testament's prohibition of images and the meaning and purpose of the New Testament image. First of all, we have the three Old Testament readings *(paroimiai)* of Vespers: two are taken from Deuteronomy (4:6-7, 9-15; and 5:1-7, 9-10, 23-26, 28, 6:1-5, 13, 18) and the last is an excerpt from III Kings (I Kings in the Hebrew Bible), 8:22-23 and 27-30.[9]

The first two readings speak of the revelation of the law to the people of Israel on Mount Horeb just before the entry of the Chosen People into the Promised Land. The meaning of the readings can thus be summarized by the fact that, in order to enter into this Promised Land and to own it, it is essential for the people to observe the revealed law and to adore the only true God with an undivided adoration, without any confusion with the cult of other "gods." One is also reminded that it is impossible to represent the invisible God: "You heard the sound of words, but saw no form; there was only a voice," and "take good heed to yourselves, since you saw no form," *etc.* Therefore the law in its totality, and in particular the prohibition to adore other "gods" and to make images, is an indispensable condition of entry into the Promised Land. And, of course, the Promised Land is a prefiguration: It is an image of the Church, of the Kingdom of God.

The third reading is also a prefiguration of the New Testament revelation. It includes the prayer of Solomon at the consecration of the temple which he had built: "But will God indeed dwell on the earth?" asks Solomon. "Behold, heaven and the highest heaven cannot contain Thee; how much less this house which I have built!" All this alludes to the future coming of God on earth, to His participation in

[9]We do not take these readings from the Menaion but directly from the Bible, because in the Menaion they are abridged and some passages important for the understanding of the meaning of the image are omitted.

the course of human history, to the presence in a terrestrial temple, built by man, of the One for whom "the highest heaven does not suffice."

The meaning of these Old Testament readings is more fully revealed by the Epistle reading of the Liturgy (Col. 1:12-17): "Giving thanks to the Father, who has qualified us to share in the inheritance of the saints in light. He has delivered us from the dominion of darkness and transferred us to the kingdom of his beloved Son, in whom we have redemption, the forgiveness of sins. He is the image of the invisible God, the first-born of all creation." Thus, the entire development of the Old Testament which defended the purity of the Chosen People, the entire sacred history of Israel, appears as a providential and messianic process, as a preparation for the appearance of the Body of Christ on earth, the New Testament Church. And in this preparatory process, the prohibition of images leads to the appearance of the One who was invisible, to "the image of the invisible God" revealed by the God-Man Jesus Christ. As we hear in the Vigil of the feast: "In former times, Moses could obscurely contemplate the divine glory from behind; but the new Israel now sees Thee clearly face to face" (second troparion of the fourth ode of the canon).

Let us finally examine the Gospel readings for the day of the Holy Face, both at Matins and at the Liturgy (Luke 9:51-56; and 10:22-24):

> When the days drew near for Him to be received up, He set his face to go to Jerusalem. And He sent messengers ahead of Him, who went and entered a village of the Samaritans, to make ready for Him; but the people would not receive Him, because His face was set toward Jerusalem. And when His disciples James and John saw it, they said, "Lord, do you want us to bid fire come down from heaven and consume them?" But He turned and rebuked them. And they went on to another village. And Christ turned to His disciples saying, "All things have been delivered to me by my Father; and no one knows who

the Son is except the Father, and who the Father is except the Son and any one to whom the Son chooses to reveal Him." Then turning to the disciples, He said privately, "Blessed are the eyes which see what you see! For I tell you that many prophets and kings desired to see what you see, and did not see it, and to hear what you hear, and did not hear it.

The meaning of the image in the Epistle and the Gospel on the one hand, and in the first two Old Testament readings on the other hand, are opposed to each other. The Old Testament text says: "You saw no form." In the Gospel we read: "Blessed are the eyes which see what you see," *i.e.* "the image of the invisible God," Christ. This is why the last words of the Gospel readings are only addressed to the apostles. In fact, not only the disciples but all those who surrounded Him saw the man Jesus. But only the apostles discerned in this son of man, under His "form of a servant," the Son of God, "the brightness of the glory of the Father." As we have seen, St. John of Damascus understands these last words of the Gospel as the repeal of the biblical prohibition, the repeal which for us is the visible aspect of the image of Christ whom we worship. "Formerly Thou wast seen by men," we hear in a troparion, "and now Thou appearest in Thy image not made by human hand" (second troparion of the first ode of the canon).

The first passage of the Gospel (Luke 9:55-56) draws a sharp distinction between the apostles and the world. In fact, it shows what makes *the Church different from the world:* the spirit and the ways which are the Church's alone and which are not the world's. (Remember that it is this difference which determines the Church's modes of action and, in particular, its art.) On the one hand, the Old Testament readings explain why images were prohibited. The Gospel, on the other hand, reveals the purpose of the image. Note also that this difference of the spirit and the ways of the apostles with those of the world is noted by Christ just before His entrance into Jerusalem. Starting with the Old Testament readings and moving to the New Testament read-

ings, we see a developing revelation through symbolic images: The Old Testament is a preparation for the New Testament; the Promised Land is an image of the Church. The New Testament is the realization of these preparatory prefigurations. But the New Testament itself is not yet the final end: It is only another step towards the Kingdom of God. Thus in the Old Testament the confession of the true God and the absence of His image were essential conditions for the people to be able to enter the Promised Land and possess it. In turn, in the New Testament the confession of Christ and of His image, the declaration of our faith in this image, plays an analogus role: It is also an essential condition to enter the Church and, through the Church, the Kingdom of God, that celestial Jerusalem towards which the Church is leading us. This is why this passage of the Gospel is read precisely on the day when the Church celebrates the icon of the Holy Face. It is Christ Himself who leads His apostles into Jerusalem. As for us, it is His image which leads us into the celestial Jerusalem. A hymn of the feast proclaims: "We praise Thee, the lover of man, by gazing upon the image of Thy physical form. Through it, grant unto Thy servants, O Savior, to enter into Eden without hindrance" (sticheron in tone 6). Thus, by the simple choice of liturgical readings, the Church unfolds before us the impressive picture, showing the slow and laborious progress of the fallen world towards the promised redemption.

Besides the image of Edessa, there must have been other representations of Him made by persons who had seen and known Him. This tradition is expressed, for example, by the statue of the hemorraging woman. These portraits served as models for the images which were made later. Very few of these ancient images of Christ have survived. In general, most of the monuments of sacred art, particularly those of the Eastern Christian world, were destroyed by the iconoclasts and, later, by the Crusaders or simply by time. There remain, above all, frescos in catacombs, particularly in Rome. As we know, these are direct and not symbolic representations of Christ. Many of His representations in the catacombs of Pretextatus and of Calistus, dating back to the second century,

are a part of biblical scenes. He is sometimes represented as an older man, with a beard, as in the scene of the Samaritan woman (the catacomb of Pretextatus, Fig. 5). Sometimes, however, He is young and beardless. In the following centuries, the number of images of Christ continuously increases.

It is necessary to mention here what some historians call a "controversy" in the writings of the authors of antiquity and the Fathers concerning the physical aspect—the beauty or ugliness—of Christ. This so-called discussion began in the second century. Among the fathers and ecclesiastical writers, some, such as St. Justin Martyr, Clement of Alexandria, Tertullian, St. Cyril of Alexandria and St. Irenaeus, assert that Christ was ugly. They base their argument on the idea of the *kenosis,* the emptying, the abasement of God and on the words of Prophet Isaiah: "He had no form or comeliness that we should look at him, and no beauty that we should desire him" (Isaiah 53:2-3). These writers understood literally the words of St. Paul: "But He emptied himself, taking the form of a servant" (Phil. 2:7-8), and believed that Christ could not have an attractive physical aspect. Other Fathers, such as St. Gregory of Nyssa, St. Ambrose of Milan, St. John Chrysostom, St. Jerome, and also Origen, believe that Christ was physically very beautiful. They base their opinion on other prophecies, such as Psalm 44 (45): "Thou art the fairest of the sons of men." As for the words of Isaiah on the absence of beauty in the humiliated servant, they understand this to speak of Christ during His Passion.

The very names of these writers show that there could not have been a "controversy" among them on this topic. Each of them simply expressed his opinion on the matter, but not one, I think, placed any great importance on it. It is characteristic that most of those who believed in the ugliness of Christ lived in a pagan world and were, therefore, fierce enemies of the ancient conception of beauty. An ugly Christ was psychologically more understandable to them. On the other hand, most of those who believed in the beauty of Christ lived in a time when the beauty of antiquity was considered to be less of a challenge to Christianity. For them, beauty was not necessarily pagan and sensual. It could express

the radiance of an internal, spiritual beauty. Church Tradi-
tion, as it is reported by St. John of Damascus among others,
appears to solve this so-called controversy. It asserts that the
messenger of king Abgar could not make a portrait of
Christ because of the supernatural radiance of His face. Thus,
the issue of His beauty clearly transcends the usual meaning
of the word: It is an issue of internal and spiritual beauty.

This so-called controversy is sometimes used in arguments
to prove the absence of an "authentic image" of Christ. But
actually, no argument based upon the categories of secular
aesthetics can prove anything. One person can find Christ,
as He is represented on an icon, beautiful; another can find
Him ugly. It is a matter of conditioned subjectivity, which
would allow one person to appreciate a portrait which others
do not. Divergences would increase if the same face was
represented by different painters.

Besides the rare direct images of Christ, many symbolic
or allegorical representations of Him can be found, either
painted in the catacombs or sculptures in bas or high reliefs.
Excluding animal or vegetable symbols, the representation of
the Good Shepherd is the most important of those repre-
sentations using the human form. This image is directly
linked with that of the Lamb and is based on biblical texts,
for example, Ezekiel 34 and Psalm 22, in which Ezekiel and
David see the world as a sheepfold with God as the shepherd.
Christ, when speaking of Himself, takes up this biblical
image: "I am the good shepherd," He says (John 10:14),
or "I was sent only to the lost sheep of the house of Israel"
(Matt. 15:24). Some authors of antiquity, such as Clement
of Alexandria or St. Abercius, bishop of Hierapolis, also
use the image of the Good Shepherd. In this figuration,
Christ is always represented as a slender and elegant young
man, beardless, his hair either long or short. Sometimes He
holds a scroll of the Scriptures in His hand, sometimes a
shepherd's staff. The image of the Good Shepherd appeared
in the Roman catacombs in the first century. There are, in
particular, many in the catacomb of Domitilla. Christ is seen
either surrounded by sheep or carrying one sheep on His
shoulders. The latter type of iconography is not of Christian

origin. Pre-Christian art also used this image. With foreboding, it seemed to express an archaic myth of deliverance by a good god: In ancient Greece, it was Hermes, the protector of the herd, and in more ancient Indo-European mythology, it was the god-liberator of cows. The image of the Good Shepherd carrying a sheep on His shoulders was also known in Etruscan art. However in Hellenistic times it simply became a "scene from nature." One could also ask whether the mystery cults did not give it a new, soteriological value.

In any case, Christianity adopted this iconographic type and gave it a precise, dogmatic meaning, which simultaneously fulfills its primitive foreboding and completely renews it in the historical certainty of the salvation through Jesus Christ: The Good Shepherd—not dreamed about, but incarnate—takes upon Himself the lost sheep, that is, according to patristic commentaries, fallen human nature, humanity which He unites to His divine glory. It is the deeds of Christ and not His historical form which are explained in this scene. It is almost an image of a hero of antiquity, such as, for example, the young solar god, Apollo. In no way can it be likened to the image of an adolescent Christ, or Emmanuel.

Another symbolic image of Christ is also borrowed from ancient mythology. This is the infrequent representation of Christ as Orpheus, with a lyre in His hand and surrounded by animals. Christians used this image as yet another way to express the eminence of a divine teaching. Just as Orpheus subdued wild beasts and charmed the mountains and trees with his lyre, so also Christ attracted men with His divine word and subdued the forces of nature. This symbol was also frequently used by the writers of Christian antiquity, starting with Clement of Alexandria. Such symbolic representations of our Lord, as well as the symbols borrowed from the animal world, gradually lost their meaning and disappeared from the liturgical life of the Church.

Let us now consider the first representations of the Mother of God, which tradition also dates back to the time when she lived on earth. If the icon of Christ, the foundation of all Christian iconography, reproduces the traits of God who became man, the icon of the Mother of God, on the other

hand, represents the first human being who realized the goal of the incarnation: the deification of man. The Virgin is the first of all humanity to have already attained, through the complete transfiguration of her being, that to which all creatures are summoned, and who has raised herself above the celestial hierarchy, she who is "more honorable than the cherubim and more glorious beyond compare than the seraphim." She has already passed the limit of time and eternity and now finds herself in the Kingdom which the Church awaits with the second coming of Christ. She who "contained the uncontainable God" presides with Christ over the destiny of the world. This is why the icons of the Virgin play a particularly important role. In our churches, in our worship, they are parallel to those of Christ Himself. In the private life of the faithful, these icons also play a very important role.

Orthodox tradition attributes the first icons of the Virgin to the Evangelist St. Luke. According to this tradition, St. Luke made, after Pentecost, three icons of the Virgin: two with the Child and the third without. One is of the type called *Hodighitria* (Ὁδηγήτρια, fig. 6), which means "She who leads the way." Both the Virgin and the Child are represented full face, turned toward the spectator. This austere and majestic image particularly emphasizes the divinity of the Christ-Child. Another image is of the type *Umilenie* (Ἐλεοῦσα, fig. 7), "Our Lady of Tenderness." It represents the mutual caress of the Mother and Child. But it portrays more than the natural human feeling, the tenderness of motherly love. It is the image of a Mother who suffers deeply for the anguish which awaits her Child in a silent consciousness of His inevitable suffering. As for the icon representing the Virgin without the Child, the facts about it are confused. It is probable that this icon is connected with the composition known as *Deisis,* that is, the Virgin and St. John the Baptist praying to Christ.

Actually, a score of icons of the Virgin attributed to St. Luke are found in the Russian Church alone. Besides these, there are twenty-one on Mount Athos and in the West, of which eight are in Rome. Obviously, it cannot be maintained

that these icons are themselves made by the hand of the Evangelist, since nothing which he painted has survived. For example, among the old reproductions of the Virgin of the *Umilenie* type, we do not know of one which dates back further than the tenth century.[10] Of the *Hodighitria* type, those prototypes which we know of date back to the sixth century (the Rabula Gospel).[11] But those icons which are said to be St. Luke's form a tradition for which he may have provided the prototypes. Similar expressions are used when one speaks, for example, of an "apostolic liturgy" or of "apostolic canons": These date back to the apostles not because they were written by their hand, but because they have an apostolic character and are covered by apostolic authority.

The tradition which attributes the first icons of the Virgin to St. Luke is transmitted by liturgical texts, particularly those of the feasts consecrated to the Virgin, such as the feast of Our Lady of Vladimir, an icon of the *Umilenie* type (August 26). During Vespers, the following sticheron in tone 6 is sung during the Litia: "When for the first time your icon was painted by the announcer of evangelical mysteries and was brought to you so that you could identify it and confer on it the power of saving those who venerate you, you rejoiced. You who are merciful and who have blessed us became, as it were, the mouth and the voice of the icon. Just as when you conceived God, you sang the hymn: 'Now all the generations will call me blessed,' so also, looking at the icon, you say with force: 'My grace and my power are with this image.' And we truly believe that you have said this, our Sovereign Lady, and that you are with us through this image . . ." During Matins, the first hymn of the canon in praise of the Virgin, tone 4, is: "Painting your all-honorable image, the divine Luke, author of the Gospel of Christ, inspired by the divine voice, represented the Creator of all things in your arms." The latter text simply states that the first icon of the Virgin was made by St. Luke. But the former asserts that the Virgin herself approved her image

[10] In the church Toqale Kilisse—963-969. V. Lazarev, *Istoria vizantiiskoi zhivopisi*, t. I, p. 125.

[11] N. Kondakov, *Ikonografia Bogomateri*, t. I, pp. 191-192.

and conferred on it her grace and her power. The Church uses this same text for the feasts of different icons of the Virgin. By this, the Church emphasizes that this power and grace of the Virgin are transmitted to all of the images which reproduce the authentic traits of the Virgin as she was represented by St. Luke. This is why the supposed images of the Virgin which are painted from another model can never have this unique advantage which the traditional icons have: to be carriers of all the power of the Virgin—this being true for the simple reason that they have nothing in common with the Mother of God.

The oldest historical evidence which we have about the icons painted by St. Luke dates back to the sixth century. It is attributed to Theodore, called the Reader, a Byzantine historian in the first half of the century (around 530) and a reader in the church of St. Sophia in Constantinople. Theodore speaks of an icon of the Virgin *Hodighitria* sent to Constantinople in the year 450, which was attributed to St. Luke. It was sent from Jerusalem by the Empress Eudoxia, wife of Emperor Theodosius II, to her sister, Pulcheria. St. Andrew of Crete and St. Germanus, Patriarch of Constantinople (715-730), also speak of an icon of the Virgin painted by St. Luke, but which was found in Rome. St. Germanus adds that the image was painted during the life of the Mother of God and that it was sent to Rome to Theophilus, the "excellent" Theophilus who is spoken of in the prologue of the Gospel of St. Luke and in the Acts of the Apostles. Another tradition tells of an icon of the Virgin which, after having been painted by St. Luke and blessed by the Mother of God, was sent to the same Theophilus, but to Antioch rather than Rome. According to the tradition, this is probably the prototype of the icons which now exist in our Church under the name of Tikhvin (celebrated on June 26; the Tikhvin icon is now preserved and venerated at the Cathedral of the Holy Trinity in Chicago, Illinois). After the death of Theophilus, this icon supposedly was brought from Antioch to Jerusalem, and, from there, to Constantinople.[12] It is possible that this is the same

[12]G. S. Debolsky, *Dni bogosluzheniia*, vol. I (Saint Petersburg, 1901), p. 188.

icon of which Theodore the Reader spoke. But this fact is difficult to ascertain, because here probably were many reproductions of icons by St. Luke brought to Constantinople. In any case, among the icons found in Russia and attributed to St. Luke, five reproduce prototypes once brought from Jerusalem to Constantinople. It is possible that among those which exist in the West, there are also some which had once been brought from Jerusalem to Constantinople and that it is about one of these that Theodore the Reader speaks. The famous document in the defense of icons addressed to Emperor Constantine Copronymus and attributed to St. John of Damascus also speaks of an image of the Virgin painted by St. Luke.[13] These are the remains of a very old tradition which still lives today in the Christian people.

As we have seen, there are two traditions about the icon which St. Luke sent to Theophilus. The Patriarch St. Germanus speaks of an icon brought to Rome, while another tradition asserts that this same Theophilus possessed an icon of the Virgin painted by St. Luke, but in Antioch. That Theophilus, an important person, could have had two icons of the Virgin, one in his house in Rome (since he was of Roman origin) and another in Antioch where he was retained by his work, is not impossible. St. Luke was a painter, and he surely did not limit himself to painting only one icon of the Virgin. Moreover, Church tradition, as we have seen, attributes several to him. In any case, from the fourth century on, when Christianity became the religion of the state and there was therefore no danger in exposing sacred objects, the icon of Theophilus, which until then had remained hidden in Rome, became known to an ever-growing number of Christians. The icon itself, or a reproduction, was moved from a private house to a church. And, in 540, Pope St. Gregory I (590-604) carried the venerable icon of the Mother of God, "which is said to be the work of St. Luke" (*quam dicunt a sancto Luca fac-*

[13]This document, according to recent scholarship, belongs to an unknown author and consists of homilies by St. John of Damascus, St. George of Cyprus and John of Jerusalem. G. Ostrogorsky, *Seminarium Kondakovianum* 1 (Prague, 1927), p. 46.

tam), to the basilica of St. Peter in a solemn procession and with the singing of litanies.

Other than the images painted by St. Luke, tradition also tells us of an icon of the Virgin made in a miraculous way and not by the hand of man. Thus, during the liturgical service commemorating the icons of the Virgin of Kazan (October 22), we hear in the third ode of the canon: "The divine apostles of the Word, announcers of the Gospel of Christ to the universe, built a divine church consecrated to your holy name, O Mother of God. Therefore they came to you, our Sovereign Lady, asking you to come to its consecration. But you, O Mother of God, said to them: 'Go in peace, and I shall be there with you.' And when they went, they found on the wall of the church a likeness of your image, O our Sovereign Lady, made in colors by a divine force. When they saw it, they fell down before it and glorified God. And we also with them . . ." According to Tradition, the apostles in question are St. Peter and St. John. After having converted many people in the town of Lidda, later called Diospolis, near Jerusalem, they built a church consecrated to the Virgin. They then went to Jerusalem to ask the Virgin to come to the consecration of this church. The Virgin sent them back with the promise to be there with them. Upon their return to Lidda, they found in their church an image of the Virgin on the wall, or, according to other sources, on a column.[14] This image is called Our Lady of Lidda and is celebrated on March 12.[15] In the eighth century, St. Germanus, the future patriarch of Constantinople, passing through Lidda, had a reproduction made of it which he sent to Rome during the time of the iconoclastic controversy. After the defeat of iconoclasm, it was returned to Constantinople. From this time on the image of our Lady of Lidda was also called our Lady of Rome (celebrated on June 26).

[14]G. S. Debolsky, *op. cit.,* p. 168.

[15]The oldest written evidence we have about this dates to the eighth and ninth centuries. These are a passage attributed to St. Andrew of Crete and written about the year 726; a synodal letter written by the three patriarchs of the East to Emperor Theophilus, an iconoclast, in 839; and a work of George, called the Monk, written in 886-887. We know nothing definite

The very first icons of Christ and of the Virgin which served as prototypes for all later icons have not survived to our own times. The very material with which an icon is made does not last forever. An icon cannot last indefinitely, and if we have several rare icons which date back to the fifth century, they too will soon no longer exist. Besides, man at times does everything he can to destroy this ancient evidence. Iconoclasm, for example, was a true disaster. Everything which could be destroyed was systematically done away with, and we now can no longer say what icons from early Christian times were like. All that can be asserted is that the most authentic evidence was found in Syria and Palestine. But, in effect, all that remains from the first centuries of Christianity are the frescos in the catacombs, particularly in Rome, bas reliefs of sarcophagi and the remains of various sacred objects, also found particularly in the catacombs.

The Virgin is represented in the catacombs at least as often as Christ. But while Christ is primarily represented symbolically, the Virgin is always represented directly. The oldest representation of the Virgin which we know of dates to the second century, and some scholars even think that it may date back to the first.[16] It is found in the catacomb of Priscilla in Rome and represents the Mother of God sitting with the Child on her lap, with a prophet at her side pointing at a star (fig. 8). A fresco dating to the beginning of the second century and representing the adoration of the Wise Men can also be found in this catacomb. It is, however, practically effaced. The adoration of the Wise Men was frequently represented in the first centuries of Christianity and was a separate feast in the liturgical year, as is still the case in the West. (The East celebrates it together with the feast of the Nativity.) In the Roman catacombs, ten or twelve images of the adoration of the Wise Men can be found, dating from the second to the fourth centuries. The Virgin is always represented sitting down, holding the Child on her lap and receiving with Him the adoration of the Wise Men,

about what happened to this image except that it still existed in the ninth century. Dobschütz, *Christusbilder* (Leipzig, 1899-1909), pp. 79-80.

[16]Pokrovsky, *op. cit.*, p. 64.

which particularly emphasized her dignity as the Mother of
God. This iconographic theme is not only important histor-
ically; it is not simply an illustration of a celebrated event. It
answered a very piercing question of that time: that of the
role of the Gentiles, *i.e.* of the non-Jewish nations, in the
Church. This no longer poses any problem for us, but in the
first centuries, the problem of the Gentiles, of the pagans
who entered the Church, the house of Israel for which Christ
had come, was very acute. It was the source of a controversy
between the Apostles (Acts 11:1-4) and was discussed at the
apostolic council (Acts 15). It played an important role in
the life of the first Christians (for example, Acts 6:1).
Images frequently and in different ways reflected this prob-
lem. The Wise Men coming to adore Christ were the fore-
runners of the nations, the first-fruits of the Church of the
Gentiles, *i.e.* of the non-Jewish Church. This is why the Chris-
tians of the first centuries, through the representation of the
worship of the Wise Men, emphasized the place of the non-
Jewish Christians in the Church, the legitimacy of their minis-
try parallel to that of the Christians of Israel. Even in the
sixth century, mosaics in the church of San Vitale in Ravenna
represent the adoration of the Wise Men embroidered on the
robe of the Empress Theodora, in that famous scene which
shows her with Emperor Justinian, carrying gifts to the
Church. Thus, the imperial couple re-enacts the action of the
kings of the Orient, carrying gifts to Christ in the name of
their people.

Apart from icons of the adoration of the Wise Men, the
Virgin appears in other iconographic scenes, for example, the
annunciation (catacomb of Priscilla) and the nativity (cata-
comb of St. Sebastian, fourth century). She is also often repre-
sented alone, as an *Orans, i.e.* with arms lifted in prayer.
This latter image emphasizes her role as the mediator before
God for the Church and for the world. And it is usually in
this pose that she is represented on the bottoms of many
sacred vases in the catacombs (Fig. 9). She also sometimes
appears surrounded by the apostles Peter and Paul and others,
or else with her mother, St. Ann.

Following the images of Christ and the Virgin, there ap-

peared images of apostles, prophets, martyrs, angels, *etc.*—in other words, a variety of Christian iconography. Thus we find in the catacombs from the first century, representations of Noah's ark, Daniel in the lions' den, *etc.* In short, many elements of present-day Orthodox iconography gradually materialized between the first and fourth centuries.

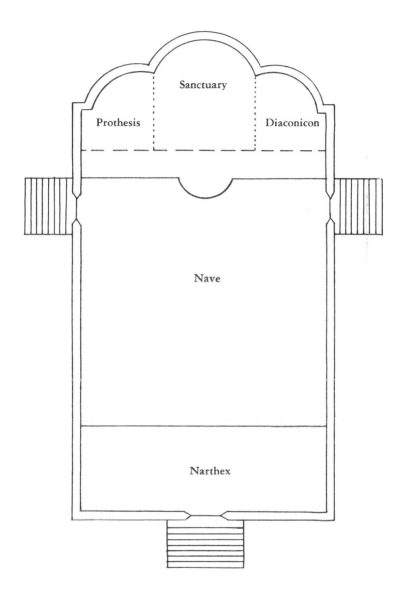

Sanctuary

Prothesis

Diaconicon

Nave

Narthex

FIG. 1
Plan of an Orthodox Church.

FIG. 2

The image, in bas-relief, on the sarcophagus of the Lateran which reproduces, we believe, the statue of the hemorrhaging woman. This is the scene on the right. One notes that Christ is bearded, while on the same sarcophagus in other images (for example, that on the left) He is beardless. On one side we see the classic figure of a young god (perhaps Apollo), on the other, a concrete person rather than a conventional figure, a type of portrait. The fact that He is bearded is important because this is an exception to the general rule of Christian bas-reliefs of the first centuries. In the West, the Savior during His life on earth is generally represented beardless. This general rule makes some people conclude that this image represents the appearance of Christ to Mary Magdalene. But on the one hand this rule is not invariable, and Christ is sometimes represented without a beard after the Resurrection. On the other hand, when the appearance of Christ to Mary Magdalene is represented, the scene does not occur in a town but in a garden. However, here, directly behind the figures, we see the construction of a basilica with two other similar temples. It is not impossible that this small church is the house of the hemorrhaging woman, "maintained in the form of a temple," as Eusebius tells us.

Fig. 3

A Roman medallion from the second or third centuries representing St. Peter and St. Paul. Museum of the Vatican. This medallion confirms the evidence of Eusebius on the existence of portraits of the apostles in the first centuries. The particularities of their faces clearly denote the characteristics of a portrait. Without any doubt, this medallion reproduces representations based on a direct observation of the models.

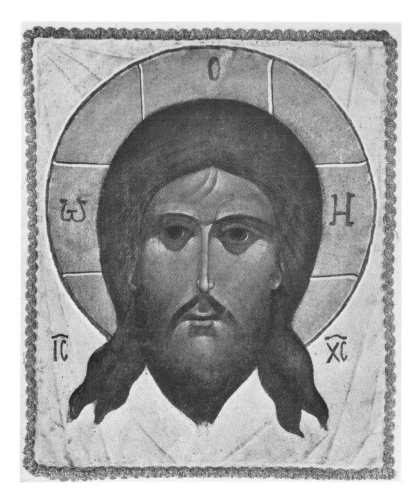

Fig. 4
The Holy Face.
Icon from the twentieth century.

FIG. 5
Christ and the Samaritan Woman.
Catacomb of Pretextatus, second century.

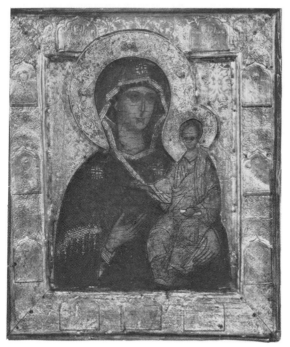

FIG. 6
The Smolensk Mother of God.
Russian icon from the sixteenth
century, an example of the
Hodighitria type.

FIG. 7
The Vladimir Mother of God.
Russian icon from the fifteenth
century, an example of the
Umilenie type.

FIG. 8
Virgin with Child.
Catacomb of Priscilla,
second century.

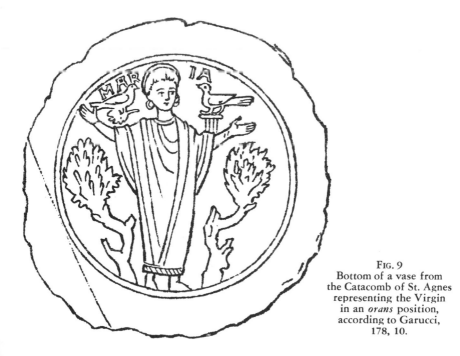

FIG. 9
Bottom of a vase from
the Catacomb of St. Agnes
representing the Virgin
in an *orans* position,
according to Garucci,
178, 10.

FIG. 10

FIG. 11

Two series of representations from the Catacomb of Calixtus, second century.

IV

The Art of the First Centuries of Christianity and its Symbolism

WE HAVE SEEN that the scholarly theories concerning sacred objects have been based on diverse and changing hypotheses, sometimes even on prejudices. Thus Protestant scholars, because of their doctrinal position, have tended to deny the existence of the sacred image in the beginning of Christianity. Moreover, this attitude concurred with the rationalism of the eighteenth, nineteenth, and twentieth centuries. The outlook of the Church, however, did not change. The Church believes that the first icons originated within and were propagated together with Christianity, thus spreading from the very places where Christ lived and where biblical preaching began, that is, to Palestine and Syria, Judaic countries where, it would seem, the Old Testament prohibition should have been most strictly observed. The Church does not support this belief with some formal and obvious proofs, but rather with the belief that the image is inseparable from Christianity. The Church does not violate the biblical prohibition but, on the contrary, maintains its only possible outcome in the framework of the New Covenant. Church tradition is not based on theories, scholarly hypotheses or archeological findings, but rather on the Church's teaching and on historical facts. Indeed, we know that the Gospel was preached, according to the last commandment of Christ, "to all nations, beginning from Jerusalem" (Luke 24:47): It was preached by the word and by the image.

The little which remains of primitive Christian art, and in

particular the frescos of the catacombs,[1] leads us to the conclusion that the first images of Christ and the Virgin were not purely naturalistic portraits, like those on the Roman medallion of St. Peter and St. Paul, but rather that these were images of a completely new and specifically Christian reality. Certain scholars today have reached the same conclusion. For example, here is what the Russian Byzantinist, V. Lazarev, writes: "Linked to antiquity, primarily to its late spiritualized forms, this art, from the first centuries of its existence, is charged with a whole series of new tasks. Christian art is far from being the art of antiquity as practiced by Christians, as is thought by some writers... The new subject matter of primitive Christian art was not a purely external fact. It reflected a new outlook, a new religion, a fundamentally different understanding of reality. This subject matter could not adapt itself to the old forms of antiquity. It required a style which could best incarnate the Christian ideas and, thus, all the efforts of the Christian painters were directed towards

[1]Though we must constantly refer to the Roman catacombs, this does not mean that there were no Christians, or Christian art, elsewhere. On the contrary, Christianity spread much faster in the East than in the West, so much so, that when St. Constantine came to the throne, the Christians had already formed more than 50% of the population in parts of the East, in contrast to the 20% in Rome. But it is in the Roman catacombs that most of the Christian monuments of the first centuries were preserved. Outside of Rome, catacombs also existed in Naples, Egypt and Palestine. These were underground cemeteries; Roman law considered these burial places inviolable no matter what religion they belonged to. The pagans also had catacombs, but these were always personal or family tombs, while those of the Christians were public. All the members of a community, irrespective of social rank, were buried there. The catacombs consisted of a network of underground passages, sometimes reaching ten to fifteen meters in depth (the catacomb of Calixtus), in which the walls were hollowed out and the bodies, covered with a slab of rock, were placed in the niches. The name of the deceased, the date of his burial and his age, either from birth or from his baptism, were ususally inscribed on this slab. Symbols, such as the fish, the initials of Christ, or a palm, as well as prayers, were also engraved. There were small chapels in the catacombs where the liturgy was celebrated, particularly during the persecutions when burials were more frequent. The sanctuary is either an apse or an alcove, separated from the rest of the chapel by a low railing (a primitive form of our iconostasis), of which traces can be seen in some catacombs. It is into this apse that the sarcophagus of a martyr was placed, serving as an altar for the celebration of the Eucharist; this is the origin of our custom of placing the relics of a martyr either in the altar itself, or on the altar in the antimension. Frescos, the remains of which still exist, were painted on the walls. (See N. Pokrovsky, *op. cit.*, p. 11.)

elaborating this style." [2] And Lazarev, relying on the research of other scholars, emphasizes that in the paintings of the catacombs, this new style has already developed its basic characteristics. With the help of this art, the Christians attempted to convey not only that which is visible to the human eyes, but also that which is invisible, *i.e.* the spiritual content of that which was being represented. To express its teaching, the primitive Church also uses pagan symbols and certain subjects from Greek and Roman mythology. It also uses art forms of Greek and Roman antiquity, but it gives them a new content, thus changing the very forms which express it.

The art of the catacombs is not only a funeral art and does not only consist in symbolic or allegorical representations, as is sometimes thought to be the case. Of course, it does include many funeral elements, but it is above all an art which teaches the faith. Thus most of the subject matter in the catacombs, whether symbolic or direct, corresponds to sacred texts, those from the Old and the New Testaments, as well as to liturgical and patristical sources. As we know, a whole series of themes from the Old and New Testaments appeared in the catacombs of Rome already in the first and second centuries. In the first century, these consist of the Good Shepherd, Noah and the ark, Daniel in the lions' den and the banquet scene. In the second century, there are many images from the New Testament: the annunciation, the nativity of Christ, His baptism and others.

Obviously, we cannot study here in detail the art of the catacombs nor, more generally, the art of the first Christians as such. We will limit ourselves to a few examples which will help us to understand the purpose of this art, its meaning and its contents.

Side by side with the relatively few direct representations, the language of symbols was very widespread and played an important role in the Church during the first centuries. This symbolic language can be explained, first of all, by the necessity of expressing through art a reality which could not be expressed directly. Furthermore, the main Christian sacraments remained hidden from the catechumens until a certain

[2]*Historiia vizantiiskoi zhivopisi* (Moscow, 1947), vol. 1, p. 38.

point, according to a rule established by the Fathers and based
on the Holy Scripture. St. Cyril of Jerusalem (fourth cen-
tury) mentions the symbolic expressions which must be used
in teaching Christians, "since all are permitted to hear the
Gospel, but the *glory* of the Good News belongs only to those
who are close to Christ. This is why the Lord spoke in para-
bles to those who were not capable of hearing, and then ex-
plained these parables to His disciples when they were alone,
because that which, for the initiated, is a splendor of glory,
is blinding for those who do not believe . . . One does not
explain the mysterious teaching of the Father, Son and Holy
Spirit to a pagan, and even to the catechumens we do not
speak clearly of the mysteries, but we express many things in
a veiled way, for example, with parables, so that the faithful
who know can understand, and those who do not know will
not suffer harm."[3]

Thus the meaning of the Christian symbols was revealed
progressively to the catechumens, as they were prepared for
baptism. Futhermore, the relations between the Christians
and the external world also required some kind of ciphered
language: "One does not explain the mysterious teaching . . .
to a pagan," according to St. Cyril of Jerusalem. It was not
in the interest of the Christians to divulge the sacred myste-
ries to a pagan and hostile world.

The early Christians primarily used biblical symbols—the
lamb, the ark, *etc.* But once the pagans began entering the
Church, these symbols were no longer sufficient since the
pagans frequently did not understand them. And so the
Church adopted some pagan symbols capable of conveying
certain aspects of its teaching. The Church gave a new mean-
ing to these symbols, purifying them so that they would re-
capture their primitive meaning. They were then used to ex-
press the salvation accomplished in the incarnation.

Thus, for example, the oldest symbol, that of a ship: To
the man of Graeco-Roman antiquity it had suggested the
voyage of souls into the beyond, but by the time of the Em-
pire it came to mean a happy passage through life; it was only
a sign of prosperity, with the end of the voyage representing

[3] *Or. Cat.*, 6, § 29, PG 33: 589.

death. Christians, taking up the symbol and restoring its primitive meaning, transformed it into a symbol of the faith of the Church and of the soul which the Church guides. Prosperity is transposed into the spiritual realm, life on earth into eternal life. The arrival of the ship to the harbor had signified the end: death. For a Christian, on the contrary, it implied the entrance of the soul into eternal repose and bliss. The pessimistic outlook of the pagan was replaced by the joyous confidence in the resurrection.

To allow for a better understanding of its teaching, the Church used myths of antiquity which, to a certain extent, paralleled the Christian faith. This is the case, for example, with the myth of Eros and Psyche (Love and Soul) which, in paganism, had served to explain the thirst for God characteristic of man. In the first centuries of our era, both the myth itself and its iconography lost their symbolic, primitive meaning and acquired a purely sensual and anecdotal character: Eros and Psyche were often represented without wings, and the image of the myth simply became a love scene. Christianity resurrected the true meaning of this myth by placing it into a new context: The representations in the catacombs and on the sarcophagi express the love for the only true God which overcomes the soul.

Another myth which is represented in the Christian catacombs is that of Orpheus, which we have already mentioned. Orpheus, having lost his wife, Eurydice, descends into hell to find her. He charms the infernal monsters which kept her prisoner and brings her back to the world of the living. The analogy with the descent of Christ into hell is clear. This is why the teaching about the resurrection, so hard for the pagans to understand (see Acts 17:31-32), was shown to them in part through the image of Orpheus.

It should be noted that the symbolism was not limited to such subjects as the fish, the anchor, the lamb, the boat, *etc.* Even those subjects which at first appear to be decorations often have a hidden meaning, such as the vine which is often seen in the art of the first centuries. This is obviously a visible transposition of the words of Christ: "As the branch cannot bear fruit by itself, unless it abides in the vine, neither

can you, unless you abide in me. I am the vine, you are the branches. He who abides in me, and I in him, he it is that bears much fruit, for apart from me you can do nothing" (John 15:4-5). These words and this image have both an ecclesiological and a sacramental significance. The vine and the branches represent Christ and the Church: "I am the vine, you are the branches." This is most obvious when the image is found on the dome of a church (for example, the chapel of El Baouit, fifth century): The vine is in the center, while the branches completely cover the dome. This follows the same principle as the classic decoration in our churches, which depicts Christ in the dome and the apostles surrounding Him. But the image of the vine is most frequently completed by that of the vintage or by that of the birds feeding on the grapes. In this case, the vine reminds the Christians of the central sacrament, the Eucharist. "The vine gives the wine as the Word gave His blood," says Clement of Alexandria.[4] The grape-gatherers and the birds who eat the grapes represent the Christian souls feeding on the body and blood of Christ.

In the Old Testament, the vine was also a symbol of the Promised Land, as was shown by the bunch of grapes brought to Moses by those whom he had sent to Canaan. Hence in the New Testament it is also a symbol of paradise, the land promised to those who commune in the body and blood of Christ, *i.e.* to the members of the Church. The decorative vine continues to exist today in the sacred art of our Church and has the same symbolic meaning.

One of the most widespread symbols in the first centuries of Christianity was the fish. This symbol also originated in paganism. For the primitive people, the fish symbolized fertility. For the Romans in the beginning of our era, it simply became an erotic symbol.

The very important role played by the fish in the accounts of the Gospel certainly contributed to the fact that this symbol was taken up by the Christians. Christ Himself used it. The lake, the boat, the fishermen, the net heavy with fish do not form the framework for so many biblical scenes simply by chance. Speaking to the fishermen, Christ naturally used

[4]*Paedagogos.* I, cap. 5, PG 8: 634.

images which were comprehensible to them, and, calling them to the apostolate, He used the same metaphor. "Follow me, and I will make you fishers of men," He says (Matt. 4:19; Mark 1:17). He compares the heavenly Kingdom to a net filled with many different kinds of fish. The image of the fish is also used as a symbol of the heavenly good things (Matt. 7:9-11, 13, 47-48; Luke 5:10). The images of the fisherman and the fish, representing the teacher and the convert, are completely understandable. But there were other reasons for the popularity of this symbol in Christianity.

The Greek word meaning "fish," ἰχθύς, contains five letters which are the initials of five words directly corresponding to Christ: Ἰησοῦς Χριστὸς Θεοῦ Υἱὸς Σωτήρ, "Jesus Christ, Son of God, the Savior." As we have seen, these words express the faith in the divinity of Jesus Christ and in His redeeming mission. Therefore, we have in the symbol of the fish a kind of ancient credal formula, condensed into one word. This mysterious meaning of the five letters which make up the word ἰχθὺς was the main reason why the Christians adopted the corresponding image to express the Christian faith. This is why the representation of the fish was so widespread. The image appears everywhere—in the wall-paintings, on the sarcophagi, in the funeral inscriptions, on various objects. Christians wore little fish made of metal, stone or nacre with the inscription CΩCAIC, "May You save," or "Save," around their necks. This word, together with the meaning of the Greek letters ἰχθύς, may also represent a primitive form of the Jesus prayer. No written evidence exists, however. Such symbols of the fish were found in France, in Autun, in an ancient Christian cemetery. Some, in place of CΩCAIC, bore the Roman numerals X, or XXV, but the mysterious language of the numbers has still not been deciphered.[5]

A no less amazing popularity of the symbol of the fish in funeral inscriptions and among Christian writers corresponds

[5]Strangely enough, in the eighth book of the Sybils, that is, of the pagan prophetesses, written before our era, there is an acrostic in which the first letters form the words: Ἰησοῦς Χριστὸς Θεοῦ Υἱὸς Σωτὴρ Σταυρός, which means, "Jesus Christ, Son of God, the Savior, the Cross."

to the extraordinary extension of the graphic image.[6] The value of the symbol seemed so great to the first-century Christians that they tried not to disclose its meaning (as they did for other symbols), so that, as far as we can judge from the documents we possess, no writer gives a complete explanation of the fish symbol until the fourth century.

The first and foremost significance of the fish is, therefore, Christ Himself. The Old Testament narrative of the fish caught by Tobias which he uses to heal Sara of the demon and restore his father's sight undoubtedly contributed to the fact that this symbol was used to represent Christ. Christians understood it to be a prefiguration of Him who healed souls and bodies, chasing away demons and returning sight to the blind, of Him who freed the world from the shadows of ignorance and chased away the demons with His cross. Already in the second century, we see inscriptions where the image of the fish replaces the name of Jesus Christ. Some authors of antiquity occasionally call our Lord "the heavenly fish," ἰχϑὺς οὐράνιος. We can also find the image of a boat, a symbol of the Church, carried by a fish, which shows that the Church rests on Christ, its founder and the basis of its entire life. To represent Christ in the midst of Christians, many small fish surrounding one large one were portrayed, as Tertullian does when he says: "We are the small fish, taking our name from our ἰχϑύς."[7] This large fish is usually a dolphin. One must also remember the dolphin's unique reputation for being the lover of man. The ancients considered the dolphin to be the protector of sailors, having the power to forecast a storm. Is not this quality of love for men above all the quality of Christ Himself? Tertullian adds to the text we just quoted: "We are born in water and can only be saved by being in water." Thus the symbolism of the fish leads back to that of water, *i.e.* to baptism. The fish was represented on the funeral slabs

[6]Tertullian, Clement of Alexandria, St. Augustine (430 A.D.), St. Jerome (420 A.D.), Origen, Melito of Sardis, Optatus of Mileve (around 370 A.D.), St. Zeno of Verona (around 375 A.D.), St. Peter Chrysologus (450 A.D.), St. Prosper of Aquitaine (463 A.D.) and many others used the symbolism of the fish.

[7]Sisto Scaglia, *Manuel d'archéologie chrétienne* (Turin, 1916), p. 248.

either next to loaves of bread or else eating bread, which signifies that the deceased had taken communion and was therefore a Christian.

The eucharistic significance of this symbol is particularly emphasized in the representations and writings which use the image of the fish. Two funeral inscriptions found at the two different ends of the Christian world, in Phrygia and in Gaul, both dating back to the second century, are particularly characteristic. The first is of St. Abercius, bishop of Hieropolis and venerated by the Church as being "equal to the Apostles." This inscription reproduces a text written by the saint himself. Being a frequent traveler, he lived in Rome and traveled throughout the East. He himself says that he has traveled "to Syria, through all the towns, even through Nisibis, throughout the countryside, and beyond the Euphrates." "The faith led me everywhere," he writes. "Everywhere it fed me fresh, pure fish, caught by a holy virgin; it constantly fed this fish to friends; it has a delicious wine which it serves, mixed in water, with bread." This fish, caught by the virgin, is Christ. The bread and the wine mixed with water is our eucharistic practice.

The other funeral inscription, found in France, is that of Pectorius of Autun. This is an acrostic poem in Greek in which the initial letters form the words: ΙΧΘΥΣ ΕΛΠΙΣ, that is, "Jesus Christ, Son of God, Savior, Hope." In "the eternal waves of wisdom given by the treasures," in "the divine waters" which renew the soul, the "divine race of heavenly fish (ἰχθὺς οὐράνιος) receives ... immortal life." Then the poem invites the reader to take soft nourishment such as the honey of the Savior of the saints and to eat the ἰχθὺς "which you hold in the palm of your hand."[8]

Thus St. Abercius saw everywhere, from Rome to the Euphrates, not only the same doctrine and the same sacrament, but also the same image, the same symbol in which rite and doctrine converge, that of the fish. The inscription of Pectorius speaks of the same reality at the other end of the

[8]The custom of the first Christians was for the faithful to receive the consecrated bread in the palm of the right hand which was crossed over the left. This is how the Orthodox clergy receives Communion even today.

Christian world, in Gaul. Thus, these two documents show us that the symbol of the fish was widespread and characteristic of the entire Church.

It is very mysterius that in the Gospel, each time that Christ feeds a multitude, He does so with bread and fish; this is the case in both of His miracles of the multiplication of bread and in His appearances after His resurrection. Furthermore, each time that we have an image of the eucharist as a banquet, as a consecration scene or through some symbol, a fish is also represented. And yet the fish was never used as an element of the eucharist. But it does specify the significance of the bread and the wine. A living fish, frequently surging upward, drawing the bread and wine towards the heavens, and therefore also those who consume them, is obviously, for a spectator of that time, the "heavenly fish" which links the earth and the heavens. Its presence next to the bread and the wine signifies, therefore, that this is not ordinary nourishment. Since the spectator who contemplated it already knew the christological significance of the letters IXΘΥΣ, he could not be mistaken: This bread and this wine was truly the body and blood of the Son of God, the Savior.

On the funeral inscriptions, as we have already noted, communion is often represented by loaves of bread marked with a cross and a fish or else by a fish eating bread. On the walls of the catacombs, the eucharistic images are obvious. Thus a fresco from the second century in the catacomb of Calixtus (chapel A 2) portrays a tripod on which lies a fish and some bread; on one side of the table there are three baskets filled with bread; on the other side there are four baskets. The seven baskets of bread denote the miracle of Christ which foreshadowed the eucharist. The tripod therefore represents an altar, and the fish on the altar designates the sacrifice of Christ in the eucharistic sacrament. The bread in this case is not a simple bread but is truly the "bread of life," according to the words of Christ Himself (John 6:48).

Let us take two series of images from another chapel of the second century (A 3), also from this catacomb, a series which forms a group: A fisherman draws a fish out of the

water, a symbol of conversion, which is followed by baptism. To emphasize that the baptism is the beginning of a new life, the baptized is almost always represented as a child, even if he is an adult.[9] After the image of baptism, one sees the healing of the paralytic (Fig. 10), *i.e.* the remission of sins (Mark 2:5-12). To show that the remission of sins is linked with physical healing, the paralytic is represented carrying his bed. What is shown here is therefore the result of conversion and baptism. On another wall in the same chapel is another series of images with a eucharistic significance, forming a single whole. It portrays a tripod, the image of an altar, with a fish and a loaf of bread. A priest, dressed in a pallium, still in the style of the ancient philosophers, with the right shoulder uncovered, is consecrating the gifts (Fig. 11). On the other side of the table is a woman standing in the *Orans* position; contemporary scholarship understands her to be the figure of the Church. Next to this image is another image, that of a banquet: Seven persons are seated at a table on which lie two platters of fish and some bread. This is a symbolic representation of communion. On the other side, parallel to the consecration scene, is a prefiguration of the eucharistic sacrament from the Old Testament, the sacrifice of Abraham, indicating the meaning of the bloodless sacrifice in the New Testament. Thus, this series represents the prefiguration of the Old Testament, its fulfillment in the New Testament sacrifice and the fruit of this sacrament: the communion of the faithful. Together these frescos demonstrate to us the teaching, or rather, the initiation methods of the first Christians, showing through images the steps leading to salvation, starting with conversion and ending with communion, with heavenly life, with the supreme goods of which St. Jerome speaks: "No one is richer than he who carries the Body of Christ in a wicker-basket and His Blood in a glass vase" *(Nihil illo ditius qui corpus Domini in canistro vimine et sanguinem portat in vitro).*[10]

[9]This almost always happens in the catacombs, to the point that, on the tombs of adults, the ages of four years or three months are indicated, obviously counted not from birth, but from baptism.

[10]Epistle 125, to Bishop Exuperius; quoted from S. Scaglia, *op. cit.*, p. 239.

A living fish, carrying on its back a basket of bread and a glass of red wine (Fig. 12), the eucharistic elements, symbolizes this man participating in the celestial goods.

Another very widespread symbol of Christ in the catacombs is that of the lamb, which appears in the first century. We will have to return to this image when we discuss its suppression in the seventh century. It must only be mentioned that the lamb, like the fish, though primarily a symbol of Christ, could also represent the Christian in general, and in particular the apostles. As an image of Christ, it was often represented alone, with no accessory, or else with a shepherd's crook or a halo. The lamb was often represented on a mountain, at the peak of which flow four streams where two lambs are drinking. The mountain stands for the Church; the lamb at the peak of the mountain is the Head of the Church, Christ; the streams are the four rivers of paradise or the four evangelists who overwhelmed the four parts of the world with their teaching. The lambs drinking in the streams represent the Christians who are drinking the water of life of the evangelical teaching. They are two in order to indicate the Church of the Jews and the Church of the Gentiles. The lamb was the main symbol of Christ and replaced, for a long time, the direct representation of our Lord even in historical scenes, such as transfiguration or baptism. The image of the lamb is also used to represent St. John the Baptist.

Let us take another example which is particularly characteristic and will also help us understand the later development of sacred art. This is the oldest known representation of the Virgin and Child, on a fresco in the catacomb of Priscilla in Rome which dates back to the second century (Fig. 8). It is a painting of a characteristically Hellenistic style, and external signs must be used to show that this woman with a child is indeed the Virgin. These external signs are a biblical prophet at Her side and a star above Her Head. The composition follows the same principle as the indirect images of the eucharist which we have already studied. To show that the scene, whether a banquet, a consecration or simply bread and wine, is the central sacrament

of Christianity, an external sign, a eucharistic symbol—the fish—is added. Similarly, to show that the woman represented with a child in her arms was not just any woman, but the Mother of God, the external signs—the prophet and the star— were necessary. Here, the prophet is holding a scroll or a little book containing the prophecy in his left hand and is pointing to the star above the Virgin with his right hand. Some believe that this is Isaiah saying: "The Lord will be your everlasting light" (60:19). The star is the symbol of the heavens and the celestial light. Others believe that this is the prophet Balaam who proclaimed: "A star shall come forth out of Jacob, and a scepter shall rise out of Israel" (Num. 24:17). The prophecy of Balaam is clearly more direct and comes closer to the meaning of our image. The Virgin wears a veil on Her head, a sign of a married woman. Her civil state was, indeed, one of a married woman, and this veil is a very important characteristic of historical realism which has remained a part of Orthodox iconographic tradition. The picture is both a symbolic and a historical image. This union of historical truth and symbolism forms the basis of Christian sacred art. In this time, the artistic language of the Church, like its dogmatic language, did not as of yet have the accuracy, clarity and precision of the following centuries, which now permit us to recognize the Mother of God without a prophet pointing her out. The artistic language was in the process of being formed, and the frescos in the catacombs illustrate well the first steps of this genesis.

It would be a serious mistake to study the art of the first Christians from our present point of view, since we no longer understand the significance of the primitive Christian symbols. In the first centuries of Christianity, such symbols as the fish and the lamb (and others which we have not discussed) were certainly necessary and pregnant with meaning. One must remember that the people received, through Christianity, a revelation which by far surpassed any human expression. Nothing men could say or represent was sufficient to express it. Yet it was absolutely necessary to express it in order to obey the commandment of Christ: "Go

into all the world and preach the Gospel to the whole creation" (Mark 16:15). Thus, it becomes the task of the Church to find words and images to express that which is, in essence, inexpressible. Furthermore, the Church had to communicate the truth to some while hiding it from others, to reveal it to friends and conceal it from enemies. If we understand these difficulties, we will no longer be tempted to understand the symbolism of the early Christianity as a game—a game of words more or less abstract and futile. We will discover a coherent and profound system of expression, penetrated in its entirety and in every detail by a unique message of mystery and salvation. And this language fulfilled its task well, for it taught Christianity to thousands, educating and guiding them in the faith. It is precisely with the help of this now incomprehensible language that the saints of that time received their religious instruction, at each stage, from conversion to the crowning of their witness through martyrdom.

As we see, in the first centuries of Christianity, the subjects which were represented were primarily either pure symbols, such as the fish or the vine, or historical images which also served as symbols, for example, the resurrection of Lazarus, an image of the general resurrection to come. As forms of expression all symbols of this kind, once found and adopted by the entire Church, were no longer modified and were used in the whole Christian world. They became part of a common symbolic language, accessible and understandable to every Christian, irrespective of his nationality and his culture.

We have used only a few examples from all the monuments of primitive Christian art. These examples show us a very developed system of teaching and religious initiation. The art of the first Christians is a doctrinal and liturgical art. The assertion that sacred art was born outside the Church or that it had no importance until the third century certainly cannot be taken seriously.[11] Quite the contrary is true. This art followed very clear ecclesiastical guidelines and reflects

[11]See Ochsé, *La nouvelle querelle des images* (Paris, 1952), p. 41.

tight control over the artists' work. Nothing was left to chance or to the whim of the artist. Everything is concentrated on the expression of the Church's teaching. From its first steps, the Church begins to develop an artistic language which expresses the same truth as the sacred word. We shall see later that this language, just like the theological expression of the Christian teaching, will become more and more specific throughout the historical events of its existence, and will become a most perfect and exact instrument of teaching.

Thus, in the art of the catacombs, not only the very principle of sacred art clearly appears, but also some of its external characteristics. As has already been mentioned, unprejudiced scholarship, based on actual facts, asserts that a new style, characteristic of Christianity, appeared already in the catacombs of the first centuries, a style which had the essential traits henceforth characteristic of the art of the Church. This art, we repeat, primarily expresses the teaching of the Church and corresponds to the sacred texts. Its aim, therefore, is not to reflect everyday life, but to throw the new light of the Gospel upon it. No traces can be found in the catacombs of images which have a documentary, anecdotal or psychological character. It would be impossible, through this art, to provide a description of the everyday life of the early Christians. Thus, no trace of the frequent persecutions and the numerous martyrs of this time can be found in the liturgical art of the catacombs. The Christian artists who lived in the times of Nero or Diocletian undoubtedly saw the atrocious scenes of the amphitheaters, and these episodes were a matter of glory and consolation for all the brothers of the Church. One would expect to see recollections of these days when the struggle of the Christians against the pagan gods reached its paroxysm. But not one scene of martyrdom can be found in the catacombs. This same holds true in the writings of the great saints of this time. St. Paul, for example, teaches, denounces fallacies and vices, *etc.*, but he mentions only in passing, without any allusion to his spiritual state and without any description, the tortures which he endured (2 Cor. 11:23-27). It is there-

fore not surprising that we also find no evidence of these in art. It is only much later, when the persecutions had ceased and the anguish of the Christians had become history, that they were sometimes represented.

At the same time, this art was not cut off from life. It not only speaks the artistic language of its time, but it is intimately connected with it. This connection does not consist in episodic images like those in secular painting, but in the answer which it brings to the everyday problems of a Christian. The essential part of this answer is the state of prayer which this art communicates to the spectator. Seen face on or from the side, these persons are most often in the *Orans* position, *i.e.* in the ancient position of prayer. This position of uplifted hands is not a uniquely Christian pose; it was known in the world of antiquity and in the Old Testament, where the psalms evoke it many times. Particularly widespread in the first centuries of Christianity, it gained a symbolic value. Thus many figures, holding this position and personifying either prayer or the Church in prayer, can be seen in the Roman catacombs. This state of prayer becomes the *leit-motiv* of a wide variety of often dramatic situations, such as the sacrifice of Abraham or Daniel in the lions' den (Fig. 13). The drama of the represented situation is not so much the very moment of sacrifice as the internal, spiritual state of the persons, *i.e.* the state of prayer. The Christian, who always had to be prepared for confession through suffering, was therefore provided with an internal attitude which he had to preserve at all times. That which could calm, strengthen and teach was portrayed, and not that which could possibly repel or frighten. What these images also conveyed was the teaching of salvation. Sacrificed Isaac was saved, as were Noah and Daniel, and this portrayed our salvation. Besides prayer, toil was represented in order to demonstrate its purifying character and to remind Christians that all human toil should be to the glory of God. It was not some episode of human activity that was represented, but rather activity as such: trades, for example. Thus we see a woman selling herbs at her stall, a ferryman loading or unloading a cargo

of amphora, dockhands unloading a ship, a baker, a wine-grower, a coachman, or coopers at work.

The other characteristic trait of Christian art which can be seen already in the first centuries is that the image is reduced to a minimum of details and to a maximum of expression. This laconism, this sobriety in methods also corresponds to the laconic and sober character of Scripture. The Gospel dedicates only several lines to those events which decide the history of humanity. Similarly, the sacred image portrays only the essential. Details are tolerated only when they have some significance. All of these traits directly lead us to the classical style of the Orthodox icon. From this time on, the painter had to give a great simplicity to his works in which the profound meaning was understandable only to the eye initiated by the spirit. The artist had to purify his art of all individual elements; he remained anonymous (the works were never signed), and his first concern was to pass on tradition. Simultaneously, he had to renounce aesthetic joy for its own sake and use all the signs of the visible world in order to suggest spiritual reality. Indeed, to represent the invisible to the eyes of the flesh, a confused haze is unnecessary. On the contrary, one must be very clear and very precise, just as the Fathers, when they speak of the spiritual world, use particularly clear and vigorous expressions.

The Christian painter gradually renounces naturalistic representation of space, very noticeable in the Roman art of this time. With depth, the shadows disappear. Instead of representing a scene which the spectator can only look at, but cannot participate in, this art represents figures mutually bound to the general meaning of the image, and, above all, to the faithful who contemplate them. They are almost always represented face on, as we have said. They address the spectator and communicate their inner state to him, a state of prayer. What is important is not so much the action which is represented, but this communion with the spectator.

The beauty of this art of the first centuries of Christianity consists above all in the possibilities which it contains. It

does not yet realize the fullness of its meaning, but it promises an infinite development.

The general character of the art of the catacombs allows us to conclude that the icons themselves originated from the same principle and that, through them, the Church not only represented some historical event or some person, but that it also conveyed, with a symbolic language, the spiritual reality manifested by this event or this person. The decoration of the catacombs, in fact, did not consist only in frescos. There were also so-called icons, that is, representations of saints painted on boards, and it would be difficult to believe that these icons would have been painted following a different principle than the one used for the frescos. The existence of icons in the catacombs is not simply a supposition. In 1913, when a new section of the catacombs of St. Calixtus was opened, the great Russian Byzantinist, N. P. Kondakov examined in it a sarcophagus of the end of the second or beginning of the third century. Here is what he writes: "We have personally had the chance to see an example of the use of portraits by Christians in the end of the second or in the beginning of the third centuries. Above a stone sarcophagus, which was found empty because the relics had been removed centuries ago, there was found on the wall an elongated linen cloth, covered with *levkas* [a white coating used for painting], from which a portrait of a martyr who had lain here was removed."[12] And so, Kondakov, who until that time had taught that icons of saints appeared only in the fourth or fifth centuries, was forced to admit that icons already existed in the second and third centuries.

This analysis of the art of the Roman catacombs should not lead us to forget that we are concerned here with only one branch of primitive Christian art: the Greek and Roman art, which has been better preserved. The characteristic trait of the Graeco-Roman art of this epoch is its naturalism, that is, its tendency to duplicate nature or visible objects exactly. The examples we have used demonstrate to what extent Christian art was breaking away from the principle of

[12]N. P. Kondakov, *The Russian Icon* (Prague, 1931), p. 14.

Graeco-Roman art. The technique used in Graeco-Roman art was very developed and very perfected, and Christian art inherited this perfection. This is why the Christian art of the first and second centuries is characterized by the same lightness and spontaneity which distinguishes the art of antiquity. But from the second century on, the technique already begins to change, to elaborate on the methods which bring this art closer to iconographic art.[13]

Besides this branch of Graeco-Roman art, there were others. Thus, the frescos in the Christian Church of Dura Europus from the third century have a clearly Oriental character; the essential traits of these frescos are described by A. Grabar in his study of a pagan temple in this same town: "Contracted space, flat figures with stressed outlines, isocephalous bodies, without volume or weight; the figures moving forward turning their heads towards the spectators; in short, an art of expression which does not pretend to imitate optical vision or give the illusion of material reality."[14] These traits of Oriental art were frequently used by Christianity. Several other monuments and certain indicators lead us to the conclusion that sacred art was no less developed in the Eastern part of the Empire than in the Western. In any case, when Constantinople was founded in 330, Christian art in Rome and in the East already had a long history.

[13]See N. D. Kondakov, *Ikonografia Bogomateri* (St. Petersburg, 1914), p. 20.

[14]A. Grabar, *La peinture byzantine* (Geneva, 1953), p. 38.

V
Sacred Art in the Constantinian Era

IN THE FOURTH century, with the advent of the Constantinian era, a new period begins for the Church. The Church leaves its forced confinement and opens its doors wide to the world of antiquity. The influx of new converts requires larger places of worship and a new kind of teaching, one that is more direct and more explicit. The symbols used in the first centuries, intended for a small number of initiated people, were incomprehensible to the new converts. This is the obvious reason why large historical cycles of monumental paintings, portraying the events of the Old and New Testaments, appeared in the churches in the fourth and fifth centuries. For example, from the reign of St. Constantine the basilica of the Lateran was decorated with a cycle of frescos beginning with the fall of Adam and ending with the entrance of the good thief into paradise.[1] It is in this period that the dates of most of the major feasts were set, along with the iconographic schemes for them, which still are followed in the Orthodox Church today.

It is known that St. Constantine built churches in Palestine on the very spots where the biblical events took place: a rotunda of the resurrection which enclosed the Holy Sepulcher, a basilica on the place where St. Helena discovered the "True Cross," another on the Mount of Olives where the ascension took place, yet another on Mount Zion where the descent of the Holy Spirit occurred, another in Bethlehem above the cave of the nativity, another in Nazareth at the place of the annunciation, another on the shore of the Jordan where Christ was baptized. All of these buildings were dec-

[1] L. Leclercq, *Manuel d'archéologie chrétienne*, vol. 2, p. 222.

orated with mosaics. Some date back to the time of St.
Constantine, others were assembled in the following centuries.
In any case, the series was complete in the sixth century,
as it can be found on the famous phials of Monza. These
silver phials, decorated with scenes from the Gospel, were
offered to Theodelinda, queen of the Lombards, around the
year 600. They are preserved in the cathedral of Monza not
far from Milan and are, for us, a very precious document.
Scholars today agree in recognizing that the engraved biblical
scenes reproduce the mosaics of Palestinian churches. Dating
back to the time between the fourth and sixth centuries,
these phials are, for us Orthodox, of considerable importance.
In representing many feasts, they confirm the antiquity of our
iconography of these feasts. Indeed, some of them portray
a fully elaborated iconography, the very same which we use
today in our icons. One of these phials, for example, displays
together seven representations: of the annunciation, the
visitation, the nativity of Christ, His baptism, the crucifix-
ion, the myrrh-bearing women at the grave, and the ascension
(Fig. 14).

However, the change which occurs in the fourth century
was not only external; this triumphant epoch was also one of
great temptations and ordeals. The world which entered the
Church brought with it all its restlessness and all its doubts,
which the Church had to appease and dissipate. This new
contact between the Church and the world is characterized
by both a flare of heresies and a new vigor in Christian life.
If, until this time, it had been the martyrs who were the
pillars of the Church, now it was above all the theologians
and the ascetic saints. This is a time of great personalities,
like St. Basil the Great, St. Gregory the Theologian, St. John
Chrysostom, St. Gregory of Nyssa, St. Anthony the Great,
St. Macarius of Egypt, St. Mark, St. Isaiah and others. The
empire become a Christian empire, the world slowly becomes
sacralized. But it is precisely this world on the way to
sacralization, the Christian empire, which was to go to the
desert. The people were attracted to the desert not because
it was easier to live there, not because they wanted to flee
from the difficulties of the world, but, on the contrary, be-

cause they wanted to escape the well-being of the world, the glamor of a society which only pretended to be Christian. Around the end of the fourth century, all of Egypt is scattered with monasteries where the monks can be counted by the thousands. Pilgrims flock from everywhere, both from Asia and from the West.[2] The experience of the ascetic Fathers and their writings spread throughout the Christian world. The theory and the *praxis* of theology, *i.e.* the teaching of the Church and the living experience of the ascetics, become the source which also nourishes sacred art, which guides and inspires it. The task of sacred art consists in conveying, on the one hand, the dogmatically formulated truths, and, on the other hand, the living experience of these truths, the spiritual experience of the saints, living Christianity, in which dogma and life are one. All of this must no longer be taught to a limited group but to masses of believers. This is why the Fathers of this time recognized so well the pedagogic role of art. In the fourth century, many outstanding Christian authors[3] attribute a very large role to images. Thus, St. Basil considers that painting possesses a greater power of conviction than his own words. After having uttered an entire oration in memory of the martyr St. Barlaam, he finishes by saying that he does not want to humiliate the great martyr by his words, but that he yields his place to a higher language, to the "resounding trumpets of the masters." "Rise now before me," he says, "you, painters of the saints' merits. Complete with your art this incomplete image of a great leader (*i.e.* the martyr Barlaam). Illuminate with the flowers of your wisdom the indistinct image which I have drawn of the crowned martyr. Let my words be surpassed by your painting of the heroic deeds of the martyr. I will be glad to acknowledge such a victory over myself ... I will look at this fighter represented in a more living way on your paintings. Let the demons cry, defeated once again by the

[2]G. Florovsky, *Vostochnye otssy IV i V vekov* (Paris, 1931).

[3]St. Basil the Great, St. Gregory the Theologian (Second Oration on the Son), St. John Chrysostom (Third Oration on the Epistle to the Colossians), St. Gregory of Nyssa (Oration on the Divinity of the Son and the Holy Spirit; Oration on the Martyr St. Theodore), Saint Cyril of Alexandria (Oration to Emperor Theodosius) and others.

courage of the martyr. Let them be shown once again the burned and victorious hand (of Barlaam during his martyrdom). And let the Initiator of combats, Christ, also be represented in this painting."[4]

In his oration on the feast of St. Theodore, St. Gregory of Nyssa explains that "the painter ... having represented the great deeds of the martyr on this icon ... and the image of the Initiator of combat, Christ, through the colors of art has clearly recounted, like in a book, the struggles of the martyr ... For the silent painting speaks on the walls and does much good."[5]

Among the western authors, St. Paulinus, bishop of Nola (353?-431?) wrote particularly detailed accounts of images. He built many churches and decorated them with sacred images which he describes at length in his letters and poems. A very experienced pastor, St. Paulinus saw that images attracted the attention of Christians and, particularly, of neophytes and catechumens much more than did books. This is why he strove to have many images in his churches.[6]

In the firth century, we have a similar characteristic indicated in the works of one of the greatest ascetic writers of antiquity, St. Nilus of Sinai, disciple of St. John Chrysostom (d. 430 or 450). A prefect, Olympiodorus, after having built a church, wanted to represent on the walls of the large nave solid ground with hunting scenes and many animals on one side and the sea with fishing scenes on the other side, reflecting, as he says, a purely esthetic concern. Olympiodorus asked St. Nilus for his advice. And St. Nilus writes: "My answer to your letter is that it is infantile and dangerous to seduce the eye of the faithful with such things ... Let the hand of the best painter cover both sides of the church with images from the Old and New Testaments, so that those who do not know the alphabet and cannot read the Holy Scriptures, will remember, while looking at the painted representations, the courageous deeds of those who served God without malice.

[4]*Or.* 17, PG 31: 489 AC.
[5]PG 46: 737.
[6]Epistle 32 to Severus, PL 61: 339.

Thus, they will be encouraged to emulate the ever-memorable virtues of these servants of God who preferred the heavens to the earth and the invisible to the visible."[7]

As we see, the Fathers attribute a great importance to the image. But it is not its artistic or esthetic value which they praise; it is, as we see, its teaching value. We have already mentioned the obvious dogmatic and liturgical character of some of the images in the catacombs, such as the series of images which decorate the chapels (Catacomb of St. Calixtus), and that these constitute a true confession of the Christian faith. This dogmatic character is an essential trait of Orthodox sacred art at all times. Beginning with the fourth century, however, we also have examples of the Church using the image to fight heresy. In its struggle for the purity of its life and its teaching, the Church, at the Council of Laodicea (around 343), confirmed Apostolic Canon 85, which deals with the sacred books, and put an end to improvization in worship (canons 59 and 60), through which errors had penetrated the liturgy. It is understandable that the Church also became more exacting in the field of art. To errors and heresies, it responded not only with the teaching of the Fathers, not only by the experience of the saints, but also with the liturgy and with images. In the image, it is sometimes the details, sometimes whole cycles of wall paintings or mosaics which define the sound doctrine of the Church in opposition to heresies. It is particularly in response to the teaching of Arius, who saw Christ not as God but as a creature, a teaching which was condemned by the First Ecumenical Council (325), that the letters alpha and omega (A, Ω) are placed at the two sides of the image of Christ, an allusion to the words of the Apocalypse: "I am alpha and omega, the First and the Last, the Beginning and the End" (22:13).[8] In 431, at the Council of Ephesus, the doctrine of Nestorius was condemned, a doctrine which rejected the hypostatic union of the divine and human natures in Christ and which, therefore, denied the divine motherhood of the Virgin, calling her not the Mother of God, but the Mother

[7]PG 79: 577.
[8]L. Bréhier, *L'Art chretien*, p. 67.

of the man Jesus or of Christ. The council condemned
Nestorius and proclaimed the divine motherhood of the
Virgin, solemnly attributing to Her the name of Mother of
God (Θεοτόκος). From then on, particularly solemn rep-
resentations of the Virgin sitting on a throne with the divine
Child on her lap and with angels at her side appeared every-
where. At Santa Maria Maggiore in Rome, a whole cycle of
images is consecrated to the fight against Nestorianism.
The divinity of the Child is particularly emphasized, as is the
importance of the Mother of God. Similarly, the decorations
of the sixth and seventh centuries in St. Sophia and in the
Church of the Holy Apostles in Constantinople reflected the
struggle against Nestorianism and Monophysitism.[9]

The task of developing the most appropriate forms of
sacred art, its most precise language, fell on the Church of
Constantinople. The new capital never knew the worship
of idols. Furthermore, its geographical position was partic-
ularly favorable, for, situated at the junction of Europe and
Asia, it formed a bridge between them and received a rich
heritage from both. In the realm of art, it adopted an already
existing iconography of both the Old and the New Testa-
ments, a perfected technique of fresco, of the mosaic and of
the encaustic, a rich ornamentation, refined colors and a
developed system of monumental decoration.

To develop its language, the Church used, as we have
seen, forms, symbols and even myths of antiquity, *i.e.* pagan
forms of expression. But it did not use these forms without
purifying them and adapting them to its own goals. Chris-
tianity absorbs everything that can serve as a form of expres-
sion from the world around it. Thus the Fathers of the
Church used all the apparatus of ancient philosophy for
the benefit of theology. Similarly Christian art inherits the
best traditions of antiquity. It absorbs elements of Greek,
Egyptian, Syrian, Roman and other arts, sacralizing this com-
plex heritage, guiding it in expressing the fullness of its own
meaning and transforming it in accordance with the require-
ments of Christian teaching.[10] Christianity selects in the pagan

[9]V. N. Lazarev, *op. cit.*, p. 51.

[10]The origins of Christian art are complex and no single factor can

culture all that is its own, all that was "Christian before Christ," all the truth which was expressed in it, and integrates this into the fullness of revelation.

It must be remembered that the very word Church ('Εκκλησία) implies, according to the Fathers, "calling together" and reuniting all men in communion with God. Thus the men who are called from the world into the Church bring with them their culture, their characteristic national traits and their creative abilities. The Church then chooses from this contribution all that is the purest, the truest and the most expressive and creates its sacred language. The first Christians had a eucharistic prayer which was very characteristic of this process: "As this bread, which at one time was dispersed in many ears on the hills, has now become one, let Thy Church similarly be gathered from all the corners of the world into Thy Kingdom." This process of integration by the Church of those elements of the pagan world which are able to be Christianized is not a penetration of pagan customs into Christianity, but their sacralization. In the realm of art this is not a paganization of Christian art and, therefore, of Christianity itself, as is often thought, but on the contrary, it is the Christianization of pagan art. The reverse occurred in the art of the Renaissance. When it is said that Raphael painted his madonnas in the style of the catacombs, one forgets that in the first centuries of Christianity, it is Hellenism which entered the Church, whereas in the Renaissance epoch, it is Christianity that returns to an artificially resurrected Hellenism.

There were two essential artistic trends which were preponderant at the time of the formation of Christian sacred art: Hellenistic art and the art of Jerusalem and of the Syrian

provide an exhaustive explanation. For example, the icon is sometimes connected with the Egyptian funeral portrait because of the obvious resemblance between the two. Like the icon, the portrait presents the characteristic fixity of the face, but does not go beyond the life on earth. It aims at a kind of preservation which is reminiscent of Egyptian mummification. It tries to represent man as he was, as if he were still alive, and to preserve this image of life on earth for eternity. In an icon, on the contrary, the face is transfigured and this very transfiguration reveals another world to us, a fullness incomparable to the fallen life. The Egyptian funeral portrait strives to prolong terrestrial life indefinitely, while the icon strives to deify it.

regions. The use of these two very contrasting trends illus-
trates well the selection process through which the Church
elaborated the most adequate forms of its art. The Hellenistic
trend was that of the Greek towns, particularly of Alexandria.
It inherited the beauty of antiquity with its harmony, modera-
tion, grace, rhythm and elegance. On the other hand, the
art of Jerusalem and Syria represented historical realism,
sometimes even a bit naturalistic and brutal. The Church
adopted from each of these art forms that which was the
most perfect, the most authentic. It discards the sometimes
coarse naturalism of Syrian art, but retains its truthful icono-
graphy, faithfully preserved in the very places where the
biblical stories took place. From Hellenistic art, on the other
hand, it rejects the somehow idealistic aspects of iconography,
but retains the harmonious beauty, the rhythmic feeling and
certain other artistic elements, such as, for example, the
reversed perspective. It rejects the Hellenistic iconography
which portrays Christ as a young god like Apollo, beardless
and elegant but lacking in majesty and historical truth. It
adopts the Palestinian iconography of a man with a dark
beard, long hair, with realistic traits and great majesty. The
same holds true for the Virgin. Hellenistic art gave the
Virgin a tunic, a head-dress, sometimes even earrings like
those worn by the grand ladies of Alexandria and Rome. The
art of Jerusalem enveloped her in the long veil of the Syrian
women, a cloak which hid her hair and fell to her knees,
just as we continue to represent her on our icons. The Church
also uses the rhythmic and frequently symmetrical embellish-
ments coming from the East, and other elements of different
cultures which converged in Constantinople. With this large
variety of elements, the Church of Constantinople created an
art form which, from the time of Justinian in the sixth century,
was a well-developed artistic language.

The Church's acceptance of a variety of cultural elements
and their integration in the fullness of the revelation does
not respond to a need of the Church but to a need of the
world. The final meaning of the world's existence is to
become God's Kingdom. And, conversely, the purpose of the
Church is to make the world participate in the fullness of

the revelation. This is why the process of selecting and assembling, which began in the first centuries of Christianity, corresponds to the normal saving task entrusted to the Church. This process is not limited to a specific historical period. It is a general trait of the role of the Church in the world's history. The Church always continues and will continue, until the consummation of the ages, to collect all authentic realities outside of itself, even those which are incomplete and imperfect, in order to integrate them into the fullness of the revelation and to allow them to participate in the divine life.

This does not mean that the Church suppresses the specific character of the cultural elements which it adopts. It excludes nothing which is a part of the nature created by God, not one human trait, not one indication of time and place, not one national or personal characteristic. It sanctifies all the diversity of the universe, revealing to it its true meaning, orienting it towards its true end: the building up of the Kingdom of God. Cultural diversity does not violate the unity of the Church, but offers it new forms of expression. Thus the catholicity of the Church is confirmed both in cultural wholeness and in the individual details. In the realm of art, just as in other areas, catholicity does not mean uniformity, but rather the expression of the one truth in a variety of forms, characteristic of every people, of every epoch, of every man.

So far, our goal has been to show the place of art in the Church of the first centuries and to emphasize that the image was not born by chance nor was it a later addition to liturgical life and dogmatic teaching.

The tradition reporting that the first icon of Christ was the Holy Face and that the first icons of the Virgin were made by St. Luke cannot be substantiated with scholarly proofs, but they reflect the very meaning of Christianity, which implies that the image is its organic and primordial expression. Without images, Christianity is no longer Christianity. This is why the existence of the sacred image, according to the teaching of the Church, dates back to the very

beginning of Christianity and is part of the revealed truth.
It is based on the person of the God-Man, Jesus Christ.

Why then, were there so many symbols in the first cen-
turies of Christianity? As we have seen, the Christians were
forced to hide the truths of their teaching from the hostile
world with the help of symbols. The biblical prohibition
against idolatry also played a part, since its true meaning was
sometimes difficult to understand. This can be seen in the
reasoning of Eusebius, for whom the image was nothing more
than a pagan way of venerating the memory of benefactors;
and Eusebius was certainly not the only one to think this way.
One must remember that Christ chose the Judaeo-Roman
world for His incarnation. In this world, the reality of the
incarnation of God and the mystery of the cross was a scandal
to some and madness to others. The image which reflected
these events, the icon, was therefore also "scandalous." But
the Christian teaching was addressed to that particular world.
The Church had to comply—as it always does—with human
weakness. It sometimes chose a language which the people
understood better than a direct image. It seems to us that
this is one of the main reasons for the abundance of symbols
in the first centuries of Christianity. It was, as St. Paul says,
the liquid nourishment of childhood. To give an example,
let us use the crucifixion. On a phial of Monza, we see an
image where the thieves are seen crucified, but Christ is
represented as a bust above the cross (Fig. 14). There are
also crucifixions where Christ is replaced by the symbolic
lamb. Crucifixion, which was practiced until the time of
Constantine, was the most degrading, infamous and shameful
way to die. Men could simply not accept a crucified God.
Thus, one can frequently read in scholarly works that cruci-
fixion was never directly represented until the sixth century.
This is not absolutely correct, since we do have images of
the crucifixion which date back to the time between the first
and third centuries, but it is true that they are rare and are
found on small personal objects, such as small medallions
of precious stones which the Christians wore (for example,
the carnelian from the second century found in Constanza,
Rumania, which represents the crucifixion together with the

inscription ἰχθύς).[11] Thus the iconographic quality in the image penetrated into the conscience of men and into their art very slowly and with great difficulty. Only time and the new requirement of history slowly made this sacred character of the image obvious, bringing an end to primitive symbols and purifying Christian art of those foreign elements which blurred its contents.

This art was a manifestation, an expression of Christian teaching, of a new life which was not subject to the law. According to the Christian apologist who wrote to Diognetus, Christians lived *in* the flesh but not *according to* the flesh. And St. Paul writes: "So then, brethren, we are debtors, not to the flesh, to live according to the flesh" (Rom. 8:12). But the world around the Church lived precisely *according to* the flesh, according to a principle directly opposed to Christian salvation. This idea of a triumphant flesh was expressed with great perfection in pagan art, this art of antiquity whose beauty has retained its enticing charm even today. Christian art, meanwhile, had to reflect the principles of the specifically Christian life, contrasting it with the style of paganism.

The official art of the Roman Empire was an art of the state, *i.e.* an art aiming at educating the citizens in a certain way. For the Christians, this was indeed a demonic function of art. The state was pagan and every official act was simultaneously a religious ritual and a confession of paganism. When the Roman Empire became Christian, the official art ceased to be idolatrous, but it remained programmatic and pedagogical, very different from ordinary secular art as we now understand it. Life as it is, or rather, as the artist sees it, was not represented. Even less could this art be called "a free art" or "art for art's sake." It was supposed to reflect civic ideas and educate the citizens in a very precise way. For example, in order to show that the imperial power was given by God, the emperor and empress were represented crowned by Christ. This official art was not only limited to certain well-defined subjects, but always used a very clear and concise manner, calculated to make its subject-matter as

[11]H. Leclercq, *op. cit.*, vol. 2, p. 368 ff. See also the carnelian of the third century.

accessible and as easy to understand as possible. Each subject
had its own intention, its "function," so to speak. Thus the
portrait of the emperor presented by a state official meant
that this official was acting in the name of and with the
power of the emperor; the image of the emperor trampling
down a barbarian signified the invincibility of the empire,
etc.

For the Church, in its own spiritual realm, it was neces-
sary to develop a sacred art which would educate the Chris-
tian people in the same way that the liturgy did, conveying
the dogmatic teaching and sanctifying them with the presence
of the grace of the Holy Spirit. In short, the Church needed
an art which would reflect the Kingdom of God on earth.
The Church needed an image which would bring the teach-
ing and the real presence of sanctifying grace to the world.
Such an image was slowly wrought by the Church of Con-
stantinople, which was, at this time, the main stage of the
struggle for Orthodoxy. In the sixth century, Christian art
had already established its essential traits. It is the beginning
of the art which will later be called "Byzantine art" or "the
Byzantine style." And this term will be arbitrarily extended
to apply to the art of all the Orthodox peoples.

VI

The Quinisext Council: Its Teaching
on the Image

WE WILL now study the teaching of the Church concerning
the contents of the sacred image. Just as the image itself,
the teaching of the Church concerning the image follows
from its teaching on salvation. Therefore, an Orthodox can-
not accept the idea that the iconographic doctrine of the
Church was formed under the influence of ancient philosophy,
and in particular of Neo-Platonism. In fact, the doctrine of
the image has always been rooted in the heart of the Christian
vision of the world. From its very origin, it existed with an
implicit fullness. Just as for other aspects of its teaching,
the Church gradually explained it in response to the demands
of history. In a similar way, the doctrine of the two natures
of Christ, the divine and the human, was lived by the first
Christians, even if it was not yet explicitly formulated, until
the need arose to refute heresies. The same is true for the
doctrine of the icon. It is at the Quinisext Council that the
Church formulates for the first time a principle of direction
which reflects the true character of sacred art. It does so
in response to a practical need.

The Quinisext Council opened on September 1, 692. It
is called "Quinisext" because it completes the two ecumenical
councils which preceded it, the fifth in the year 554 and the
sixth in the year 681, both held in Constantinople. Like the
Sixth Ecumenical Council, the Quinisext was held in a
"chamber" (in Trullo) of the imperial palace, whence the
name sometimes given to it: "Synod in Trullo." Both of
these ecumenical councils—the Fifth which condemned mono-
physitism and Origenism, and the Sixth which condemned

113

Monotheletism—were only concerned with dogmatic questions. A whole series of disciplinary issues needed to be solved, and it was with this in mind that the Quinisext Council convened. The Orthodox Church, therefore, considers it to be complementary to the two preceding councils, and it is even frequently referred to as the Sixth Ecumenical Council. The questions examined by the council concerned various aspects of ecclesiastical life. These included sacred art. "Some remains of the pagan and Jewish immaturity have become mixed with the wheat ripe with truth." These words from a letter written by the Fathers of the council to Emperor Justinian II directly concern our subject, as we shall see.

Three canons of the Quinisext Council are concerned with sacred art. Canon 78 mentions the image of the cross: "Given that the vivifying cross brought us salvation, we must strive in every possible way to show it the honor it deserves, since it saved us from the ancient fall. This is why, venerating it in thought, word and feeling, we order that all those images of the cross made by certain individuals on the ground be destroyed, so that this sign of our victory may not be trampled down by the feet of those who walk. We order that those who trace the representation of the cross on the ground be henceforth excluded from Communion."[1] This is a simple order which needs no explanations: It is wrong to trace the image of the holy cross on the ground since it risks being trampled on by the feet of passersby.

It is Canon 82 which is the most interesting to us. It is of critical importance because it shows us the contents of the sacred image as the Church understands it. This canon specifies how this image developed. Here is the text:

> In certain reproductions of venerable images (γραφαῖς), the Precursor is pictured pointing to the lamb with his finger. This representation was adopted as a symbol of grace. It was a hidden figure of that true lamb who is Christ our God, shown to us according to the Law. Having thus welcomed these ancient figures (τύπους) and shadows as symbols of the

[1]Rhalli and Potli, *Syntagma,* vol. 2 (1852), p. 474.

truth transmitted to the Church, we prefer (προτι-μῶμεν) today grace and truth themselves, as a fulfill-ment of the Law. Therefore, in order to expose to the sight of all, at least with the help of painting, that which is perfect, we decree that henceforth Christ our God be represented in His human form (ἀνθρώ-πινον χαρακτήρα) and not in the form of the an-cient lamb. We understand this to be the elevation of the humility of God the Word, and we are led to remembering His life in the flesh, His passion, His saving death and, thus, deliverance (ἀπολυτρώσε-ως) which took place for the world.[2]

The first sentence of the canon explains the situation existing at that time. It speaks of St. John the Baptist (the "Precursor") pointing out Christ, who is represented as a lamb. We know that the realistic image of Christ, His adequate portrait, existed from the beginning, and it is this portrait which is the true witness of His incarnation. In addition, there were also larger cycles representing subjects from the Old and New Testaments, particularly those of our major feasts, where Christ was represented in His human form. And yet symbolic representations *replacing* the human image of Christ also existed in the seventh century. This attachment to the biblical prefigurations, in particular to the image of the lamb, was particularly widespread in the West.[3] It was necessary, however, to guide the faithful to-wards the stand adopted by the Church, and this is what Canon 82 of the Quinisext Council does.

As we know, the lamb is an Old Testament symbol which played a very important role in the art of the first Christians. In the Old Testament, the paschal sacrifice of the lamb was the center of worship, just as the eucharistic sacrifice in the New Testament is the heart of the life of the Church, and Easter—the Feast of the Resurrection—is the center of the liturgical year. The immaculate lamb of Israel is above all

[2]*Ibid.,* p. 492.
[3]"We do not know of one representation of Byzantine origin where a lamb is pointed out by the Precursor." N. Pokrovsky, *op. cit.,* p. 29.

the prefiguration of Christ. In the first centuries, when the direct image of the Savior was frequently hidden out of necessity, the image of the lamb was very widespread. (One of the most ancient representations of the lamb appears in a fresco in the cemetery of Domitilla; it dates back to the first century.) Like the fish, it signified not only Christ but also the Christian who imitated and followed Him.

The image of which the Quinisext Council speaks—Christ in the form of a lamb pointed out by St. John the Baptist—was a very important dogmatic and liturgical image. It is based on a well-known passage of the Gospel according to St. John. The evangelist conveys the witness of St. John the Baptist to the imminent coming of the Savior. The high priests and Levites came to ask him if he was not Elijah or a prophet. But St. John the Baptist, who was precisely the last of the Old Testament prophets, replies that he is the Precursor of Him who comes directly after him. And, indeed, the very next day Christ appears before the people, asking St. John to baptize Him, and the Precursor points Him out saying: "Behold, the Lamb of God who takes away the sin of the world!" (John 1:29). The image which represents St. John the Baptist designating the Lamb in this manner literally translates these words and fixes them in our memory. Canon 82, in forbidding this symbol, is inspired by the very same passage of the Gospel according to St. John. It interprets this text, however, not in isolation or literally, but in the context which precedes it, emphasizing not the words of St. John the Baptist but *Him at whom John was pointing.* Indeed, the description of the appearance of Christ is preceded in the Gospel according to St. John by a prologue which prepares for the manifestation of the Lord: "And the Word became flesh and dwelt among us, full of grace and truth; we have beheld his glory, glory as of the only Son from the Father . . . And from His fullness have we all received grace upon grace. For the law was given through Moses; grace and truth came through Jesus Christ" (1:14, 16-17). Because it is the *truth* which came through Jesus Christ, it is not a matter of translating a word into images, but of showing the truth itself, the fulfillment of the words. Indeed, when

he was speaking of "the Lamb who takes away the sin of the world," it was not a lamb at which St. John the Baptist was pointing but rather Jesus Christ Himself, the Son of God who became Man and came to the world to fulfill the law and to offer Himself in sacrifice. It is He who was prefigured by the lamb of the Old Testament. It is this fulfillment, this reality, this truth which had to be shown to everyone. Thus the truth is revealed not only by the word, but it is also shown by the image. The text of the canon implies an absolute denial of all abstractions and of all metaphysical conceptions of religion. Truth has its own image. For it is not an idea or an abstract formula, it is concrete and living, it is a Person, the Person "crucified under Pontius Pilate." When Pilate asks Christ, "What is truth?" (John 18:38), Christ answers by remaining silent before him. Pilate leaves, without even awaiting an answer, knowing that a whole multitude of answers can be given to this question without one of them being valid. For it is the Church alone which possesses the answer to the question of Pilate. Christ says to His apostles: "I am the way, and the truth, and the life" (John 14:6). The correct question is not "What is truth?" but rather "Who is the truth?" Truth is a person, and it has an image. This is why the Church not only *speaks* of the truth, but also *shows* the truth: the image of Jesus Christ.

The Fathers of the council continue: "Having thus welcomed these ancient figures and shadows as symbols of the truth transmitted to the Church, we prefer today grace and truth themselves, as a fulfillment of the law." Thus the Quinisext Council speaks of symbolism as a stage already overcome in the life of the Church. It mentions "figures and shadows" in general. But undoubtedly it understands the lamb to be not just one symbol among others, but the main symbol, whose unveiling must naturally lead to the unveiling of all the other symbolic figures.

The council orders that the symbols of the Old Testament, used in the first centuries of Christianity, be replaced by direct representations of the truth they prefigured. It calls for the unveiling of their meaning. The image contained in

the symbols of the Old Testament becomes reality in the incarnation. Since the Word became flesh and lived among us, the image must directly show that which happened in time and became visible, representable and describable.

Thus the ancient symbols are suppressed because a direct image now exists and, in relation to this direct image, these symbols are belated manifestations of "Jewish immaturity." As long as the wheat was not ripe, their existence was justified, even indispensable, since they contributed to its maturation. But in "the wheat ripe with truth," their role was no longer constructive. They even became a negative force because they reduced the principal importance and role of the direct image. As soon as a direct image is replaced by a symbol, it loses the absolute importance it embodies.

After having prescribed the use of the direct image, Canon 82 formulates the dogmatic basis of this usage, and this is precisely where its essential value lies. For the first time, a council decision formulates the link between the icon and the dogma of the incarnation, the "life of Christ in the flesh." This christological basis of the icon will later be greatly developed by the defenders of icons during the iconoclastic period. We have already discussed this question in relation to the Holy Face and the Old Testament prohibition, and we shall return to it again later. But Canon 82 does not limit itself to suppressing symbols and formulating the dogmatic principle which is the basis of the direct image. It also indicates, though indirectly, what this image should be. This image portrays the face of the incarnate God, the historical person of Jesus Christ who lived in a determined time and place. But the direct image of our Lord could not be only an ordinary representation which would recall His life, His suffering and His death. The contents of a sacred image cannot be limited to this because the represented person is distinct from other men. He is not simply a man; He is the God-Man. An ordinary image can remind us of His life but cannot show us His glory, "the elevation of God the Word," according to the Fathers of the council. As a result, the representation simply of a historical event is not sufficient for an image to be an "icon." The image, using all the means

accessible to figurative art, must show that He who is repre-
sented is the "Lamb who takes away the sins of the world,
Christ our God." If the historical traits of Jesus, His portrait,
are a witness to His coming in the flesh, to the abasement and
the humiliation of the divinity, then the way in which this
"Son of man" is represented must also reflect the glory of
God. In other words, the humility of God the Word must
be represented in such a way that, when looking at the image,
we contemplate also His divine glory, the human image of
God the Word, and that, in this way, we come to under-
stand the saving nature of His death and the resulting deliv-
erance of the world.

The last part of Canon 82 further explains the symbolism
of sacred art: what matters is not the iconographic subject,
i.e. what is represented, but the means used for an adequate
representation. Thus the teaching of the Church not only
expresses what the subject of the image must be, but also
the way in which this subject is represented. When speaking
of the symbolism of the Church, we noted that this symbolism
led us to understand the divine revelation. In the realm of
figurative art, the Church develops an artistic language which
corresponds to its experience and its knowledge of this revela-
tion. It places us in personal contact with revelation. All of
the figurative possibilities of art converge towards the same
end: to convey faithfully a concrete, veracious image, a
historical reality, and, through this historical image, to reveal
another spiritual and eschatological truth.

The Quinisext Council marks the end of the dogmatic
struggle of the Church for the Orthodox confession of the
two natures of Christ, His humanity and His divinity. The
Fifth Ecumenical Council had condemned monophysitism.
The monophysites were divided into many heterogeneous sects,
but on the whole they shared the belief that the divine nature
of Christ, infinitely superior to human nature, absorbed, so
to speak, this human nature, or else that human nature was
only an instrument of the divine nature. The Sixth Ecumenical
Council condemned monotheletism, which was a more subtle
form of monophysitism. The monothelites no longer spoke
of the human nature of Christ as being completely absorbed

by His divinity; they had in mind only one property of this human nature: the will. According to their belief, the human will in Jesus Christ was completely replaced by the one divine will. The Fathers and the christological councils had found clear and precise dogmatic formulas to express, as much as it was possible to do in words, the teaching of the Church on the incarnation of God. But words were not enough: The truth still had to be defended for a long time against those who did not accept it, in spite of the extreme clarity of conciliar decrees and patristic formulas. It was not only necessary to *speak* the truth, it was also necessary to *show* it. In the realm of the image, it was also necessary to make a rigorous confession which would stand up against the obscure and confused doctrines which everyone could accept equivocally, but which were not true. It was not a matter of finding a compromise to satisfy everyone, but of clearly confessing the truth, so "that this fulfillment might be seen by all," according to the words of Canon 82.

But a symbol cannot refute a christological heresy. The reality of the incarnation cannot be proven by an image of a fish or a lamb. Several years later, St. Germanus, Patriarch of Constantinople, wrote to the iconoclastic bishop Thomas: "The representation of the image of the Lord in His human appearance on icons confutes the heretics who claim that He became man only illusively and not in reality."[4] This is why the Quinisext Council demands a direct image and rejects those signs which do not represent Jesus Christ in His concrete humanity.

Thus Canon 82 of the Quinisext Council expresses, for the first time, the teaching of the Church on the icon and simultaneously indicates the possibility of conveying a reflection of the divine glory through the means of art and with the help of some symbolism. It emphasizes all the importance of historical reality, acknowledging the realistic image, but only one which is represented in a special way, with the help of a symbolic language that reveals the spiritual reality which only the Orthodox teaching conveys. It considers that

[4]PG 98: 173 B.

the symbols, "the figures and shadows," do not express the fullness of grace, although they are worthy of respect and may correspond to the needs of a given epoch. The iconographic symbol is therefore not completely excluded. But its importance is seen as secondary. Our own contemporary iconography still retains several of these symbols: for example, the three stars on the robe of the Virgin, which denote her virginity before, during and after the nativity, or else a hand descending from the sky to designate the divine presence. But this iconographic symbolism is relegated to its secondary place and never replaces the direct image.

Canon 82 expresses, for the first time, what we call the iconographic canon, *i.e.* a set criterion for the liturgical quality of an image, just as the "canon of Scripture" establishes the liturgical quality of a text. The iconographic canon is a principle allowing us to judge whether an image is an icon or not. It establishes the conformity of the icon with Holy Scripture and defines what this conformity consists in: the authenticity of the transmission of the divine revelation in historical reality, by means of what we call symbolic realism, and in a way that truly reflects the Kingdom of God.

Let us now pass on to Canon 100 of the Quinisext Council. Its text reads as follows: "Let your eyes look directly forward; keep your heart with all vigilance! (Prov. 4:23, 25) Wisdom demands it, for the bodily sensations easily enter the soul. We therefore ordain that misleading paintings which corrupt the intelligence (νοῦν) by exciting shameful pleasures, whether these are paintings (πίνακες) or any other similar objects, not be represented in any way, and that anyone who undertakes to make such an object be excommunicated (ἀφοριζέσθω)."[5]

From the contents of this canon, one can conclude that it does not concern sacred art. In fact, it is difficult to believe that representations "exciting shameful pleasures" were used in churches. This canon can be understood as being an attempt of the Church to put an end to the diffusion, among the faithful, of the remains of paganism in the coarse form of lewd

[5]Rhalli and Potli, *Syntagma, ibid.,* p. 545.

images. Pagan feasts which the council prohibited in Canon 62 still existed at the time of the Quinisext Council, in particular the Brumalia, solemn ceremonies honoring Bacchus, dances honoring ancient gods, *etc.* These pagan feasts were naturally reflected in art, and the Church thought it necessary to defend its members from the corrupting influence of such representations. Canon 100 is particularly interesting in the way it is formulated, for it shows that the Church required that its members retain a certain asceticism not only in life, but also in art, which reflects and influences life.

The decisions of the Quinisext Council were signed by the emperor, and a place was left for the signature of the Pope of Rome; following were the signatures of the Patriarchs Paul of Constantinople, Peter of Alexandria, Anastasius of Jerusalem and George of Antioch. These were followed by the signatures of 213 bishops or their representatives. Among the signatures was that of Basil, archbishop of Gortyna (in Crete), who signed on behalf of the Church of Rome. There were also signatures of other bishops of the West. The authority of these representatives of Western Christianity is contested. Hefele writes: "It is true that the *Vita Sergii* in the *Liber Pontificalis* reports that the legates of Pope Sergius, having been deceived by the emperor, signed their names. But these legates of the pope were simply pontifical apocrisiaries living in Constantinople and not legates who had been sent expressly to take part in the council." [6] In any case, as soon as the council had ended, the acts were sent to Rome requesting Pope Sergius' signature. He refused, even rejecting his copy of the acts. He declared that the decisions of the council had no value and asserted that he preferred death to accepting error. The error consisted undoubtedly in some teachings and practices which were condemned by the council, such as, for example, the obligatory celibacy of clergy, the Saturday fast (already forbidden by the First Ecumenical Council), the representation of Christ in the form of a lamb, and others. Yet the Roman Church

[6]*Histoire des Conciles*, vol. III, (Paris, 1909), p. 577.

eventually accepted the Seventh Ecumenical Council, which refers to Canon 82 of the Quinisext Council. Therefore, it can be said that the Roman Church implicitly also recognizes this canon. Pope St. Gregory II refers to Canon 82 in his letter to the Patriarch of Constantinople, St. Germanus.[7] Pope Hadrian I, for example, solemnly declares in his letter to Patriarch St. Tarasius his adherence to the Quinisext Council; he does the same in a letter to the Frankish bishops in defence of the Seventh Ecumenical Council. Pope John VIII spoke of the decisions of the Quinisext Council without voicing any objection. Later, Pope Innocent III, quoting Canon 82, calls the Quinisext Council the Sixth Ecumenical Council. But all this is only the agreement of some popes, whereas there were others who had contrary opinions. On the whole, the West did not receive the decisions of the Quinisext Council.

The teaching of the Church on the christological basis of the icon, therefore, remained foreign to Western Christianity. This teaching could not enrich the sacred art of the West, which even today retains certain purely symbolic representations such as the lamb. The refusal to accept the decisions of the Quinisext Council later had, in the realm of sacred art, a great importance. The Roman Church excluded itself from the process of a development of an artistic and spiritual language, a process in which all the rest of the Church took an active part, with the Church of Constantinople providentially becoming the leader. The West remained outside of this development.

The Orthodox Church, on the contrary, in accordance with the Quinisext Council, continued to refine its art in form and in contents, an art which conveys, through images and material forms, the revelation of the divine world, giving us a key to approach, contemplate and understand it. It seems to us that it is particularly important for Western Orthodoxy, as it emerges in our own time, to be well aware of the significance of Canon 82 of the Quinisext Council. The canon, in fact, is the theoretical basis of liturgical art. Whatever course Western Orthodox art will take in the future,

[7]Quoted from G. Ostrogorsky, *Seminarium Kondakovianum* 1 (Prague, 1927), p. 43.

it will not be able to bypass the basic directive which was formulated for the first time in this canon: the transmission of historical reality and the revealed divine truth, expressed in certain forms which correspond to the spiritual experience of the Church.

VII
The Pre-Iconoclastic Period

SIDE by side with the nascent sacred art, there was a secular art which was not unacquainted with Christian subjects, particularly the portraits of those persons whom the Christians venerated. The secular world looked at these persons through different eyes than the Church. It considered them as benefactors of humanity, similar, for example, to the ancient philosophers, and not witnesses of the divine revelation. As benefactors, they were venerated and represented. Thus, it is said that in the third century Emperor Alexander Severus had in his pantheon, alongside the portraits of Plato and Aristotle, one of Christ and Abraham, which he worshipped.

On the other hand, the heretics also possessed a sacred art. Thus, the gnostics of the Carpocratian sect venerated the portraits of Christ and St. Paul, as well as those of the philosophers of antiquity. The art of the Church and the art of the world, in particular the official art of the state, coexisted and unavoidably came into contact with one another. It is even possible that the same artists worked in different realms at the same time. The icon and the portrait, for example, mutually influenced each other and were possibly even confused at times.

The ancient world entered the Church slowly and with great difficulty. With its very sophisticated culture, it was like the rich man of whom Christ speaks: It would be more difficult for him to enter the Kingdom of God than it would be for a camel to pass through the eye of a needle. The Church constantly borrowed from the heritage of antiquity in order to sacralize those elements which could be used to express the Christian revelation. It is natural that in this elaborate

125

process of borrowing, certain elements of ancient art penetrated
into the Church which did not actually correspond to the
meaning of sacred art, or even contradicted it. Their influence
persisted, leaving behind carnal and sensual traits which re-
mained in some monuments of sacred art, together with the
illusory naturalism of antiquity, characteristic of paganism
but foreign to the Christian faith. The Church never ceased
to fight against these remnants of pagan art and this struggle
was simply the reflection, in the realm of art, of the struggle
of the Church for its truth. In the realm of theology, heresy
is the result of the human inability to accept divine revelation
in its fullness, of the natural tendency to try to make this
revelation more accessible, to lower the heavens down to earth.
The same is true in the realm of sacred art. Secular art brought
elements into the Church which "lowered" the revelation, which
tried to make it more "accessible," more familiar, and thus
corrupted the teaching of the Gospel, diverting it from its aim.
As we shall see later, these same carnal and "illusory" elements,
from the Italian Renaissance until today, will penetrate sacred
art in the form of naturalism, idealism, *etc.* They will blur its
purity and overwhelm it with elements of secular art.

 In other words, the Church brings the image of Christ to
the world, the image of man and of the world revived through
the incarnation, the saving image. The world, in turn, tries
to introduce its own image into the Church, the image of the
fallen world, the image of sin, corruption and death. The
words of the late Patriarch Sergius of Moscow are appli-
cable here: "The world, hostile to Christ, will not only try to
extinguish the light of Christ with persecutions and other ex-
ternal methods. The world will be able to penetrate into the
very Manger of Christ."[1] In other words, it will try to destroy
the Church from within. One of the ways that the world
penetrates the Church is precisely through art. In this realm,
the prince of this world always begins in the same way. He
suggests to the faithful that art is art and nothing else, that
it carries its own worth and that it can, in its own way, express
the sacred in a secular and more accessible fashion, that it

[1]*Patriarch Sergii i ego dukhovenoe nasledstvo* (Edition of the Patriarchate of
Moscow, 1947) p. 65.

does not require a spiritual effort. And it is obviously much simpler to represent God in an image resembling fallen man than to try to do the opposite: to convey in the representation the image of God and the divine resemblence of man.

This is why the Church, according to the Seventh Ecumenical Council, answers the temptation of the world by saying: No, sacred art is not only art as the world understands it. "This art," say the Fathers of the council, "was not created by artists. On the contrary, it is a sanctioned institution and a tradition of the catholic Church . . . Only the artistic aspect of the work belongs to the artist; the institution itself is obviously dependent upon the Holy Fathers."[2] Unfortunately, the vigilance of the Church sometimes flags in this realm, and both the faithful and the hierarchy succumb to this worldly temptation and our churches are overflowing with secular or semi-secular images. This profanity of sacred art is always connected with a decadence in the liturgical and sacramental life, with a reduction of spiritual life to nothing more than morality. Its dogmatic foundation, having become the realm of theologians, is identified with abstract scholarship having no connection with reality. A sober and ascetical attitude *(trezvernost)*—an indispensable psychological basis for effectively living the life of the Church—has also been relegated to "specialists," the monks. As for the liturgy, it has become, for many of us, only a traditional rite or a pious and touching custom. The organic unity between dogma and spiritual life in the liturgy is broken. This absence of internal unity destroys the liturgical fullness of our divine services.

In Byzantium, the influence which the art of antiquity had on the Christian image was so important that it has led some scholars to speak of a "renaissance" of antiquity. Moreover, in the period that we are studying, the attitude of the faithful themselves towards the image, an attitude which frequently lacked true understanding, was a powerful weapon in the hands of those who were opposed to the veneration of images. Furthermore, attacks were made against the image from outside the Church, which contributed to the development and consolidation of iconoclastic trends.

[2]Sixth Session, Mansi 13: 252C.

The christological controversies ended in the seventh century. During the first seven centuries of its life, the Church had defended its essential truth, the one which is the basis of our salvation: the truth of the divine incarnation. It defended it point by point, formulating the various aspects of its teaching on the person of Jesus Christ, God and Man, giving the world the most exact definitions possible, which cut short all false interpretations. But once the partial attacks related to different aspects of christological doctrine were over, once the Church had triumphed over each heresy separately, a general offensive against all the Orthodox teaching took place. Studying Canon 82 of the Quinisext Council, we saw its doctrinal significance and its historical necessity, for it presupposed that the image was a means of confessing Orthodoxy, just as it had been confessed doctrinally during the preceding centuries. An open struggle against the icon came immediately afterwards, that is, a struggle against the confession of the Orthodox teaching of the image. One of the most terrible of heresies, undermining the very basis of Christianity, appeared: the iconoclasm of the eighth and ninth centuries.

There were many reasons for the spread of iconoclasm, which included, first of all, the misunderstandings, incomprehensions and abuses which distorted the veneration of icons. Some Christians zealously decorated the churches and considered this to be sufficient for their salvation. St. Amphilochius of Iconium denounces them already in the fourth century. Furthermore, there were ways of venerating sacred images which could have been mistaken for blasphemy. Asterius of Amasea recounts in the seventh century that embroidered images representing saints decorated the ceremonial robes of the members of the Byzantine aristocracy.[3] In Alexandria, men and women walked on the streets dressed in clothing decorated with sacred images. An excessive veneration of icons was apparent in the practice admitted by the Church. Thus, icons were sometimes used as godfathers or godmothers in baptism and at the monastic tonsure. There were even stranger cases. Some priests removed, by rubbing, the colors of the

[3]A. Vasiliev, *History of the Byzantine Empire, 324-1453* (Madison, Wisconsin, 1952) p. 374.

icons, mixed them with the Holy Gifts and distributed this mixture to the faithful as if the divine Body and Blood still had to be perfected with something sacred. Other priests celebrated the liturgy on an icon instead of an altar. The faithful, in turn, sometimes understood the veneration of icons too literally. They would venerate not so much the person represented on the image as the image itself. This practice clearly began to resemble magic or be similar to the decadent forms of paganism.

But besides these erroneous attitudes towards icons, there were also reasons for scandal in the image itself. The historical truth was often falsified. For example, St. Augustine informs us that during his time some artists arbitrarily represented Christ, following their own imagination,[4] just as it often happens today. Some images scandalized the faithful by their subtle sensuality which did not conform to the holiness of the represented person. Such images made the holiness of the icon —and indeed its very necessity for the Church—doubtful. Even worse, they provided the iconoclasts with a powerful weapon against sacred art in general. In their eyes, sacred art was not capable of reflecting the glory of God, the saints and the spiritual world. Its presence in churches was a concession to paganism, as some of our contemporaries also believe. "How could one dare," they said, "represent by means of a vile Greek art, the most glorious Mother of God, who received in her bosom the fullness of divinity, she who is higher than the heavens and more glorious than the cherubim?" Or else: "How can it not be shameful to represent, with the help of a pagan art, those who reign with Christ, who share His throne, judge the universe and resemble the image of His glory, when Scripture tells us that the whole world was not worthy of them."[5] (Fig. 15 and 16)

Iconoclastic trends within the Church were strongly supported outside the Church. We see in the acts of the Seventh Ecumenical Council that Anastasius the Sinaïte had to defend icons, in the sixth century, against enemies who had attacked

[4]*De trinitate* VIII, 55, 7, PL 42:951-952.
[5]Acts of the Seventh Ecumenical Council, Sixth Session, Mansi 13: 276, 277 D.

them. Similarly, in the sixth century, St. Simeon the Stylite, in his epistle to Emperor Justin II, speaks of the Samaritans who insulted the icons of Christ and the Virgin. In the seventh century, Leontius, bishop of Neapolis (Cyprus), wrote a work against iconoclasts who accused the Orthodox of idolatry on the basis of the Old Testament prohibition.⁶ This same accusation was again refuted in the seventh century by John, bishop of Thessalonica. Again in the eighth century, Bishop Stephen of Bostra in Arabia, a Moslem land, refuted the arguments of the Jews against icons in his work against the Jews.⁷

Among these different iconoclastic manifestations, it is the intervention of Islam which played the most important role. In the seventh century, the Moslem Arabs conquered Syria and Palestine, and, after having crossed Asia Minor, besieged Constantinople in 717. Emperor Leo III the Isaurian drove them back in 718. In the beginning of their rule over the territories they occupied, the Arabs were in general fairly tolerant towards Christian images.⁸ But the Jews, at the moment of the

⁶PG 93:1597-1609, and Mansi 13: 45.

⁷Quoted by St. John of Damascus, PG 94:1376.

⁸This can undoubtedly be explained by the importance of Jesus and Mary in the teaching of Mohammed. These are the only human beings, he says without excluding himself, whose conception remained untouched by the devil (Koran 3:31); Jesus will return as conqueror at the hour of judgment. "No Mahdi, except Jesus," proclaims a Hadith. (The Hadiths are selections of the words of Mohammed which are not a part of the Koran but which were piously preserved and which constitute, parallel to the Koran, something like our traditions.) He will be the voice of the Judge, the "scholarship of the hour" (Koran 43:61); and the world, like incredulous Israel, will, if it remains obstinate, be judged and condemned by the sign of the virginity of Mary. Damnation awaits those who deny the Holy Table to which Jesus invited His Apostles (Koran 5:114 and 115).

Having these texts in mind, one can understand the relative tolerance of Islam towards Christian icons. The Moslems even had representatitons of the Virgin. They venerated these images, as is proven by the following episode in Mohammed's life: When he victoriously entered Mecca, he had the idols that stood on the parvis of the Kaaba knocked down; then he entered the temple. The walls in the interior of the sanctuary were covered with many paintings, perhaps made by a Byzantine artist, which primarily represented scenes from the life of Abraham, intermingled with allusions to pagan customs (such as Abraham throwing divinatory arrows). Mohammed was scandalized by these paintings. But there was also an image of the Virgin with the Child. The prophet covered it with both hands and said: "Destroy all the rest." (This image probably disappeared in a fire which later destroyed the building of the Kaaba.)

However one should not relativize the prohibition of the image in primitive Islam, nor explain it by Jewish influences. Let us not forget that if Mohammed exiled himself to Medina, in a Jewish biblical milieu, to proclaim the irreproachable transcendence of the glory of God, he never ceased to affirm, against all the blasphemies accepted among the Jews, the virginity of Mary and the legitimacy of the mission of Jesus to the people of Israel. On the other hand, even if no verse can be found in the Koran which forbids images, this prohibition is mentioned many times and very explicitly by the Hadiths. Here is one of the most characteristic Hadiths: "Artists, the makers of images, will be punished at the Last Judgment, for God will impose on them the impossible task of resurrecting their works." Theologians later will only systematize this traditional teaching, which is rooted in the very essence of Islam. In this realm, in fact, Islam is very similar to Judaism (or rather to the religion of Abraham before the divine promise, for the Arabs claim descent from Ishmael, the son of Hagar. As for the divinity of Jesus, this is a question to which Mohammed, before the Christians of Najian at the moment when his vocation as prophet was being affirmed, replied with an *a priori* negation, but with a demand for a trial, a judgment of God (*mubâhala*, Koran 3:54), a demand to which the Christians did not reply. This absence of witnesses to Christ at the decisive moment when Islam was being created partially explains why it found itself established in an almost insurmountable ignorance of the Incarnation and of the Cross, and that it was satisfied to believe in the God of Abraham, to venerate only Him with a veneration which excluded any possibility of images. The Islamic faith therefore avoids and prohibits all that it considers to be a possible idol limiting or opposing the Divinity, because the absolute transcendence of God is its central theme. This is rigorous logic from the point of view of Mohammed, who does not believe in the Incarnation and for whom Jesus is only a prophet, as he himself is. For Jesus has the "seal of holiness" and is the Messiah whose return will mark the end of time. But his divinity will remain an unanswered question and will be asked by God to Jesus Himself on the Day of Judgment. Just as it was completely impossible to have an image of worship in Israel before the Incarnation, so also today it is an impossibility for those who, without accepting the coming of God in the flesh, vigorously reject paganism and idolatry and solemnly proclaim the unity of God, creator of heaven and earth. It is obvious that God for them also remains completely unknowable, indescribable and unrepresentable in any form. His presence for them is invisible. No image can represent Him because the Divinity, to whom nothing is comparable, transcends the created. As for the created world, it can no longer be represented because of the danger that the artist will fall into a demonic "mimicry." In Moslem thought, which emphasizes in a particularly abrupt manner the integral freedom of the Creator in relation to creation, each part of the world is being shaped by God at every moment. This is why man cannot congeal into forms the appearance of the created without giving it, in relation to the creating act, a delusive and finally diabolic autonomy. This is why there are no images in the mosques and why Moslem sacred art amounts to open geometric figures of arabesques which continually refer back to an omnipresent, though unknowable and invisible, center. A flat image is tolerated in secular art as long as it does not represent either God or the face of a prophet. The image "which throws a shadow" is completely forbidden, with the rare exception of stylized animals in the architecture of palaces and in jewelry. In a general way, the representation of fantastic plants and animals is clearly permitted, but only as long as it is not possible to confuse their fantastic charac-

birth of Islam, again began to believe very firmly in the prohi-
bition of the image by the Law of the Old Testament; they not
only ceased decorating their synagogues with images, as they
had done in the first centuries of Christianity, but, on the con-
trary, they destroyed the images which were found in them.
The synagogues of Ain-Douq and Bech Alfa retain traces of
this destruction. The kinship between Judaism and Islam
made them allies against Christian iconography. It is un-
doubtedly because of this kinship that the Moslem theological
school in Medina submitted to such a large Jewish influence
and was even, at one moment, almost completely in the hands
of Jews. It is not impossible that a Jewish iconoclastic influ-
ence left its mark on the commentaries and perhaps determined
the formulation of certain Hadiths. In any case, in 723, Khalif
Yezid abruptly gave an order to remove the icons from all the
Christian churches in his territory. The Moslems, therefore,
sought out the icons, but the persecution was neither consistent
nor systematic.

Besides Islam and Judaism, the iconoclastic camp also con-
tained various Christian sects of a docetic tendency,[9] that is,
accepting the teaching according to which the incarnation was
illusory and unreal. These were, for example, the Paulicians
and certain monophysite groups.[10] At the Seventh Ecumenical

ter with created beings. Only stylized, "geometrized" vegetable decorations are
sometimes introduced into sacred art, based on the "abstractions" of arabesques.
As for Persian miniatures, their development, which sometimes violates this rule,
seems to be not so much connected with the fact that the ethnic milieu is differ-
ent from the original semitism of Islam, as with the importance in Persia of the
Shiite tradition, which is separate from the strict Sunnite orthodoxy. It is pre-
cisely Shiite belief in the suffering and the personality of saints (and more par-
ticularly in the quasi-redemptive value of the son-in-law of Mohammed, Ali, and
of his progeny) which moderates the rigorous transcendentalism of Islam.

[9]The best modern study on the iconoclastic period is by G. Ostrogorsky,
Studien zur Geschichte des byzantinischen Bilderstreites (Breslau, 1929). See
also chapter three of his *History of the Byzantine State.*

[10]Most of the monophysites were not hostile towards icons and even today
the Ethiopians, Copts and Armenians continue to have them. Arians did not
venerate saints, relics or icons. Most of the Nestorians venerated icons. What
remains of this sect lost the veneration of icons under the influence of Islam but
continues to venerate the Cross. The Paulician sect is a dualist, Manichaean sect.
Matter, having been created by an inferior and evil god, is contemptible to them.
Christ did not assume a real, material body, which is the reason why He is abso-

Council, the Patriarch of Constantinople, St. Tarasius, says that the iconoclasts were inspired by Jews, Saracens, Samaritans, Manichaeans and two monophysite sects, the phantasiasts and the theopaschites.[11] In the judgment which the Fathers of the council pronounce on iconoclasm, it is claimed that this heresy, both in its opinions and its practices, recapitulates all of the errors and heresies of the past.

However one must not think that iconoclasm was only an eastern heresy. It also appeared in the West. But the West occupied only a "provincial" position in the Church in this period, and it was in the eastern part of the Empire that the destiny of the Church was decided. It is therefore in the East that the heresy was the most violent and the answer of the Church was also the most elaborate and effective. Iconoclasm did not become a systematic and organized heresy in the West, and it only appeared in isolated cases both before and after Byzantine iconoclasm. One of the most characteristic episodes occurred at the end of the sixth century. In 598 or 599, the bishop of Marseille, Serenus, threw all the icons out of the churches and had them destroyed under the pretext that they were improperly worshipped by the people. Pope St. Gregory the Great praised the zeal with which the bishop opposed the worship of images but criticized him for destroying them. "It was unnecessary," he wrote, "to destroy the icons. They are exposed in the churches so that the illiterate, looking at the walls, can read what they cannot read in books. Brother, you should have preserved the icons, but not allowed the people to worship them."[12] Having received the papal letter, Serenus tried to put its authenticity into question. Therefore, in the year 600, St. Gregory the Great wrote to him again, demanding that he put an end to the trouble which his act had provoked and that he place the icons back into the churches and explain to the people how they should be venerated. St. Gregory adds:

lutely unrepresentable. In the tenth century, Emperor John Tzimisces deported them to the European confines of the Empire. Their dualist and fanatically iconoclastic doctrine therefore spread in southern Europe. This led to the mass movements of the Bogomils, of the Patarenes and of the Cathars or Albigensians.

[11]Fifth Session, Mansi 13: 157 D.

[12]Book IX, ep. 105, PL 77:1027C-1028A.

"We greatly praise the fact that you prohibited the worship of icons, but we forbid you to destroy them. It is necessary to distinguish between the worship of an icon and the process of learning through the icon that which must be worshipped in history. What the Scripture is for the man who knows how to read, the icon is for the illiterate. Through it, even uneducated men can see what they must follow. It is the book of those who do not know the alphabet. This is why the icon replaces the book primarily for foreigners."[13] But these iconoclastic manifestations in the West were only isolated cases, not having the profound roots of Eastern iconoclasm and, therefore, not having similar consequences.

[13]Book XI, ep. 13, PL 77:1128A-1130B.

VIII
The Iconoclastic Period: An Abridged History

THE ICONOCLASTIC movement originated in the eastern provinces of the empire. From these provinces came the initiators of the movement and most of the imperial army which formed the main support of the leaders of iconoclasm. These provinces were to a large extent influenced by Jewish and Moslem religions, the Paulician sect as well as others. What were the immediate reasons for the imperial prohibition of icons? There are many different opinions on this subject. Some put forth religious and political reasons; others believe that the religious reasons were only a pretext and put forth the political, social and economic factors. According to some historians, for example, Leo III decided to abolish the worship of icons to get rid of one of the main obstacles that separated Christians, Jews and Moslems and to secure the unity of the Empire; or else, it is said that he wanted to free the people from the influence of the Church and hence attacked the icons, a principle instrument of the Church. Still others believe that the aim of the iconoclastic emperors was to free education from the clergy's control[1] or else to reduce the number of monasteries. The many men who became monks reduced the number of agricultural workers, soldiers and civil servants.[2] It is only necessary to remember that the estimated number of monks in the Byzantine Empire was 100,000. In comparison, Russia at the beginning of this century had only 40,000 monks and nuns, and a much larger general population.[3] However, all of the external fac-

[1] A. Vasiliev, *History*, pp. 252 ff.
[2] C. Diehl, *History of the Byzantine Empire* (New York, 1969), p. 58.
[3] A. Vasiliev, *History*, p. 256.

135

tors which really existed are only secondary to the main reason, which was one of a doctrinal nature.

In 726, Emperor Leo III the Isaurian, influenced by bishops from Asia Minor who were hostile to the worship of images and who had just been in Constantinople, openly took a position against the veneration of icons. Until today, scholarship has considered that he proclaimed two decrees to this effect: the first in 726, accepted unanimously by the Senate, the second in 730. The texts of both decrees are lost and certain modern scholars, for example, G. Ostrogorsky,[4] assert that in actuality there was only one decree in 730, and that the years 726-730 were filled with futile attempts by the emperor to persuade Patriarch St. Germanus (715-730) and Pope St. Gregory II to adhere to iconoclasm. In any case, St. Germanus categorically refused to sign the imperial decree. He announced to the emperor that he would not tolerate any change in the teaching of the faith without an ecumenical council. This is why St. Germanus had to suffer humiliation and be deposed, deported and replaced by an iconoclast, Patriarch Anastasius (730-753). Thus, the iconoclastic decree which appeared in 730 was not only signed by the emperor, but also by the patriarch. In other words, it was proclaimed not only by the State, but also by the hierarchy of the Church of Constantinople. After the decree of 730, icons began to be destroyed everywhere.

The first iconoclastic act was to destroy, by the order of the emperor, a sculptured icon, a statue of Christ above one of the entrances to the imperial palace. The destruction of this statue provoked a popular uprising, the civil servant sent by the emperor to smash it was killed and the murderer was harshly punished by the emperor. These were the first victims of the dispute over images. A fierce struggle began, marked by the blood of martyrs and confessors. Orthodox bishops were exiled, the faithful laity were presecuted by torture and death. This struggle lasted just over one hundred years and can be divided into two periods. The first stretches from 726-730 to 787, the date of the Seventh Ecumenical Council, which, under the rule of the Empress Irene, re-established the worship of

[4]"Les débuts de la querelle des images," *Mélanges C. Diehl*, vol. 1 (Paris, 1930), pp. 235-255, and *History of the Byzantine State*, p. 163 n. 1.

icons and formulated the dogma of their veneration.

In reality, the attack against the veneration of icons represented an illegitimate intervention of civil power in the realm of the Church, its liturgical life and its teaching. Emperor Leo III was a despotic and brutal man. For example, he compelled Jews and Montanists to be baptized; they sometimes preferred suicide. For the iconoclasts, the power of the State in Church affairs, caesaropapism, was a normal principle. In response to this principle, St. John of Damascus, in his second treatise *In the Defense of Holy Icons*, expressed the point of view of the Church: "Emperor, we submit to you in all that concerns life, the things of this world, taxes, contributions and the like, in all that is the extent of your jurisdiction in the management of our terrestrial affairs, but in the ecclesiastical institution, we have shepherds who spoke to us and who established the ecclesiastical institutions."[5]

The Orthodox position was very clear and strict from the beginning. Thus, Patriarch St. Germanus, who even before explicit manifestations of iconoclasm wrote three dogmatic epistles to the iconoclastic bishops, preferred humiliation and exile to heresy. Immediately after the imperial decree, St. John of Damascus responded with the first of his three treatises *In the Defense of Holy Icons*. This treatise, like the other two, not only represents a response to the iconoclastic theory, but also a very complete and systematic theological exposition of the Orthodox teaching on the image.

In the beginning of iconoclasm, the Pope of Rome was St. Gregory II. Like Patriarch St. Germanus, he refused to submit to the emperor, and in 727 he called together a council which confirmed the veneration of icons, referring to the tabernacle of the Old Testament and the image of the cherubim in it. Most of Italy revolted against the emperor and the insurgents declared that they would place another emperor on the throne of Constantinople. St. Gregory II wrote letters to the emperor and the patriarch which were later read at the Seventh Ecumenical Council. In 731 his successor, Gregory III, a Greek from Syria, called together a new council in Rome where it was decided that iconoclasts would be deprived of

[5]Ch. XII, PG 94: 1297.

the Body and Blood of Christ and cut off from the Church
community. "In the future, whoever removes, destroys, dis-
honors or insults the images of the Savior, His Holy Mother,
Virginis immaculatae atque gloriosae, or the Apostles . . . will
not receive the Body and Blood of the Savior and will be ex-
cluded from the Church." [6] Gregory III zealously decorated the
churches and ordered icons to be painted. Honoring the in-
sulted saints, he instituted in Rome, in the chapel of St. Peter,
the feast of all the saints who at the time were celebrated only
locally.

The struggle for and against icons which raged in the East
and in the West was primarily concentrated in the Church of
Constantinople. The patriarchs of the East were, at the time,
under Moslem rule and did not suffer from the systematic
persecutions which raged in the Byzantine Empire.

The first period of iconoclasm reached its paroxysm during
the reign of Constantine Copronymus, the son of Leo III
(741-755). [7] He was an even more fanatical iconoclast than
his father, and the three patriarchs who followed one another
on the seat of Constantinople during his reign were completely
dependent upon him. The first ten years of his reign were
relatively quiet, for Constantine was engaged in political strug-
gle to maintain his rule. But then, persecution of the Ortho-
dox broke loose with a violence which was comparable to that
of Diocletian. Constantine wrote a treatise in which he sum-
marized the iconoclastic doctrine, and called together a council.
Neither the treatise of the emperor nor the acts of the council
were preserved, for they were later burned, but we know the
contents of both: the treatise of Constantine is frequently
quoted by Patriarch St. Nicephorus in a polemical work, and
the decisions of the iconoclastic council of 754 were completely
recorded in the polemical section of the acts of the Seventh
Ecumenical Council. The treatise of the emperor, very violent
in tone, was written just before the iconoclastic council, an
assembly preceded by clever preparation. Presided over by the

[6] Hefele, *Histoire des Conciles,* vol. 3, part 2 (Paris, 1910), p. 677.

[7] In the beginning of his reign, there was a short interval of 16 months when
the veneration of icons was restored by the usurper Artavasdus.

bishop of Ephesus, Theodosius,[8] it began on February 10, 754, in Hieria and ended August 8 in the Church of Blachernae in Constantinople. Three hundred thirty-eight bishops participated, which is an impressive number. These were the iconoclasts who had replaced the deposed Orthodox bishops. For some of them, new episcopal sees were created by the emperor.[9] It was decided at the council that whoever painted or possessed icons would be deprived of his priesthood if he was a priest, and excommunicated if he was a monk or a layman. The guilty ones were delivered to a civil tribunal, and questions of faith were thus made subject to the jurisdiction of public power.[10] At the close of the council, the confessors of Orthodoxy, St. Germanus, St. John of Damascus and St. George of Cyprus were excommunicated.[11] The believers were required to make an iconoclastic confession of faith, and the persecutions became particularly cruel.

In spite of all this, the believers did not allow themselves to be fooled and did not renounce the veneration of icons. The leaders of Orthodoxy were the monks, those "idolaters and worshippers of the shadows," as Constantine Copronymus called them. They were fiercely persecuted. Their heads were shattered against icons, they were sewn into sacks and drowned, they were forced to break their monastic vows, and the hands of the iconographers were burned. The monks emigrated in groups, particularly to Italy, Cyprus, Syria and Palestine. According to some historians, Italy alone received 50,000 of these monks during the time of Leo III and Constantine Copronymus.[12] Many of them were iconographers, which is

[8]Patriarch Anastasius died in 753 and his successor, Constantine, was named by the emperor and presented to the council only at its last session. G. Ostrogorsky, *History*, p. 201.

[9]To understand the composition of the council to be an active minority (the iconoclasts) on the one hand, and a passive majority (the Orthodox) on the other, as is done by A. Schmemann, *The Historical Road of Eastern Orthodoxy*, (New York, 1963), p. 250, does not correspond to the historical situation. In fact, the venerators of icons were not represented at the council at all. Cf. G. Ostrogorsky, *History*, p. 200.

[10]See A. Vasiliev, *op. cit.*, p. 345.

[11]Mansi 13: 356 C-D.

[12]See Andreev, *German i Tarasii, Patriarkhi Konstantinopolskie* (Sergiev Posad, 1907), p. 79.

why the city Rome never produced more works of sacred art
than during the iconoclastic epoch. All the popes who suc-
ceeded one another during the reign of Constantine Copro-
nymus (Zacharias, Stephen II, Paul I, Stephen III and Hadrian
I) remained firm in the Orthodox faith and continued the
work of their predecessors in decorating the churches with
icons with the help of monk-iconographers who had emigrated
from the eastern part of the Empire.[13]

With the death of Constantine Copronymus, the persecu-
tions became less violent. His son, Leo IV, was a moderate
and rather indifferent iconoclast. At his death in 780, his
wife Irene came to the throne with her underage son, Con-
stantine. Being an Orthodox who had never ceased venerating
icons, Irene immediately began restoring Orthodoxy. The
Orthodox candidate to the patriarchal throne was Tarasius
(784-806). Under his influence, the empress began to pre-
pare for the Seventh Ecumenical Council. However, as soon
as this council began its work in Constantinople, the troops
revolted, urged to do so by the iconoclastic bishops, and did
not allow the council to continue. But soon after, when these
troops were replaced with others, Irene resumed her attempt,
and the council was called together in Nicaea in 787. Three
hundred fifty bishops and many monks participated. An im-
perial decree and an address of Patriarch Tarasius guaranteed
freedom of speech, and the heretics were invited to put
forth their doctrine, already developed at this time. In response,
on the Orthodox side, a deacon read, point by point, the refuta-
tions. The council reestablished the veneration of icons and
relics and took a series of steps to reestablish normal life in
the Church.

Peace lasted for 27 years. Then the second iconoclastic
period began. Nicephorus I, a rather indifferent Orthodox
who did not take a stand either for or against icons, ruled after
Empress Irene. But his successor, Leo V the Armenian (813-
820), decided that the iconoclastic emperors had much more

[13]It is during this period that Santa Maria Antiqua was decorated in Rome.
During the second iconoclastic period, the cathedral of St. Mark was rebuilt and
the churches of Santa Maria in Domnica, Santa Prassede and Santa Caecilia
were built and decorated.

political and military luck than the Orthodox emperors. Because of this, he turned back to iconoclasm. Leo V asked John the Grammarian, "the brain of the iconoclastic renaissance,"[14] to compose a treatise using decisions dating back to before the iconoclastic period. Thus these decisions, which had already received a complete Orthodox answer, were artificially resurrected to serve the political aims of the emperor. The second wave of iconoclasm, like the first, was a violation of the sovereignty of the Church in its internal realm by the power of the State. But the emperor did not find the support in the episcopate which Constantine Copronymus had enjoyed. When, in 814, John the Grammarian had finished his work, the emperor began a discussion with the Patriarch St. Nicephorus I (810-815) in an attempt to reach a compromise which would forbid the veneration of icons without suppressing them completely. The emperor did not use threats; he earnestly asked, in the name of the peace of the Church, that concessions be made to iconoclasm. But the holy patriarch refused to make any compromises. St. Theodore of Studios, who with 270 other monks took part in the discussion, told the emperor that he had no right to meddle in the internal life of the Church. The negotiations were never completed and persecutions began. The patriarch first saw his powers limited, and then, in 815, he was dismissed, exiled and replaced by an iconoclast, Theodotus I (815-821). The same year, a new iconoclastic council, presided over by Patriarch Theodotus, was called together in Constantinople, at the cathedral of Haghia Sophia. It was neither as important nor as large as the first. In general, during this second period, iconoclasm lost much of its doctrinal vitality. The iconoclasts could say nothing new and were therefore limited to continuously repeating the old arguments, already refuted by the Orthodox.[15] This time, the council emphasized that it did not consider icons to be idols,[16] but this

[14]G. Ostrogorsky, *History*, p. 231.

[15]The doctrine promulgated at this second iconoclastic council is known by a letter of Emperor Michael to Louis the Pious (Mansi 14: 417-422) and by the *Refutations* of St. Theodore of Studios, but particularly by the response of Patriarch St. Nicephorus, who quoted it abundantly.

[16]G. Ostrogorsky, *Studien*, p. 51, and *History*, p. 202.

did not lead to any less destruction, and even though there
was nothing new or valid in the iconoclastic doctrine, the
persecutions only became more violent, reaching the force of
those of Constantine Copronymus. Monks were again per-
secuted, and icons, books and sacred vases with images were
destroyed. Iconoclasm was taught in schools and appeared in
manuals. The great defender of icons, St. Theodore of Studios,
was dragged from one prison to another and was beaten to
such an extent that his bruised flesh rotted alive, and his
disciple, St. Nicholas, who never left him, was obliged to
remove this rotten flesh with a knife.

Another turnabout occurred when Emperor Michael II
came to the throne in 821. He was an iconoclast but recalled
the Orthodox from exile and from prison. His reign was a
calm one. But the situation changed again during the reign of
the son of Michael, Emperor Theophilus. When John the
Grammarian came to the patriarchal throne in 837, a new
wave of persecutions began.

It was at this time that the monk-iconographer, St. Lazarus,
suffered martyrdom. Having been cruelly beaten, with his
hands burned, he dragged himself directly from the execution
place to the church of St. John the Baptist and started to paint
his icon. The learned Theodore and Theophanes, who at the
request of the patriarch of Jerusalem raised their voices against
iconoclasm, were cruelly beaten several times. Moreover, an
insulting inscription was marked on their faces with a red hot
iron. This is why the Church venerates them as Theodore
and Theophanes the "marked" (*graptoi*).

When Emperor Theophilus died in January, 848, his widow,
Theodora, became the regent for his son, Michael III, who was
underage. She was Orthodox, and the worship of icons was
decidedly reestablished by a council held in Constantinople in
843 under the Patriarch St. Methodius (842-846). The council
confirmed the dogma of the veneration of icons which had
been established by the Seventh Ecumenical Council, excom-
municated the iconoclasts and established, in March, 843, the
feast of the Triumph of Orthodoxy on the first Sunday of
Lent, with the exaltation of icons in all the churches. We
continue to celebrate the Triumph of Orthodoxy, and we will

see all its importance when we study the contents of the icon.

In the West, during the second iconoclastic period, Pope Pascal I and Pope Gregory IV continued to defend and propagate sacred images. In 835, *i.e.* during the persecution of Theophilus, Pope Gregory IV decreed that the feast of all the saints, which had been instituted by Gregory III, was to be celebrated by all of Christianity on November 1. In general in the West, both in Rome and in other areas, the iconoclastic persecutions encouraged the worship of saints and their relics. It is during the iconoclastic period that the relics of many saints were brought to France (for example, those of St. Guy in 751, of St. Sebastian in 826 to the church of St. Medard in Soissons, and of St. Helena in 840 to Hautevilliers near Reims).[17] Thus the Church of Rome did not succumb to the temptation of iconoclasm. On the contrary, it remained firm in its belief in the veneration of icons, saints and their relics, in contrast to the iconoclasm of the Church of Byzantium.

What was the end result of the iconoclastic period? Everything that could be destroyed, was destroyed during this period, which is why we have so few icons from earlier times. Images were subjected to every possible kind of outrage. They were broken, burned and painted over. "Wherever there were images," says a contemporary, "they were destroyed by burning or were thrown down, or else erased with a coating of paint." "The mosaics," says another, "were torn down; icons that were painted with colored wax were scraped; everything beautiful disappeared from the churches."[18] Civil servants were sent to the most distant provinces to search out and destroy the works of sacred art. Many Orthodox were executed, tortured or imprisoned, and their properties were confiscated. Others were banished or exiled in distant provinces. In short, it was a real catastrophe. But this catastrophe finally turned into a triumph for the Church. Before iconoclasm, the Orthodox were fre-

[17]Iconoclasm also had other consequences in the West. When the Lombards were threatening Rome, the Pope, rather than ask an iconoclastic emperor for help, turned to Pepin the Short, who, having saved Rome from the barbarians, in effect created the papal state in 756, thus making the Pope a temporal sovereign.

[18]C. Diehl, *Manuel d'Art byzantin*, vol. I (Paris, 1926), p. 364.

quently unaware of the importance of sacred art. But the violence of the persecutions and the resolution of the Orthodox confessors in the veneration of icons emphasized once and for all the importance of sacred images. In spite of all the persecutions and all the cruelties, in spite of the iconoclastic imperial decrees signed by patriarchs, in spite of the large number of iconoclastic bishops (338 in the first iconoclastic council), in spite of the anathema which threatened those who venerated, painted or possessed icons, the faithful never ceased to venerate icons. As St. John of Damascus said: "Our aim is to hold out our hand to the truth, which is being attacked."[19] In the heat of the fight, the Church found the words capable of expressing the richness and depth of its teaching. Its confession was sealed by the blood of the martyrs and confessors, and is a treasure which we have inherited and which today has acquired a new and special actuality.

[19]*First Treatise*, ch. 3, PG 94:1233.

FIG. 12
Eucharistic symbol.

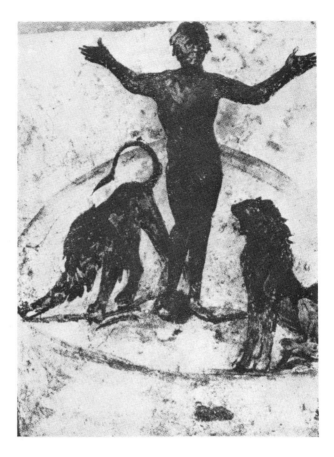

FIG. 13
Daniel in the lions' den.
Fresco of the Cimitero dei Giordani, Rome, fourth century.

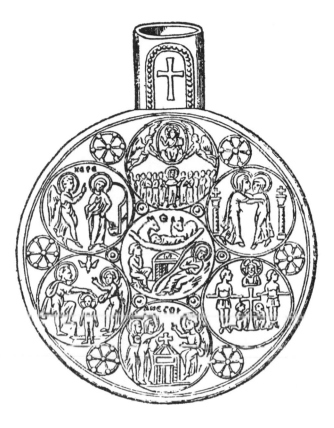

FIG. 14
Phial of Monza, Garrucci 438, 8.

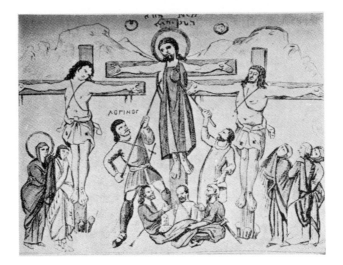

FIG. 15

Two representations that can give an idea of the tendencies which could be used as pretexts by persons hostile to sacred art. One is an image of the crucifixion of the sixth century, in the so-called Lectionary of Rabula. The nude bodies are represented with a sensual, even coarse naturalism. Christ is clothed. This contradicts the biblical account, but it is obvious that His body, represented in such a way, could shock the faithful.

FIG. 16

The other image represents the head of an angel. This is a mosaic from the Cathedral of St. Sophia of Constantinople, made during the years directly following the restoration of the icons. From an artistic point of view, the mosaics of St. Sophia from the ninth century are some of the most beautiful monuments of Byzantine art. Some of them are nevertheless strongly marked by reminiscences of antiquity which occasionally appeared in the art of the Church of Constantinople. In this face, we see a curious mixture of sensuality and spirituality. The tired gaze of the wide-open, oval eyes, the traits of the face, and above all the sensual lips give it a sensual and sickly character. The face has a blasé and degenerate look. This mixture of sensuality and spirituality appeared in art already before the iconoclastic period (for example, in the mosaics from the seventh century in the Church of the Dormition in Nicaea). Such images certainly could repel the faithful and encourage opposition to sacred art.

FIG. 17
Head of an angel from an Orthodox icon.

FIG. 18
Head of an angel from a painting by Verocchio.

FIG. 19
St. Paul.
Icon from the fifteenth
century (detail).

FIG. 20
St. Peter.
Icon from the fifteenth
century (detail).

FIG. 21
Roman medallion from the second or third century. St. Peter and St. Paul.

One can be sure that the Russian iconographers of the fifteenth century had never seen these Roman portraits and that they were even unaware of their existence. And, in spite of this, the icon reproduces the same faces, the same characteristic traits with great anatomical exactness. This shows how the iconographic tradition retains the historical traits of the saints with exactitude.

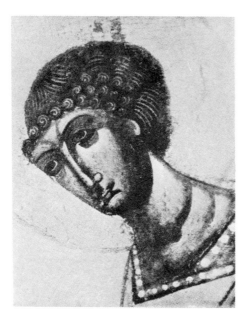

Fig. 22
St. George.
Icon from the fourteenth
century (detail).

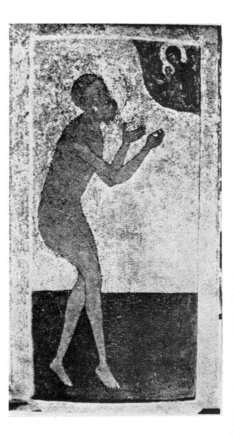

Fig. 23
St. Basil the Blessed.
Icon from the sixteenth century.

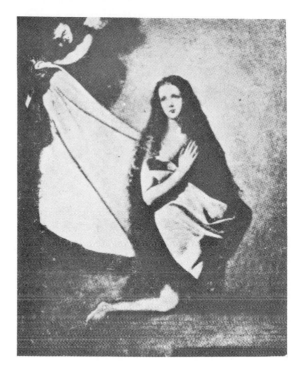

FIG. 24
"St. Agnes"
By Ribera, seventeenth
century.

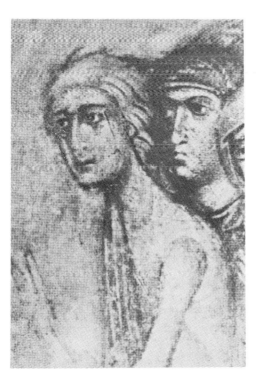

FIG. 25
St. Mary of Egypt.
Fresco in the St. Dimitri
Cathedral in Vladimir,
the twelfth century
(detail).

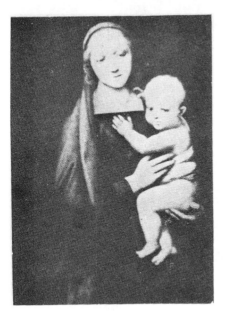

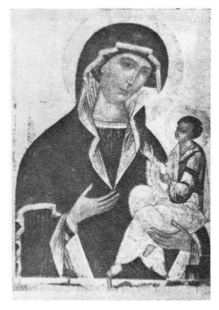

FIG. 26
"La Madonna del Granduca."
By Raphael.

FIG. 27
The Virgin and Child.
Icon from the sixteenth century.

Two images of the Virgin, both from the sixteenth century. One is a Madonna of
Raphael, the other is a Russian icon. The iconography, the poses, the gestures and even
the folds of the Virgin's robe are the same. Both portray the same human feeling—
tenderness and motherly love. This only makes the contrast more striking. The image
of Raphael is that of a human being. It is carnal and sentimental. The sacred subject
only serves as a pretext to express the feelings and ideas of the painter. All that we
learn about the Mother of God in this image is that she was a woman, and all that we
learn of the divine Child is that He was a baby undistinguishable from all other children.
Through the appropriate symbolism in the icon, however, we learn the teaching of the
Church on the incarnation of God and the divine motherhood. The Child is not a baby
like all others. His majestic pose, His halo, the scroll in His hand, His blessing, the
manner in which His clothing is treated—all of this portrays to us the incarnate divine
Wisdom.

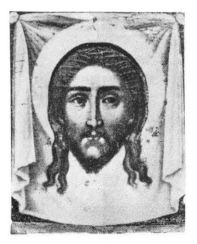

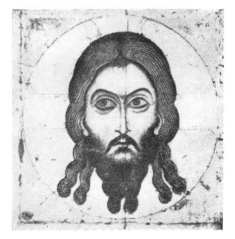

FIG. 28
The Holy Face.
Icon from the seventeenth century
by Simon Ushakov.

FIG. 29
The Holy Face.
Icon from the twelfth century.

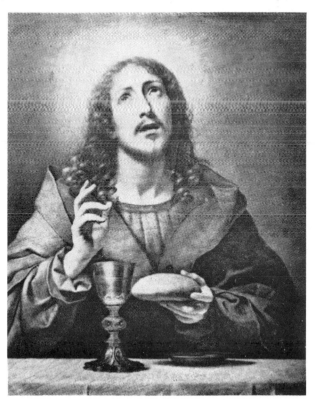

FIG. 30
"Christ."
By Carlo Dolci.

FIG. 31
An example of iconographic clothing
(detail of an icon).

Fig. 32
The Nativity of Christ.
Icon from the sixteenth century.

Fig. 33
"The Nativity."
By Ribera.

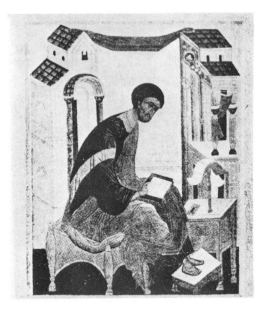

FIG. 34
St. Luke.
Icon from the fifteenth century.

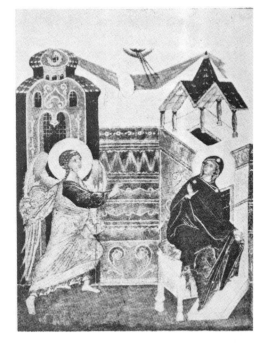

FIG. 35
The Annunciation.
Icon from the sixteenth century.

Two representations illustrating the a-logical character of architecture in icons. The architectural forms in the image of the annunciation are particularly characteristic in this way. We see the roof of the building behind the Virgin in which one of the columns is leaning against a void.

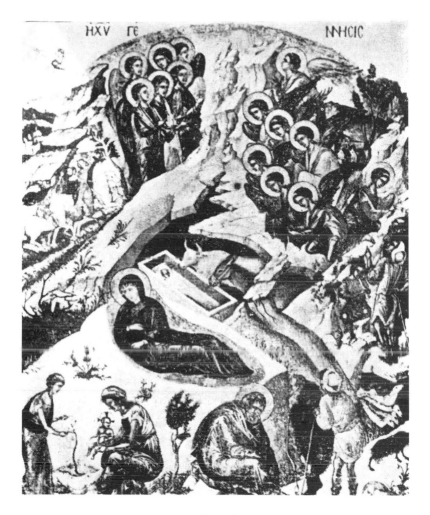

Fig. 36
The Nativity of Christ.
Icon from the sixteenth century. A town, undoubtedly Bethlehem, is represented at the two upper corners of this icon. The aerial perspective of this part of the icon in a way veils the surface of the board, and thus, also the unity of the image. It inevitably catches the eye, distracting us from the essential part of the icon.

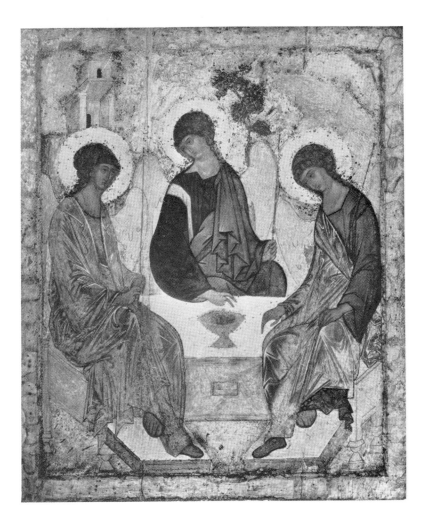

FIG. 37
St. Andrei Rublev's icon of the Holy Trinity.

IX

The Iconoclastic Teaching and the Ortrhodox Response

WE WILL now pass to the study of the general traits of the iconoclastic teaching. One must not forget that the significance of this heresy exceeds the limits of the iconoclastic period. Iconoclasm has survived, though in different forms. It is only necessary to remember the Albigensians in medieval France, the Judaizers in fifteenth-century Russia, and finally, the Protestant Reformation. This is why the theological response of the Church to the iconoclastic heresy in the eighth and ninth centuries continues to be relevant even today.

From the doctrinal point of view, iconoclasm is a complex phenomenon which has not been sufficiently studied. In the beginning, the iconoclastic position seems to have been an elementary one: The iconoclasts attacked the Orthodox on the basis of the Old Testament prohibition and accused them of idolizing stones, boards and walls. One wonders whether it is really possible that the iconoclasts—as some Protestants today— truly believed that an Orthodox Christian, praying before an icon, was not addressing God, but the image, taking it to be God Himself, that his prayer was not going to the Virgin, but to the painting. Could one truly have such a primitive notion of prayer?

Two essential trends can be found in the iconoclasm of the eighth and ninth centuries: (1) Some iconoclasts demanded a complete destruction of sacred images, denying the veneration of relics, the most intolerant going so far as to suppress the worship of the Virgin and the saints. This trend of iconoclasm is interesting because, in its very violence, it is more rational and more logical, and demonstrates well what the end result

145

of denying icons would be. (2) Another more tolerant form of iconoclasm acknowledged the sacred images, but presented a variety of attitudes towards them. For example, some "moderate" iconoclasts acknowledged the icon of Christ, but not those of the Virgin or the saints; others asserted that Christ Himself should only be represented before His resurrection, and that afterwards, He was no longer representable.

From the first stages of the controversy, the apologists of Orthodoxy took a very clear dogmatic position, insisting on christological arguments to support the existence of icons. They resolutely held this dogmatic position throughout the struggle against iconoclasm. However, G. Ostrogorsky notes that somehow some scholars adopted the opinion that the christological proofs were not used by the venerators of icons before the iconoclastic council in 754; that when the council referred to this kind of argument in favor of the iconoclastic thesis, the Orthodox also resorted to it.[1]

If this were really the case, that is, if the christological arguments were really put forth by the Orthodox only in response to similar methods of their adversaries, the whole issue would be one of scholastic exercise, and christology would have no primordial importance in the struggle. But this was not the case. The question of icons was, from the beginning, linked by the Orthodox to christology, while their adversaries were not giving them any pretext for using such an argument. After having quoted proofs from the writings of the Orthodox apologists whose writings have been preserved (Patriarch St. Germanus, St. John of Damascus, Pope St. Gregory II and St. George of Cyprus), G. Ostrogorsky concludes: "Moreover, there is no evidence in the historical documents that in the first period of the struggle, the iconoclasts had accused the venerators of icons of anything but idolatry. Thus, there is a lot more evidence to support the view that the christological arguments of the iconoclastic council were only a forced response to the arguments of the Orthodox, and not the contrary. Such an assertion, in any case, would not contradict the historical

[1]"Sochinenia pravoslavnykh apologetov," *Seminarium Kondakovianum I* (Prague, 1927), p. 36.

facts as does the contrary assertion which is so often expressed."[2]

Actually, we have seen that the christological basis of the image was already expressed by the Quinisext Council (692) before the beginning of iconoclasm. It is also before the beginning of iconoclasm, at the end of the seventh century, that bishop John of Thessalonica refers to the christological basis of the icon in his polemics against the pagans and the Jews. Similarly, in his three epistles to the iconoclastic bishops Thomas of Claudiopolis, John of Sinada and Constantine of Nacolea,[3] St. Germanus uses the incarnation to justify the existence of icons. These epistles were written before the open attack launched by Emperor Leo III against the veneration of icons. Canon 82 of the Quinisext Council is the basis of the Orthodox line of thinking, and the holy Patriarch Germanus repeats the christological section almost verbatim in his work *On Heresies and Councils.*[4]

At the very beginning of the iconoclastic movement, the Orthodox understood the danger it presented to the fundamental dogma of Christianity. Indeed, if the very existence of the icon is based on the incarnation of the second person of the Holy Trinity, this incarnation, in turn, is confirmed and proven by the image. In other words, the icon is a proof that the divine incarnation was not an illusion. This is why, in the eyes of the Church, the attack against the icon of Christ is an attack on His incarnation and on the whole economy of our salvation. This is why, in defending sacred images, the Church was not only defending their didactic role or their aesthetic aspect, but the very basis of the Christian faith. This explains the resolution of the Orthodox in defense of the icon, and their intransigence and acceptance of all sacrifices.

The reasoning of the iconoclasts, the accusation of idolatry and the reference to the Old Testament, clashed with a very developed and well formulated theology and proved to be clearly insufficient. Iconoclasm had to find a theological basis with which to oppose the clear position of the Orthodox. Em-

[2]*Ibid.*, p. 44.
[3]PG 98: 164-193, 156-161, 161-164.
[4]PG 98: 80A.

peror Constantine V Copronymus himself, whom some Prote-
stants consider to be a spiritual ancestor of Luther and Calvin,
became the chief proponent of iconoclastic theology. Aware
of the Orthodox reasoning and reacting to it, Constantine com-
posed a treatise which displays the deep chasm between Ortho-
doxy and iconoclasm. All the iconoclastic tendencies can be
found in this treatise and are pushed to extreme conclusions.
The work of the emperor was presented to the iconoclastic
council in 754. The council could not accept everything in this
treatise and had to moderate some of its points. Thus, it did
not condemn the veneration of the Virgin and the saints; how-
ever, Constantine succeeded later in imposing these doctrines
also. The imperial treatise also contained expressions so gross-
ly monophysitic that the council felt obliged to modify them
and, in order to justify iconoclasm, it threw the accusation of
monophysitism on the Orthodox. The patriarchs of the east
and the Pope of Rome were not represented at the council.
The last meeting ended with a solemn procession of all the
participants into the public square and the reading of the decla-
ration of the iconoclastic faith before the crowd with the ex-
communication of the main confessors of Orthodoxy. This
declaration of faith, after a short introduction, begins by list-
ing the six ecumenical councils and the heresies condemned by
them and by asserting that the council of 754 is in line with
the ecumenical councils and perfectly orthodox. Then the
veneration of icons is declared to have its origin in idolatry
inspired by the devil and refuted in both the Old and the New
Testaments. Theological, scriptural and patristic arguments
follow.

What was an icon for an iconoclast? What did it have in
common with the represented person, and how was it dis-
tinguishable from this person? In fact, the essential difference
between the parties lay in the very definition of the "icon";
the very word "icon" was understood differently by the icono-
clasts and the Orthodox.

The iconoclastic idea of an icon is clearly and precisely
expressed in Emperor Constantine's treatise, which conveys the
point of view shared by all the leaders of iconoclasm. Accord-
ing to him, a true icon must be of the same nature as the person

it represents; it must be consubstantial with its model (ὁμο-ούσιον). Basing themselves on this principle, the iconoclasts came to the inevitable conclusion that the only icon of Christ is the Eucharist. Christ, they said, chose bread as the image of His Incarnation because bread has no human likeness, and thus idolatry can be avoided. "The very idea of an 'image,' of an 'icon,' writes G. Ostogorsky, "signifies something completely different in iconoclastic thought than it does in Orthodox thought, because for the iconoclasts, only something identical to its prototype could be considered to be a real icon, only the Holy Gifts could be confessed as an icon of Christ. But for the Orthodox, the Holy Gifts are not an icon precisely because they are identical to their prototype."[5] In fact, the "transmutation" of the Holy Gifts does not make them into an image, but into "the most pure Body and the most precious Blood" of Christ. This is why the very act of calling the Eucharist an "image" was foreign and incomprehensible to the Orthodox. The Fathers of the Seventh Ecumenical Council will respond to this reasoning by stating that "neither the Lord, nor the Apostles, nor the Fathers, ever used the term 'images' to speak of the unbloody sacrifice offered by the priest, but always called it the very Body and Blood."[6] "For the Orthodox, not only was the icon not consubstantial with (ὁμοούσιον) or identical to (ταυτὸ) its prototype, as it was for the iconoclasts, but on the contrary, according to the Orthodox apologists, the very idea corresponding to the word 'icon' (εἰκών) implies an essential difference between the image and its prototype";[7] "because the representation is something different from that which is represented," says St. John of Damascus.[8] This is why the holy Patriarch Nicephorus finds this theory that the image has the same nature as its prototype "senseless and ridiculous."[9] He explains that "the icon bears a resemblance to the prototype . . . or it is an imitation of the prototype and

[5]"Osnovy spora o sviatykh ikonakh," *Seminarium Kondakovianum II* (Prague, 1928), p. 48.

[6]Sixth session, Mansi 13: 264.

[7]G. Ostrogorsky, "Osnovy spora . . ." p. 48.

[8]*Third Treatise*, ch. 16, PG 94: 1337.

its reflection, but by its nature (τῇ οὐσίᾳ καὶ τῷ ὑποκει-
μένῳ), it is distinguishable from its prototype. An icon re-
sembles its prototype because of the perfection of imitating
art, but it is distinguishable from its prototype by its nature.
And if it were not distinguishable from its prototype, it would
not be an icon, but it would be the prototype itself."[10] St.
Theodore the Studite expresses himself more crudely: "No one
could be so foolish as to think that reality and its shadow . . .
the prototype and its representation, the cause and the conse-
quence are by nature (κατ᾽ οὐσίαν) identical."[11] "Patriarch
Nicephorus certainly grasped the very essence of the question,"
writes Ostrogorsky, "when, having indicated the difference be-
tween an image and its prototype, he asserts that those who do
not accept this difference, who do not understand it, can rightly
be called idolaters.[12] In fact, if the icon were identified with
the person it represents, it would be impossible for an even
slightly developed religious conscience to venerate icons.
Everyone agrees on this. And the person who was unable to
understand a relationship other than that of essential identity
obviously had to repudiate all veneration of icons. On the
other hand, the question of idolatry could not even come up
for the person who saw, in the very notion of the image, the
essential difference between the image and the person being
represented and with whom the icon was only connected in a
certain way."[13]

 Thus, iconoclastic thought could accept an image only when
this image was identical to that which it represented. Without
identity, no image was possible. Therefore, an image made by
a painter could not be an icon of Christ. In general, figurative
art was a rejection of the dogma of the divine Incarnation.
"What then does the ignorant painter do when he gives a form
to that which can only be believed in the heart and confessed
with words?" asked the iconoclasts. "The name of Jesus Christ
is the name of the God-Man. Therefore," they said, "you com-

[9]PG 100: 225 ff.
[10]PG 100: 277A.
[11]PG 99: 341B.
[12]PG 100: 277B.
[13]G. Ostrogorsky, "Osnovy spora . . ." p. 50-51.

mit a double blasphemy when you represent Him. First of all, you attempt to represent the unrepresentable divinity. Second, if you try to represent the divine and human natures of Christ on the icon, you risk confusing them, which is monophysitism. You answer that you only represent the visible and tangible flesh of Christ. But this flesh is human and, therefore, you represent only the humanity of Christ, only His human nature. But, in this case, you separate it from the divinity which is united with it, and this is Nestorianism. In fact, the flesh of Jesus Christ is the flesh of God the Word; it had been completely assumed and deified by Him. How, then, do these godless persons," asserts the decision of the iconoclastic council, "dare to separate the divinity from the flesh of Christ and represent this flesh alone, as the flesh of an ordinary man? The Church believes in Christ who inseparably and purely unites in Himself divinity and humanity. If you only represent the humanity of Christ, you separate His two natures, His divinity and His humanity, by giving this humanity its own existence, an independent life, seeing in it a separate person and thus introducing a fourth person into the Holy Trinity."[14] In other words, the iconoclasts believe that an icon cannot express the relationship which exists between the two natures of Christ. It is therefore impossible to make His icon, that is, to represent with human means the God-Man. This is why the Eucharist is the only possible icon of the Lord. G. Ostrogorsky writes that "it is characteristic that certain modern scholars, and particularly Protestant theologians, consider this reasoning not only to be well founded, but also to be irrefutable, not seeing that they are simply missing the point."[15]

We see that the iconoclasts tried to justify their position with the Chalcedonian dogma. But the flaw in their reasoning, which those who defended icons did not fail to point out, was precisely in their fundamental incomprehension of the dogma of the God-Man. Chalcedon makes a very clear distinction between *nature* on the one hand, and *person* or *hypostasis* on the other. It is precisely this clarity which is lacking

[14]See Hefele, *op. cit.*, pp. 697-703. Abridged form of the iconoclastic horos.

[15]G. Ostrogorsky, "Osnovy spora . . . " p. 50.

in iconoclastic thought. The iconoclasts see only two possibilities in the image of the incarnate God the Word: Either, in representing Christ, we represent His divine nature, or, in representing the man Jesus, we represent His human nature distinct from His divinity. Both cases are heretical. There is no third possibility.

But the Orthodox, fully aware of the distinction between nature and person, maintain precisely this third possibility, which abolishes the iconoclastic dilemma. The icon does not represent the nature, but the person: Περιγραπτὸς ἄρα ὁ Χριστὸς καθ᾽ ὑπόστασιν κἂν τῇ Θεότητι ἀπερίγραπτος, "Christ is describable according to His hypostasis, remaining undescribable in His Divinity," explains St. Theodore the Studite.[16] When we represent our Lord, we do not represent His divinity or His humanity, but His Person which inconceivably unites in itself these two natures without confusion and without division, as the Chalcedonian dogma defines it.

The monothelites of old had attributed to the person that which was part of the nature. Christ is a person, they said, therefore He has only one will, one action. In contrast, the iconoclasts attributed to the nature that which belongs to the person. From here stems the confusion in iconoclastic thought. If will and action are characteristic of both natures of Jesus Christ, so that He has two wills and two actions which correspond to His two natures, then His image is not characteristic of either of His natures, but of His person, of His hypostasis. The icon is not an image of the divine nature. It is an image of divine person incarnate; it conveys the features of the Son of God who came in the flesh, who became visible and therefore could be represented with human means. The Orthodox did not even ask the question of nature. Aware of the primordial difference between nature and person, they clearly understood that an icon, like an ordinary portrait, could only be a personal image, because "nature does not exist alone, but appears in persons," explains St. John of Damascus.[17] In other words, nature exists only in persons, and each person fully

[16]*Third Refutation*, ch. 34, PG 99: 405B.

[17]*On the Orthodox Faith*, ch. 5, "On the number of natures," PG 94: 1004A.

possesses his own nature. The nature is the same in all men, but each man is unique and irreplaceable. When we represent men, we do not represent a number of variants of one and the same nature, nor do we represent certain aspects of this nature. We represent concrete persons—Peter, John, Paul, *etc.*—with traits characteristic of these persons.[18] An icon is connected with its prototype not because it is identical to that which it represents, but because it portrays his person and carries his name. This is precisely what makes communion with the represented person possible, what makes him known. It is because of this connection that "the honor rendered to the image belongs to its prototype," according to the Fathers of the Seventh Ecumenical Council, quoting the words of St. Basil the Great. In their explanations, the Fathers often refer back to the comparison between the icon and the secular portrait. For example, they say that the portrait of the emperor is the emperor; similarly, "the representation of Christ is Christ," and that of a saint is the saint. "And the power is not sundered, nor is the honor divided, but the honor rendered to the image belongs to the person whom this image represents."[19]

In other words, the iconoclasts see only two alternatives: identity of the two objects or difference between them. The Orthodox, however, even when a difference between the natures exists, admit a certain connection between the two objects, which can simultaneously be distinct and identical. The persons of the Holy Trinity are distinct one from another, but they are consubstantial, that is, identical in nature. In an icon, on the other hand, there is a difference of nature and an identity of person. St. Theodore the Studite expresses it as follows: "In the Trinity, Christ differs from the Father by His person. Similarly, in icons, He differs from His own representation by nature."[20]

Having rejected the basis of Christian iconography, the

[18]The Fathers use word *person* (ὑπόστασις) in a sense completely different from that of contemporary language, where "person" is synonymous with "individual." Cf. the Orthodox teaching on nature, person and grace, in V. Lossky's *The Mystical Theology of the Eastern Church*, (London, 1957).

[19]St. John of Damascus, appendices to the *First Treatise in the Defense of Holy Icons*, PG 94: 1256A.

[20]*Third Refutation*, ch. 3 § 7, PG 99: 424.

image of Christ, the iconoclasts naturally also rejected all other icons. Once the icon of Christ has been rejected, they said, it is wrong to accept others, that is, the icons of the Virgin and the saints.

As we have mentioned, the declaration of faith of the iconoclastic council, having modified Constantine Copronymus' point of view, speaks of the Virgin and the saints with the greatest respect: "How can we dare to represent, with the help of a pagan art, the Mother of God, who is higher than the heavens and the saints," and "with dead and gross material, to offend the saints who shine like the stars." But, beginning with this declaration of profound veneration, iconoclasm, in the course of its normal "organic" development, reaches the point of repudiating the veneration of the Mother of God and the saints. The Byzantine chronicler Theophanes asserts that Emperor Leo III already refused to venerate the Virgin and the saints, but this assertion is not confirmed by other sources. In any case, St. John of Damascus, immediately responding to the imperial iconoclastic edict, with his first treatise in the defense of holy icons, foretold very clearly where the rejection of icons would eventually lead. Responding to the rather moderate iconoclastic trend of his time, he writes: "If you make images of Christ and not of the saints, it is obvious that you do not prohibit the representation, but the veneration of saints . . . You do not fight against icons, but against the saints."[21] Thus, St. John of Damascus very clearly sees the intimate connection which exists between the veneration of icons and that of saints. He also sees the consequences of the refusal to represent them. The refusal to venerate saints would naturally lead the iconoclasts to deny the veneration of their relics and, more generally, of all material objects. For the Orthodox, however, salvation is connected precisely with matter, for this salvation is realized in the hypostatic union of God and human flesh. Responding to the iconoclasts, St. John of Damascus wrote: "I do not adore matter, but I adore the Creator of matter, who became matter for my sake, who was willing to live in matter and who, with matter, achieved my salvation."[22]

[21]*First Treatise*, ch. 19, PG 94: 1249.
[22]*Ibid.*, ch. 16, PG 94: 1245.

As we see, iconoclastic ideology was opposed to some of the most essential points of the teaching of the Orthodox Church. The very understanding that iconoclasts had of icons was diametrically opposed to the Orthodox understanding. This is why the two sides could not reach any agreement: They were speaking in two different languages. The iconoclastic theory of the image as consubstantial to its prototype had its origin in a magical eastern understanding which makes no distinction between divinity and its image, which identifies the image with divinity, so that the image becomes an idol. It is natural that with such an understanding of the image, an icon, for a Christian conscience, must have appeared to be an idol, and its veneration—idolatry.[23] This is why, in the words of St. John of Damascus, they "confuse the pious practice of the Church with the absurd practice of the pagans." As for the iconoclastic argument for the impossibility of representing Christ, it also reflects an insufficient awareness of the reality of the Gospel story.[24]

The iconoclasts formulated a whole series of other reasons against the veneration of icons. "There are no prayers," they said, "consecrating icons, making them into sacred objects. Thus, icons are not sacred objects; they are ordinary objects, having only the value conferred on them by the painter,"[25] that is aesthetic, psychological, historical, etc. Here is what the Fathers of the Seventh Ecumenical Council answer to this: "Many objects which we consider to be sacred are not sanctified by special prayers because they are full of holiness and grace in themselves." This is why we consider objects of this kind to be worthy of veneration and why we kiss them. Thus, the vivifying cross itself, even though it is not sanctified by a special prayer, is considered to be worthy of veneration and is used as a means to gain sanctification. Therefore, the iconoclasts must either acknowledge the cross itself as an ordinary object, not worthy of veneration because it is not sanctified by a special prayer, or else they must also acknowledge the icon as sacred

[23]G. Ostrogorsky, "Osnovy spora . . .", p. 50.
[24]G. Florovsky, *Vizantiiskie Otssy V-VIII vekov* (Paris, 1933).
[25]Sixth session, Mansi 13: 268 ff.

and worthy of veneration.[26] But the iconoclasts never ceased venerating the cross, which is quite an inconsistency, given their attitude towards icons. According to the Fathers of the Seventh Ecumenical Council, icons are full of grace and holiness simply because they are sacred objects—"holy icons"—and because they contain grace. "Divinity is equally present in an image of the cross and in other divine objects," says St. Theodore the Studite, "not by virtue of identity of nature, for these objects are not the flesh of God, but by virtue of their relative participation in divinity, for they participate in the grace and in the honor."[27] An icon is sanctified by the name of God and by the names of the friends of God, that is, the saints, explains St. John of Damascus,[28] and this is the reason why the icon receives the grace of the divine Spirit.[29]

Besides their theological arguments, the iconoclasts also used scriptural arguments from patristics. In addition to the most important one, the Old Testament prohibition, the iconoclasts also referred to the absence in the New Testament of any indication that icons should be made or venerated. "The practice of making icons of Christ has no basis either in the tradition of Christ, or in that of the Apostles, or in that of the Fathers," they asserted.[30] "But," responds St. Theodore the Studite, "nowhere did Christ order that even a few words be written. And, nevertheless, His image was drawn in writing by the Apostles and preserved up to the present. What is, on the one hand, represented with ink and paper, is represented on an icon with various colors or other materials."[31]

[26]Mansi 13: 269D.

[27]*First Refutation*, ch. 10, PG 99: 340.

[28]*Second Treatise*, ch. 14, PG 94: 1300.

[29]The iconoclastic accusation, like the Orthodox response, proves that in the time of the Seventh Ecumenical Council the rite of the blessing of icons did not exist. This is very interesting for us, given our practice of blessing icons. In fact, the benediction rite is not always well understood by the Orthodox faithful. Frequently, they bring to church a painting with a religious theme, which in no way can be called an icon, and think that if the priest blesses it, it will become an icon. However, the benediction rite of an icon is not a magic formula. An image which is not an icon does not become an icon because it is blessed.

[30]Quoted in the sixth session of the Seventh Ecumenical Council, Mansi 13:268B-C.

[31]*First Refutation*, ch. 10, PG 99: 340 D.

Ignoring the canons of the Quinisext Council, the icono-
clasts asserted that the ecumenical councils had not given any
instruction on this subject. After the iconoclastic council of
754, they hid the texts which mentioned the story of the Holy
Face, as we learn in the acts of the Seventh Ecumenical Council.
In the fifth session of this council, books are mentioned which
had been hidden by the iconoclasts and which were brought to
the council.[32] The iconoclasts are also accused of falsifying
texts of the Fathers. Thus, they frequently used the writings
of St. Epiphanius of Cyprus, a holy bishop of the fourth cen-
tury, but they added an iconoclastic passage to Epiphanius'
authentic statements. The writings of St. Epiphanius were
studied by the Patriarch of Constantinople, St. Nicephorus, in
a work entitled *Against Epiphanides*[33] and also in his refuta-
tion of the second iconoclastic council. Patriarch Nicephorus
frequently quotes the writings of St. Epiphanius and comes to
the conclusion that they had been falsified by the iconoclasts.
St. John of Damascus was already aware of this falsification.
Both the Fathers of the Seventh Council and St. John assert
that the passage in question must have been false, if only be-
cause in Cyprus, where St. Epiphanius had been a bishop, his
disciples had decorated churches with paintings while he was
still living. It should be noted that some scholars in our times
still consider St. Epiphanius as having been personally hostile
to images in his authentic writings.[34] But G. Ostrogorsky, bas-
ing himself on documents in the Bibliothèque Nationale in
Paris, maintains the contrary: that St. John of Damascus, the
Fathers of the Seventh Ecumenical Council and St. Nicephorus
were correct, and that the iconoclastic text attributed to St.
Epiphanius was not written by him.[35]

The iconoclasts also attributed to St. Theodotus of Ancyra
(fifth century) a text very hostile to images, which the Fathers
of the Seventh Ecumenical Council considered as a falsifica-

[32]Mansi 13: 169.

[33]*Adversus Epiphanidem*, ed. J. B. Pitra, *Spicilegium Solesmense* IV,
p. 292 ff.

[34]Cf. Karl Holl, *Die Schriften des Epiphanios gegen die Bilderverehrung*
(1928).

[35]*Studien zur Geschichte des byzantinischen Bilderstreites*, ch. 3.

tion. The iconoclasts managed to find an iconoclastic tendency
even in St. Basil the Great, whom we have seen as a venerator
of images. "The lives of blessed men," St. Basil wrote, "are in
a way images of a life pleasing to God." From these words,
the iconoclasts come to the conclusion that painted images were
useless since written images existed.[36] Finally, the Fathers of
the Seventh Ecumenical Council admit the legitimacy of the
iconoclastic reference to Eusebius of Caesarea, but Eusebius'
authority has little weight because of his tendency towards
Arianism.

As we know, the first part of the iconoclastic period ends
at the Seventh Ecumenical Council, which held its first session
in Nicaea on September 24, 787. The acts of this council con-
tain 307 signatures. The Pope of Rome, at that time Hadrian I,
sent two legates; the patriarchs of Alexandria and Antioch
likewise sent their representatives, who also brought a message
from the Patriarch of Jerusalem expressing his approval of the
restoration of the worship of icons.

The council began with the acceptance, after public peni-
tence, of eleven iconoclastic bishops into the Church. At the
second meeting, two messages of Pope Hadrian I were read,
one to the Patriarch of Constantinople, St. Tarasius, the other
to Emperor Constantine and his mother, the Empress Irene.
The pope expresses his approval of the veneration of icons,
but his confession of Orthodoxy amounts to a refutation of the
accusation of idolatry. For the Eastern Church, this was, as we
have seen, almost an anachronism. The Pope refers to the
biblical account of the image of cherubim in the tabernacle.
He then quotes a series of Greek and Latin Fathers who, in his
opinion, are in favor of icons. In particular, he brings up a
text of the Pope St. Gregory I on the illiterate who must read
on the walls of churches that which they cannot read in books.
All of this, for want of the basic christological argument, could
not have sounded very convincing either to the Orthodox or to
the iconoclasts. But the opinion of the Pope of Rome, the first
in honor among the bishops, demanded exceptional respect.
To give the message of the pope more weight, the Greeks com-

[36]Sixth session of the Seventh Ecumenical Council, Mansi 13:300 AB.

pleted the quotation of St. Gregory the Great—"the illiterate must read on the walls of the churches that which they cannot read in books"—by the following precision: "and in this way, with the intermediary of images, those who gaze upon them raise themselves to the faith and the recollection of the salvation through the incarnation of our Lord, Jesus Christ." Thus they gave the reasoning of the pope a christological basis, raising it to the level of Byzantine theological discussions.[37] The text of the pontifical letters was also expanded in passages dealing with other questions. The two legates did not react against these amendments and declared at the council that the modified messages were the very ones they had brought.[38]

The decisions of Nicaea are based primarily on Scripture. Among the quoted texts are Exodus 25:1, 17-22, where God orders that images of cherubim be placed in the tabernacle; Numbers 7:88-89, where God speaks to Moses from among the cherubim; and Ezekiel 3:16-20, the vision of Ezekiel of the temple with the cherubim. From the New Testament, the Fathers quote Hebrews 9:1-5, where the tabernacle is mentioned. Patristic references include St. John Chrysostom, St. Gregory of Nyssa, St. Basil the Great, St. Nilus of Sinai and others which we have already mentioned, and Canon 82 of the Quinisext Council.

Then the council was faced with the question of how icons should be venerated. Opinions were divided on this question. Some, such as the Patriarch of Constantinople, St. Tarasius, believed that icons should be venerated on the same level as sacred vessels. Others, such as the representatives of the eastern patriarchs, maintained that images had the same importance as the cross. The council decided that the latter position was correct.

The iconoclasts were excommunicated and their works were confiscated. The legates of the pope took the initiative of placing an icon in the middle of the cathedral of Haghia So-

[37]It must be noted that, among the Western writers, only Pope St. Gregory II resorts to the dogma of the incarnation in his apologetic for the image.

[38]See G. Ostrogorsky, "Rom und Byzanz im Kampfe um die Bilderverehrung," *Seminarium Kondakovianum* 6 (Prague, 1933), pp. 73-87.

phia, where the council had taken place, and it was solemnly venerated by everyone.

The iconoclastic council called together by Constantine Copronymus was rejected, since the other local churches had not adhered to it. It could not be called the "Seventh Council" because it was contrary to the six others, in particular to the Quinisext Council, which the Fathers called the "Sixth Ecumenical Council."

The last two meetings were devoted to drafting the doctrinal decision itself. Here is the next:

> We retain, without introducing anything new, all the ecclesiastical traditions, written or not written, which have been established for us. One of these is the representation of painted images (εἰκονικῆς ἀνα-ζωγραφήσεως), being in accord with the story of the biblical preaching, because of the belief in the true and non-illusory incarnation of God the Word, for our benefit. For things which presuppose each other are mutually revelatory.
>
> Since this is the case, following the royal path and the teaching divinely inspired by our holy Fathers and the Tradition of the catholic Church—for we know that it is inspired by the Holy Spirit who lives in it—we decide in all correctness and after a thorough examination, that, just as the holy and vivifying cross, similarly the holy and precious icons painted with colors, made with little stones or with any other matter serving this purpose (ἐπιτηδείως), should be placed in the holy churches of God, on vases and sacred vestments, on walls and boards, in houses and on roads, whether these are icons of our Lord God and Savior, Jesus Christ, or our spotless Sovereign Lady, the holy Mother of God, or the holy angels and holy and venerable men. For each time that we see their representation in an image, each time, while gazing upon them, we are made to remember the prototypes, we grow to love them more, and we are even more induced to worship them by kissing them and by witnessing our veneration (προ-

σκύνησιν), not the true adoration (λατρείαν) which, according to our faith, is proper only to the one divine nature, but in the same way as we venerate the image of the precious and vivifying cross, the holy Gospel and other sacred objects which we honor with incense and candles according to the pious custom of our forefathers. For the honor rendered to the image goes to its prototype, and the person who venerates an icon, venerates the person represented on it. Indeed, such is the teaching of our holy Fathers and the Tradition of the holy catholic Church which propagated the Gospel from one end of the earth to the other. Thus, we follow Paul, who spoke in Christ, and the entire divine circle of apostles and all the holy Fathers who upheld the traditions which we follow. Thus, we prophetically sing the hymns of the victory of the Church: Sing aloud, O daughter of Zion; shout, O Israel! Rejoice and exult with all your heart, daughter of Jerusalem! The Lord has taken away the judgments against you, he has cast out your enemies. The King of Israel, the Lord, is in your midst; you shall fear evil no more (Zephaniah 3.14-15).

Thus, we decide that those who dare to think or teach differently, following the example of the evil heretics; those who dare to scorn the ecclesiastical traditions, to make innovations or to repudiate something which has been sanctified by the Church, whether the Gospel or the representation of the cross, or the painting of icons, or the sacred relics of martyrs, or who have evil, pernicious and subversive feelings towards the traditions of the catholic Church; those, finally, who dare give sacred vases or venerable monasteries to ordinary uses, we decide that, if they are bishops or priests, they be defrocked; if they are monks or laymen, they be excommunicated.[39]

In the conciliar decision, the Fathers frequently refer to the Tradition or traditions of the Church. Thus, "retaining the

[39]Mansi, 13:377-380.

established ecclesiastical traditions," the Council makes its decision according to the "teaching divinely inspired by the Fathers and the Tradition of the catholic Church." As we see, the Fathers of the council used the word "tradition" both in the plural ("the traditions of the catholic Church") and in the singular ("the Tradition of the catholic Church"). This plural and singular correspond to the meaning given to the word "tradition" in each case.

Ecclesiastical traditions are the rules of faith passed on by the holy Fathers and retained by the Church. These are the various forms which externally convey the divine revelation, forms which are connected with the natural faculties and peculiarities of men—word, image, movement, custom. This includes the liturgical, iconographic or other traditions. In the latter case, the word "tradition," used in the singular ("the Tradition of the catholic Church") had a different meaning. "The true and holy Tradition," says Metropolitan Philaret of Moscow, "is not simply a visible or oral transmission of teaching, canons, rites or customs; it is simultaneously a real but invisible conveyance of grace and sanctification."[40] The idea of Tradition can, in this case, be defined as the life of the Church of the Holy Spirit, who communicates to every member of the body of Christ, the faculty of hearing, seeing and recognizing the truth in its true light and not in the light of human intelligence. It is the true knowledge produced in man by the divine light which "has shone in our hearts to give the light of knowledge of the glory of God" (2 Cor. 4:6). In other words, Tradition is the faculty of knowing the truth in the Holy Spirit, the communication of the "Spirit of Truth" to man which realizes the fundamental faculty of the Church—its awareness of the revealed truth, its ability, in the light of the Holy Spirit, to discern that which is true and that which is false. Only by living in Tradition can we say: "It has seemed good to the Holy Spirit and to us" (Acts 15:28).[41] This Tradition lives and is communicated in a variety of forms, of which

[40]Quoted from G. Florovsky, *Puti russkogo bogosloviia* (Paris, 1937).

[41]On this subject, see the article of V. Lossky, "Tradition and Traditions," in *The Meaning of Icons* (Olten, Switz., 1952).

one is iconography, as the Fathers of the Seventh Ecumenical Council say.

Scripture itself was written according to Tradition; during the first decades of its existence, the Church did not have Scripture yet, and lived only according to Tradition. Even those things which had been accomplished by Christ during His life on earth are not revealed to us only from Scripture: "But there are also many things which Jesus did; were every one of them to be written, I suppose that the world itself could not contain the books that would be written" (John 21:25), says the beloved disciple of Christ. St. John of Damascus comments: "The Apostles passed on many things without having written them down; the Apostle of the Gentiles is a witness to this: 'So then, brethren, stand firm and hold to the traditions which you were taught by us, either by word of mouth, or by letter' (2 Thess. 2:15). And in Corinthians, he writes: 'I commend you because you remember me in everything and maintain the traditions even as I have delivered them to you' (I Cor. 11:2)." [42]

Thus, the Fathers of the Seventh Council are right in saying: "We follow Paul . . . and the whole divine circle of Apostles," because "the tradition of making painted images existed already in the time of the apostolic preaching, in the same way as we see it in the teachings of the holy Fathers and historians who witness this fact in the writings which have been preserved." [43] In other words, iconography is a way of expressing Tradition which existed from the beginning of Christianity, a way of conveying the divine revelation.

An icon, being the result of human action and human effort, is inspired and directed by the Holy Spirit who lives in the Church. Being one of the ways to express Tradition, it is "simultaneously a real but invisible transmission of grace and sanctification," as Metropolitan Philaret put it. Tradition lives and is communicated through the icon, just as it is communicated, for example, through liturgical texts. In other words, the council asserts a divine inspiration for the icon, because

[42]*On the Orthodox Faith*, 14, ch. 16, PG 94: 1173 and 1176.

[43]Sixth session, Mansi 13:252.

the Holy Spirit inspires the teaching of the Apostles and the Fathers and similarly inspires iconography. In both cases, the source of the inspiration is the same. This is why the icon is rightly called "theology in images," parallel to theology in words. This is also why the Fathers of the Seventh Ecumenical Council say that "iconography was not at all invented by painters, but, on the contrary, it is an approved institution and a tradition of the catholic Church."

The true, sacred Tradition is possible only in the Church, which is the continuation of Pentecost, that is, only in the Church in which the grace of the Holy Spirit, who reveals the truth and strengthens us in it, flows uninterruptedly.[44] The council teaches through the Holy Spirit living in the Church, establishing the dogma of the veneration of icons. The icon must be an object of our veneration, not of the true adoration (λατρεία) which belongs only to God, but precisely the veneration (προσκύνησις) which we show to the cross and the Gospel; in other words, we must venerate the visible image in the same way as we do the verbal image and other sacred objects.

If the Church in the first centuries did not acknowledge icons, we would have to ask, along with the Russian theologian A. S. Khomiakov, where would the truth be if the judgment which the Church makes today contradicts the judgment it made yesterday.[45] Only the living, uninterrupted Tradition can guarantee the true knowledge of the revelation. "The Church could not have preserved the divine life which it had been given if it had denied various periods of its history, if it submitted its dogmatic teaching to revision . . . renouncing the experience of its spiritual life and its mode of piety, renouncing its worship and replacing it with a new worship."[46]

The council, therefore, asserts that the icon, like the Scriptures, helps "to prove the true and non-illusory incarnation of God the Word." This is a point made already by Canon 82 of

[44]Metropolitan Philaret, quoted by G. Florovsky, *Puti* . . . p. 180.

[45]A. Khomiakov, *Opyt Katikhizitcheskogo izlozhenia uchenia o Tserkvi, izbrannie sochinenia* (New York, 1955), p. 210.

[46]P. Victorov, "O pravoslavnom ponimanii dogmata," *Journal of the Moscow Patriarchate*, 1956, No. 8, p. 52.

the Quinisext Council, which stated that the icon is based on the incarnation. The icon can be used to refute all kinds of abstract ideas of the incarnation and the errors and heresies to which these ideas give birth. This reference to the incarnation demonstrates that the icon, like the Holy Scripture, is based on historical facts. The historical basis of the image gains a decisive importance. Through the icon of Christ, the Church constantly reminds us of the concrete, historical character of the incarnation of God the Word. In the Gospel, it indicates the time and place of His nativity. In the Creed, it mentions the moment of His death "under Pontius Pilate." Even before the council, the holy Patriarch Tarasius insisted in his letter to the emperor and the empress that it was necessary to abide by the historical exactness of the image. "It is proper to accept the precious icons of our Lord, Jesus Christ," he wrote, "because He became a perfect man, if these icons are painted with a historical exactness, conforming to the biblical account . . ."[47] Clearly, the patriarch is speaking here not only of the physical resemblance of the icon of Christ to its historical prototype, but also of the spiritual content of the image, for the Gospel is a verbal icon of Christ, the image of His spiritual perfection.

This relationship between the icon and the Holy Scripture, its conformity with the biblical preaching, the relationship between iconographic and biblical realism, completely excludes any possibility of painting icons of Christ or of the saints according to the painter's imagination, renouncing the tradition established by the Church or using a live model. Indeed, in this latter case, the relationship between the image and the biblical teaching is suppressed.

The conciliar decision asserts that the Holy Scripture and the holy image are "mutually revelatory." One single content is witnessed in two different ways—with words or with images —conveying the same revelation in the light of the same sacred and living Tradition of the Church. We read in the council's canons: "The Fathers neither transmitted to us that it was necessary to read the Gospel nor did they convey to us that it was necessary to make icons. But if they conveyed the one, they

[47]Mansi 13:404 D.

also conveyed the other, because a representation is inseparable from the biblical account and, *vice versa*, the biblical account is inseparable from a representation. Both are right and worthy of veneration because they explain one another and, indisputably, substantiate one another."[48] Later, the Fathers give a very simple example: "If we say that the sun is above the earth, it is obviously daytime. Similarly, if we say that it is daytime, it would be clear that the sun is above the earth." [49] Just as the word of the Scripture is an image, the painted image is a word. "That which the word communicates by sound, the painting demonstrates silently by representation," say the Fathers of the council, referring to St. Basil the Great. Elsewhere they say: "By means of these two ways which complete one another, that is, by reading and by the visible image, we gain knowledge of the same thing."[50]

For the Church, therefore, the icon is not an art illustrating Holy Scripture; it is a language which corresponds to Scripture, to the very contents of Scripture, to its meaning, just as do the liturgical texts. This is why the icon plays the same role as Scripture in the Church; it has the same liturgical, dogmatic, educational meaning.

The icon does not convey the contents of Scripture in the form of concepts but in a liturgical and living way, addressing all of man's faculties. It transmits the truth contained in Scripture in the light of the entire spiritual experience of the Church, of its Tradition. Liturgical texts both reproduce the letter of Scripture and are interwoven with it. By alternating and juxtaposing scriptural passages, they reveal their meaning; they teach us the living contents of the biblical preaching. The icon, representing various moments in sacred history, conveys the same fundamentally visible meaning. Thus, both through the liturgy and the icon, the Scripture lives in the Church and in each of its members.[51] This is why the union of

[48]Sixth session, Mansi 13:269 A.
[49]*Ibid.*
[50]Mansi 13:300 C.
[51]It should be noted that the image has certain possibilities which the word does not have: it is a more direct form of expression, it has a better capacity for conveying general ideas than the word. Thus, an icon portrays directly and concisely that which is expressed in the entire liturgy of a feast.

the liturgical image and the liturgical word is of capital importance, because these two modes of expression control one another. In worship, they share a common, constructive action. The denial of one of these modes of expression leads to the downfall of the other as well.

Like the liturgical texts, the sacred image conveys the dogmatic teaching and expresses the life of the Church in its Tradition. The divine revelation penetrates the faith both through the liturgy and through the icon, sanctifying their life and giving them their true meaning, becoming the fundamental task to be fulfilled by the faithful. This is why, from the beginning, the icon had a special character, just as the liturgical texts have a specific form and character. The Church creates an image which corresponds to its specific nature, and this nature of the Church marks its image and defines its purpose. The Church, according to the word of its Leader and Founder Himself, is a "Kingdom . . . not of this world" (John 18:36). But it lives in the world and *for* the world. It can only fulfill its mission by remaining itself, that is, by remaining distinct from the world, by retaining its specific nature. This is why all the ways by which it fulfills its saving mission are absolutely distinct from the ways of the world. Architecture, painting, music, poetry, lose their autonomy: They do not seek any longer for special effects characteristic of each one of them. In worship, they are subordinated to a single goal. They begin following completely new norms defined by the direction of Christian life, as is described by St. Paul (Rom. 8:12) and the Epistle to Diognetus, this direction which makes man live *in* the flesh, but not *according to* the flesh. "Thus, brethren, let us not accomplish in an impure manner that which is holy," says St. Gregory the Theologian, "nor in a vile manner that which is sublime, nor in a dishonorable manner that which is honorable, nor, to put it briefly, in an earthly manner that which is spiritual . . . In us, everything is spiritual—action, desire, words, even bearing and clothing, even a gesture, because the intellect (νοῦς) extends over everything and in every way forms man according to God; thus, even our gaity is spiritual and solemn." [52]

[52] *Or.* 11, addressed to St. Gregory of Nyssa, PG 35:840 A.

Because the icon contains and announces the same truth as the Gospel, in the light of the same sacred Tradition of the Church, it must be distinct from all other representations, just as the Gospel is distinct from all other literary works. This is why any elements from secular art which penetrate into the icon, of which we have already spoken (sensual or illusory characteristics, *etc.*) secularize the icon, decreasing its relationship to the Holy Scripture and, thus, contradicting the decision of the Seventh Ecumenical Council. This is why the authenticity of the image is no less important than that of the Gospel text. And this authenticity is both historical (because only an image historically faithful to Christ or to a saint can be used as a link to them) and spiritual, that is, implying the true transmission of the image of God restored to man by the God-Man, Jesus Christ. Therefore, the criterion of authenticity should be the same for both sacred texts or liturgical poetry; and for the icon this means a criterion requiring a relationship between the icon and Church Tradition, its spirit and meaning, that is, that which we call the Church's Canon.

The liturgical role of the icon is not limited to conveying a teaching. Quoting the words of St. Basil the Great, the Seventh Ecumenical Council asserts that "the honor rendered to the image passes to its prototype, for the person who venerates an icon venerates the person represented on it." Thus, icons are intermediaries between the represented persons and the praying faithful, causing them to commune in grace. In a church during the liturgy, the faithful, through the intermediary of icons and liturgical prayers, enter into communion with the heavenly Church, forming with it a single whole. In its liturgy, the Church is one. It includes in all fullness the angels and men, the living and the dead, and reunites the entire creation. And when the priest or the deacon censes the Church, he embraces in his movement the saints represented on icons and the faithful gathered in the church, thus expressing the unity of the earthly and heavenly Church.

The icon is not, therefore, a factor of spiritual passivity, but plays a dynamic and constructive role. This is why the council decided to have icons placed everywhere, in homes and on the roads, *etc.*, just as the precious and vivifying cross.

Thus, the conciliar decision testifies that the sacred image, the icon, has this same vivifying meaning as the cross: It is a confession of the truth and an announcement of faith. Thus sacred art is liturgical by its very nature, not only because it fulfills or completes the liturgy, but because it corresponds to it perfectly. Being an art of worship, the icon never "served" religion as an auxiliary element borrowed from outside and used by the Church. The icon is not external to religion. Just like the word, it is a part of religion; it is one of the ways to know God, one of the paths that bring us closer to Him.

But, let us return to the decision of the Seventh Ecumenical Council and, in particular, to the words concerning "those who dare to . . . make innovations or to repudiate something which has been sanctified by the Church, whether the Gospel, or the representation of the cross, or the painting of icons, or the sacred relics of martyrs . . ." If, in the light of these words, we consider the present situation in the so-called Christian world, we will see that only the Orthodox Church has remained faithful to this decision, even though in fact, as we know, the Orthodox are not beyond reproach in this area. In our Church, this decision is also frequently ignored, though only through ignorance or unconsciously. Outside of Orthodoxy, however, it is rejected either in theory or in practice. The Roman Church has completely abandoned its sacred art to the free judgement of artists, to "the constantly evolving laws of their trade," according to the official Roman manual, *Liturgia*.[53] It is only necessary to read the papal encyclicals on this question to be assured that the dependence of sacred art on the free judgment of painters is not just a tolerated practice of the Roman Church, but that it is the official point of view of this church. Sacred art no longer speaks a sacred language; its language has become that of the world.

The decisions of the Seventh Ecumenical Council were signed by the representatives of the entire Church, including the Roman Church. Having received the canons of the council, Pope Hadrian I had them translated into Latin. This

[53]*Encyclopédie populaire des connaissances liturgiques*, published under the direction of Rev. R. Aigrain (Paris, Bloud and Gay, 1947), ch. 6, § 4, pp. 213-214.

translation was very inaccurate and, according to a ninth-century Roman scholar, the librarian Anastasius, absolutely unreadable. It provoked many misunderstandings, such as the moderate iconoclasm of Charlemagne. The main error was found in its rendering of the very dogma of the veneration of icons. The Latin word *adoratio* was used for the Greek word προσκύνησις. But προσκύνησις means "veneration" and not "adoration," and the council specifies and particularly emphasizes that our attitude towards the image should be one of respect and veneration, but not one of true adoration, which belongs only to God. But the real tragedy of this translation was that it was taken seriously in the West.

Charlemagne, to whom the pope sent the canons of the Seventh Ecumenical Council (in Latin), was revolted by what he read and protested violently to Hadrian I. In response to what he believed to be the canons of the council, he sent a document called the *Libri Carolini*, which had been drawn up by his Frankish theologians. Some examples of the way in which these theologians understood the canons of the Seventh Ecumenical Council can be noted. To the iconoclasts who claimed that only the Eucharist was the true image of Christ, the council had answered that neither Christ nor the Apostles nor the Fathers had ever called the eucharistic gifts images, but had called them the true Body and Blood of Christ. Not having understood either the iconoclastic assertion nor the Orthodox response, the Frankish theologians wrote in response to the Seventh Ecumenical Council: "It is absurd and rash to place icons and the Eucharist on the same level and to say that just as the fruits of the earth (that is, bread and wine) are transformed into a mystery worthy of our veneration, similarly images are transformed into the veneration shown to the persons represented on these images." This is very simply a meaningless statement. Here is Hefele's comment: "The Council if Nicaea did not say this, nor anything like it." Pope Hadrian I had to explain in his answer that it was not the Fathers of the council, but the iconoclasts who had confused the Eucharist and the image.[54]

But the most important was not the poor translation of

[54]Hefele, *Histoire des Conciles*, vol. III, part 2, p. 1073.

the council's decrees, but the basic difference between the at-
titudes of the Greeks and the Franks towards the icon. Thus
in the *Libri Carolini* we read: "They (that is, the Greeks)
place almost all their hope in icons, while we venerate the
saints in their body or, rather, in their relics or clothing, fol-
lowing the tradition of the ancient Fathers." But the Greeks
did not show any preference to icons over relics; they only
placed each in its place. "The icon cannot be placed on the
same level as the cross, the sacred vases, or the Holy Scrip-
ture," assert the *Libri Carolini*, "because images are the prod-
uct of the artists' imagination."[55]

The divergences between the Fathers of the council and
the Frankish theologians are not limited to the examples which
we have quoted. It can be said that at the moment when the
Seventh Ecumenical Council developed the theology of the
sacred image, "at exactly the same time, the *Libri Carolini*
poisoned Western art at its very root."[56] They not only deprive
the sacred image of its dogmatic basis, but, by delivering it
to the imagination of artists, they deviate from the attitude
of St. Gregory the Great, which was already an anachronism
in the time of iconoclasm. Their attitude, which was also
that of Charlemagne, can be summarized as follows: Icons
should not be destroyed, nor should they be venerated. By
defending the existence of icons from the iconoclasts, the
West did not understand the very essence of what was hap-
pening in Byzantium. That which was, for the Byzantines, a
matter of life and death, passed unnoticed in the West. This
is why Charlemagne won his discussion with Hadrian I: The
pope was eventually obliged to give in on this particular issue.

Charlemagne called together a council in Frankfurt in
794. Consisting of more than 300 bishops, this council did
not go as far as the *Libri Carolini* and did not proscribe the
veneration of icons in favor of relics. But it rejected both
the iconoclastic council of 754 and the Seventh Ecumenical
Council, saying that "neither one nor the other deserves the
title of 'seventh.' Believing in the Orthodox doctrine which
states that images should only be used to decorate churches,

[55]*Ibid.*
[56]P. Evdokimov, *L'Art sacré*, No. 9-10 (Paris, 1953), p. 20.

and in memory of past canons according to which we should
adore only God and venerate the saints, we do not want to
prohibit images as does one of these councils or to adore them
as does the other, and we reject the writings of this ridiculous
council."[57] The whole absurdity of the situation is clear: The
Seventh Ecumenical Council forbids the adoration of icons and
the Council of Frankfurt is indignant because it decrees this
adoration. But what is most absurd is that the legates of the
same Pope Hadrian I, who had signed the decisions of the
Seventh Ecumenical Council, signed the decisions of the Coun-
cil of Frankfurt as well.

After the Council of Frankfurt, another council was held in
Paris in 825. This council also condemned the Seventh Ecu-
menical Council. Soon after the Council of Frankfurt, Bishop
Claudius of Turin, and after the Council of Paris, Bishop
Agobard of Lyons, both attacked images. Iconoclasm reached
its peak in the West when Bishop Claudius also began attack-
ing the veneration of the cross, which even the fiercest icono-
clasts in Byzantium had not dared to do.[58]

Thus, though the Council of Frankfurt approved of the
use of icons, it did not see any dogmatic or liturgical im-
portance in them. It considered them to be "decorations in
churches" and, furthermore, as "a memory of past canons."
A significant fact is that the Roman Church, even though it
recognized the Seventh Ecumenical Council, has in effect re-
mained in the same position as the Council of Frankfurt, and
this is why the image, which for the Orthodox is a language
of the Church, an expression of the divine revelation and an
integral part of its worship, never played this role in the
Latin West.

The Seventh Ecumenical Council reestablished the venera-
tion of icons. However, its teaching on the sacred image was
not accepted by its enemies. The second period of iconoclasm
soon began. As we have said, this second period brought
nothing new in the theological realm. The iconoclastic coun-
cil of 815 repealed the decisions of the Seventh Ecumenical
Council and approved those of the first iconoclastic council

[57]Hefele, *op. cit.*, p. 1068.
[58]L. Brehier, *L'Art chrétien* . . ., p. 196.

(754). Instead of theological arguments, it simply stressed again Constantine Copronymus' position on the abolition of icons.

Iconoclasm did not outlast the last iconoclastic emperor, Theophilus. A council in Constantinople, presided over by Patriarch St. Methodius, approved the teaching of the seven ecumenical councils and, in 843, proclaimed the reestablishment of the veneration of icons, the Triumph of Orthodoxy. Thus, just as iconoclasm had been a very complicated heresy, so also the reestablishment of the worship of icons was not only a victory over a particular heresy, but also a victory of Orthodoxy as such. The Church had triumphed and continued to triumph over many different heresies. But only one of its victories, that over iconoclasm, was solemnly proclaimed as the Triumph of Orthodoxy.[59]

It is important to note that iconoclasm did not renounce art as such. Iconoclasts were not enemies of art. On the contrary, they promoted it. They persecuted only the representations of Christ, of the Virgin and of the saints. Thus the iconoclasm of the eighth and ninth centuries can be likened to Western Protestantism, with the difference that the iconoclasts did not leave the walls of the churches bare. On the contrary, they enjoyed decorating them with secular subjects, landscapes, representations of animals, *etc.* Purely decorative shapes also played a large role. Iconoclastic art was both a return to the Hellenistic origins and a borrowing from the Moslem East. Emperor Theophilus in particular was a pompous prince and a great builder, who strongly encouraged monumental art. He had a palace built in the style of those of Bagdad, whose walls were covered with incrustations, mosaics and paintings of shields, weapons, all kinds of animals, trees, and flowers. He decorated the churches in this same style. When sacred images were removed everywhere, they were replaced with animals and birds. Constantine Copronymus had served as a remarkable example. In the church of Blachernae, for example, Constantine had de-

[59]The council of 843 which instituted the Triumph of Orthodoxy established the synodicon of this feast proclaiming the eternal memory of the defenders of icons and the excommunication of the iconoclasts.

stroyed a series of biblical images and replaced them with "flowers, different birds and other animals, surrounded by plants, among which cranes, crows and peacocks stirred." The emperor was reproached for having transformed the church into "an orchard and an aviary" with such images.[60] He also replaced a fresco representing the Sixth Ecumenical Council with a portrait of his favorite coachman.

While fighting for the sacred image, the Church, as we have said, was not defending the didactic or decorative role of the icon, but the essential foundation of the Christian faith, the dogma of the incarnation, of which the icon is the witness and the pledge. St. John of Damascus expressed this with resolution when he said: "I saw the human image of God and my soul was saved."[61] The dogma of the divine incarnation has two main aspects: "God became man so that man could become God." On the one hand, God comes into the world, participates in its history, "lives among us"; on the other hand, there is the purpose and meaning of this incarnation: the deification of man and, through this, the transfiguration of all creation, the building up of the Kingdom of God. The Church is the beginning of the "Kingdom to come," and this is the reason for its existence. This is why everything in the Church converges towards this aim—all life, all activity, all manifestation of human creativity, including artistic creativity.

But iconoclasm, both in its teaching and in its practices, undermined this saving mission of the Church at its very base. In theory, the iconoclasts did not renounce the dogma of the incarnation. On the contrary, they justified their hatred of the icon by invoking this same dogma. But in fact, by denying the human image of God, they denied the sanctification of matter in general and the deification of man in particular. In other words, by refusing to accept the consequences of the incarnation—the sanctification of the visible, material world—iconoclasm undermined the whole economy of salvation. "The person who thinks as you do," St. George of Cyprus said in a discussion with an iconoclastic bishop,

[60]C. Diehl, *Manuel d'art byzantin*, vol. 1 (Paris, 1925), pp. 365-366.
[61]*First Treatise*, ch. 22, with reference to Gen. 32:30, PG 94: 1256 A.

"blasphemes against the Son of God and does not confess His economy accomplished in the flesh."[62]

The iconoclastic heresy closes the series of great heresies of the first period of Church history. All of these heresies, such as Arianism, Nestorianism, Monophysitism, *etc.* attacked some aspect of the divine economy, the salvation coming from the incarnation of God. But iconoclasm was not attacking a particular aspect: It was attacking the entire economy of salvation. This is why the opinion of A. P. Lebedev: "Iconoclasm has no connection with the heretical errors of the past,"[63] and that of S. Bulgakov: "Iconoclasm in general . . . is not at all a christological heresy,"[64] do not correspond to reality. Exactly the contrary is true. Iconoclasm is the consequence of christological controversies, but under a new form. It exactly repeated all the heresies and errors of the past. According to the Fathers of the Seventh Ecumenical Council, "iconoclasm is the sum of many heresies and errors." Christianity became an abstract theory with the denial of the image. It became disincarnate, so to speak; it was driven back to the ancient heresy of docetism. It is therefore not surprising that iconoclasm was connected with a secularization of the Church, a de-sacralization of all the aspects of its life. The realm belonging to the Church, its internal structure, was violated by secular power; the churches were invaded with secular images; worship was deformed with mundane music and verse. This is why by defending the icon the Church was not only defending the foundation of the Christian faith, the divine incarnation, but also, at the same time, it was defending the very meaning of its existence: It fought for its own survival and identity.

The iconoclastic period had very important consequences for sacred art. First of all, it made the faithful more aware of the meaning of the icon. The Church adopted a more severe attitude towards abuses. Iconoclasm was partly understandable from a psychological point of view, given, on the one hand,

[62]G. Ostrogorsky, "Sochinenia pravoslavnykh apologetov," *Seminarium Kondakovianum* I (Prague, 1927), p. 46.

[63]*Istoria sviashchennykh soborov* (2nd ed., Moscow, 1876), pp. 221-222.

[64]*Ikona i ikonopotchitanie* (Paris, 1931), pp. 18-19.

the prejudices existing towards the veneration of icons, and, on the other hand, certain sensual, carnal elements, characteristic of the art of antiquity, which could be found in sacred art. As we have said, works of art existed which could even lead one to doubt the holiness of the icon. In other words, the art of the Church was not always distinguishable in its proper identity.

However, it is legitimate to ask the question: Why did the Church tolerate the existence of corrupted images so long? Why had it not formulated its teaching on the truly sacred image earlier? But the same question can be asked about any theological teaching. The fulness of the Christian teaching is already contained in the Gospels. It lived and it lives in the Church in every moment of its existence. Thus, the dogmas from the period of the great councils do not formulate anything new, but only the truths which the Church has always possessed and which it had to express in response to heresies. Even later, in spite of the perfection of the christological formulas, orthodox teaching is not accepted universally. New heresies appear and, in the following centuries, the Church continues to make its teaching explicit by new dogmatic formulas. A striking example is holiness, or more exactly, the sanctification of man by the Holy Spirit. The experience of this sanctification has, since Pentecost, always existed in the Church. But the theoretical teaching on the sanctification of man by grace was only formulated by the Church in the fourteenth century. Why? Because before this time no one had disputed it. It was precisely in response to a misunderstanding and a false interpretation that the Church supplied a theoretical formula to express its living experience in this realm. The same is true for the icon.

The entire period of the ecumenical councils is essentially a christological period, which specifies the orthodox teaching on the person of Christ, both God and Man. During this entire period, the icon, which is a part of christological theology, primarily bears witness to the incarnation, and the Church asserts its teaching both by word and by the image.

The period which follows and which stretches over from the ninth to the sixteenth centuries, is a pneumatological pe-

riod. The central question around which the heresies and
Church teaching revolves, becomes that of the Holy Spirit and
His action in man, that is, the result of the incarnation. During
this period, the Church primarily bears witness to the fact that
if "God became Man," it is so that "man could become God";
and the icon, converging perfectly with theology and the
liturgy, especially bears witness to the fruits of the incarna-
tion: the holiness and the deification of man. It shows to the
world the image of the man who became God by grace. It is
particularly at this time that the classic form of sacred art de-
velops and that all the promises of the Christian art of the
first centuries are fulfilled. The art of the Church flowers
remarkably, in connection with the great vigor of holiness,
particularly monastic holiness. Thus, the decoration of
churches adopts definite forms and, from the eleventh cen-
tury on, becomes an exact and precise dogmatic system. New
peoples, particularly Slavs, enter the Church. They participate
in the elaboration of this classical language, and each one cre-
ates his special kind of holiness and his special kind of icons.

What was the role of the West in the new phase of
Church history? We have seen that the West and the East
did not always agree and that very often their common action
was connected with grave misunderstandings. But it was,
however, a truly common action, that of two members of the
same Church. The Patriarchate of Rome was a part of the
Church, and this is the reason why all the misunderstandings,
even the important and profound ones, failed to compromise
the unity of that patriarchate with the rest of the Church, its
participation in the common sacramental life. This is why
everything which the Roman Church lacked could always be
filled by the common heritage and, reciprocally, the spiritual
riches of the West became a part of the common treasure of
the one Church. But, in the eleventh century, Rome broke
away from the rest of the Church. Communion in the sacra-
ments ceases, and the Church of Rome cuts itself off from
the common life of the Church in this pneumatological period.
This is why even in the incredibly creative burst of the Roman-
esque epoch, the sacred art of the West progressively begins to

become secularized, thus betraying its meaning, its purpose, indeed its *raison d'être*.

X

The Meaning and Content
of the Icon

NOW WE TURN to the principal part of this study, to the analysis of the meaning and content of the icon, expressed by its classical language.

The dogmatic foundation of the veneration of icons and the meaning and content of the liturgical image are particularly revealed by the liturgy of the two feast days: that of the Holy Face, which we have already mentioned, and that of the Triumph of Orthodoxy, which is the feast of the victory of the icon and of the ultimate triumph of the dogma of the divine incarnation. The basis of our study will be the kontakion of the Triumph of Orthodoxy, which is a true verbal icon of the feast. This text, which is of an extraordinary richness and depth, expresses all of the Church's teaching about images. It is believed that the text does not date back farther than the tenth century, but it is possible that it is contemporary with the canon of the feast. If this is the case, it dates to the ninth century, that is, to the very moment of the Triumph of Orthodoxy. The canon was, in fact, written by St. Theophanes the Marked, a confessor of Orthodoxy in the second iconoclastic period. St. Theophanes eventually became the Metropolitan of Nicaea and died around 847. This canon therefore is written by a man who personally participated in the struggle to preserve the icon. It represents the totality of the Church's experience, a concrete and real experience of divine revelation, an experience defended with blood.

We have said that, in the struggle against iconoclasm, the Church defended all of its teaching about our salvation. The kontakion of the Triumph of Orthodoxy is the best example

179

of this. On the occasion of the triumph of the icon, it concisely expresses, in three sentences, the entire economy of our salvation, and thereby, the teaching on the image and its contents. Here is the text of this kontakion:

> No one could describe the Word of the Father;
> But when He took flesh from you, O Theotokos,
> He consented to be described, and restored the fallen
> image to its former state
> By uniting it to divine beauty.
> We confess and proclaim our salvation in word and
> images.

The first part of the kontakion tells of the abasement of the second person of the Holy Trinity, and thus, of the christological basis of the icon. The words which follow reveal the meaning of the incarnation, the accomplishment of the divine plan for man and consequently for the universe. It can be said that these two phrases illustrate the patristic formula: "God became man so that man could become God." The end of the kontakion expresses man's answer to God, his confession of the saving truth of the incarnation, his acceptance of the divine economy and his participation in the work of God and, therefore, the achievement of his salvation: "We confess and proclaim our salvation in word and images."[1]

The first part of the kontakion ("No one could describe the Word of the Father; but when He took flesh from you, O Theotokos . . . ") can be summarized in the following way: The second person of the Holy Trinity becomes man and yet remains what He is, that is, fully God, possessing the fullness of divine nature, hence uncircumscribable in His divinity, for "no one could describe the Word of the Father." God assumes the human nature which He created; He borrows the human nature in its totality from the Mother of God, and, without changing His divinity, without confusing it with humanity, He becomes God and Man at the same time: "the Word became flesh so that the flesh could become word" according to St. Mark the Hesychast.[2] This is the humiliation, the kenosis

[1] See also the study of the kontakion in *The Meaning of Icons*, p. 33 ff.
[2] *Epistle to the monk Nicholas*, Russian Philokalia, vol. 1, p. 420.

of God; He who is absolutely inaccessible to man, who is undescribable and unrepresentable, becomes describable and representable by assuming the human flesh. The icon of Jesus Christ, the God-Man, is an expression of the dogma of Chalcedon through the image; indeed, it represents the person of the Son of God who became man, who by His divine nature is consubstantial with the Father and by His human nature is consubstantial with us, "similar to us in everything except sin," according to the dogma of Chalcedon. During His life on earth, Christ reunited in Himself the image of God and the image of the servant about whom St. Paul speaks (Phil. 2:6-7). The men who surrounded Christ saw Him only as a man, albeit often as a prophet. For the unbelievers, His divinity is hidden by His form of a servant. For them, the Savior of the world is only a historical figure, the man Jesus. Even His most beloved disciples saw Christ only once in His glorified, deified humanity, and not in the form of a servant; this was before the passion, at the moment of His transfiguration on Mount Tabor. But the Church has "eyes to see" just as it has "ears to hear." This is why it hears the word of God in the Gospel, which is written in human words. Similarly, it always considers Christ with the eyes of unshakeable faith in His divinity. This is why the Church depicts Him in icons, not as an ordinary man, but as the God-Man in His glory, even at the moment of His supreme humiliation. We shall examine how the Church does this later. Here it is only necessary to note that this is precisely the reason why, in its icons, the Orthodox Church never represents Christ simply as a man who suffers physically, as is the case in Western religious art.

The image of the God-Man was precisely what the iconoclasts could not understand. They asked how the two natures of Christ could be represented. But the Orthodox did not even think of representing either the divine nature or the human nature of Christ. They represented His person, the person of the God-Man who unites in Himself the two natures without confusion or division.

It is characteristic that the kontakion of the Triumph of Orthodoxy is not addressed to one of the persons of the Holy Trinity, but to the Mother of God. This shows the unity in the

Church's teaching about Christ and the Mother of God. The
incarnation of the second person of the Trinity is the funda-
mental dogma of Christianity, but the confession of this dogma
is possible only by confessing the Virgin Mary as the true
Mother of God. Indeed, if the negation of the human image
of God logically leads to the negation of the very meaning of
our salvation, the opposite is also true: the existence and the
veneration of the icon of Christ implies the importance of the
Mother of God, whose consent, "let it be to me according to
Thy word" (Luke 1:38), was the indispensable condition of
the incarnation, and who alone permitted God to become vis-
ible and therefore representable. According to the Fathers,
the representation of the God-Man is based precisely on the
representable humanity of His Mother. "Since Christ was born
of the indescribable Father," explains St. Theodore of Studios,
"He cannot have an image. Indeed, what image could cor-
respond to the divinity whose representation is absolutely for-
bidden by the Holy Scripture? But from the moment Christ
is born of a describable mother, He naturally has an image
which corresponds to that of His mother. If He could not be
represented by art, this would mean that He was not born of a
representable mother, but that He was born only of the Father,
and that He was not incarnate. But this contradicts the whole
divine economy of our salvation."[3] This possibility of repre-
senting the God-Man in the flesh which He borrowed from
His mother is contrasted by the Seventh Ecumenical Council
with the absolute impossibility of representing God the Father.
The Fathers of the council repeat the authoritative argument
of Pope St. Gregory II, contained in his letter to the emperor
Leo III the Isaurian: "Why do we neither describe nor repre-
sent the Father of the Lord Jesus Christ? Because we do not
know what He is ... And if we had seen and known Him as
we have seen and known His Son, we would have tried to de-
scribe Him and to represent Him in art."[4]

 This reasoning of the Seventh Ecumenical Council as well
as the words of St. Theodore of Studios touch upon a subject
of great interest to us and of great dogmatic importance, that

[3]*Third Refutation*, ch. 2, PG 99: 417C.
[4]Mansi 12:963E.

is, the representation of God the Father in our ecclesiastical practices. At the beginning of our study, we noted that just as human thought has not always measured up to real theology, so artistic creation has not always measured up to authentic iconography. Among other errors, we often find the image of God the Father. This image has been particularly widespread in the Orthodox Church since the seventeenth century. It will be necessary to return to this question later and to analyze it in more deail, in respect to the prohibition of the image of God the Father on the part of the Great Council of Moscow in 1666-67. Therefore, we will limit ourselves here simply to several general considerations regarding the texts which we have quoted.

As we see, the Seventh Ecumenical Council speaks of the absence of the image of God the Father, who is not incarnate and consequently is invisible and non-representable. The council thus emphasizes the difference between the representability of the Son, because He is incarnate, and the absolute impossibility of representing the Father. We have every right to conclude from this that the council confirms this impossibility of representing God the Father from the doctrinal point of view of the Church. Obviously anything can be represented, since the human imagination has no limit. But the fact is that everything is not representable. Many things concerning God are not only not representable by an image and not describable by words, but are even positively inconceivable to man. It is precisely because of this inconceivable, unknowable character of God the Father that the council proclaims the impossibility of making His image. We have only one way of knowing the Holy Trinity. We know the Father by the Son ("He who sees Me, sees Him who sent Me," as we read in John 12:45, and "He who has seen Me has seen the Father'" in John 14:9) and the Son by the Holy Spirit ("No man can say 'Jesus is the Lord' except by the Holy Spirit," I Cor. 12:3). Consequently, we only represent what has been revealed to us: the incarnate person of the Son of God, Jesus Christ. The Holy Spirit is represented as It manifested Itself: in the shape of a dove at the baptism of Christ, in the form of tongues of fire at Pentecost, and so on. As for God the Father, His presence is only indi-

cated symbolically in icons: usually a blessing hand is repre-
sented coming from heaven, this in general indicating the di-
vine presence.

If the beginning of the kontakion of Orthodoxy speaks of
the divine incarnation as the basis of the icon, the second part
expresses the meaning of the incarnation and thus the meaning
and contents of the New Testament image: "and restored the
fallen image to its former state by uniting it to divine beauty."

These words signify that the Son of God, in His incarna-
tion, recreates and renews in man the divine image soiled by
the fall of Adam.[5] Christ, the New Adam, the first-fruits of the
new creation, of the celestial man, leads man to the goal for
which the original Adam was created. To attain this goal, it
was necessary to return to the beginning, to Adam's point of
departure. In the Bible we read: "God said: Let us make man
in our image, after our likeness" (Gen. 1:26). Therefore, ac-
cording to the plan of the Holy Trinity, man must not only
be the image of his Creator, but he must also be a like-image
and resemble God. But the description in Genesis of the ac-
complished creative act no longer mentions the likeness. "So
God created man in His own image, in the image of God He
created him," we read (Gen. 1:27), and further on, "When
God created man, He made him in the image of God—κατ'
εἰκόνα Θεοῦ" (Gen. 5:1).[6] One could say that the text in-
sists on the word "image" by repeating it, and the absence of
the word "likeness" could not be more evident. What is the
divine image and what is the divine likeness in man?[7]

St. John of Damascus gives the following answer to this
question: "The expression 'in the image' indicates spirit and
freedom, and the expression 'in the likeness' signifies the acqui-
sition of the likeness to God in His perfection."[8] The words
"image" and "likeness" are used by Diadochus the Blessed,
bishop of Photice (second half of the fifth century) in the

[5]See on this subject, for example, St. Athanasius the Great, *On the Incarna-
tion*, PG 25:120CD.

[6]Citations from the Septuagint.

[7]Cf. Vladimir Lossky, *The Mystical Theology of the Eastern Church* (Lon-
don, 1957), ch. 6: "Image and Likeness."

[8]*On the Orthodox Faith*, Bk. 2, ch. 12, PG 94:920B.

same way. "Man is created in the image of God," he writes. "This image is given to him in his spirit and his free will. But the image must be revealed in likeness and this is accomplished in freedom and in the gift of the self in love. The likeness to God is realized by effort and sacrifice; it is fulfilled by grace, but not without the freedom of man . . . for the mark of a seal can only be imprinted on wax if it is molten."[9] By baptism, St. Diadochus explains, grace restores the image of God to man; as for the divine likeness, grace outlines it later, with the efforts of man to acquire the virtues of which love is the highest, the supreme trait of the likeness of God. "Just as painters clearly establish the resemblance of the portrait to the model by first tracing the outline in one color, then filling it in little by little, with different colors . . . so also at baptism, the grace of God begins to remake the image to what it was when man came into existence. Then, when we begin to strive with all our will power towards the beauty of the likeness . . . divine grace makes virtue flourish upon virtue, elevating the beauty of the soul from glory to glory, bestowing upon it the mark of likeness."[10]

The meaning of the biblical account of the plan of the Holy Spirit to create man "in the image and likeness" of God and the account of the creation "in the image" is commented upon by the Fathers in the sense that man, created in the image of God, is consequently called to realize his likeness to God. To be in the image of God is to have the possibility of acquiring the divine likeness. In other words, this likeness to God is assigned to man as a dynamic task to accomplish.

Man is a microcosm, a little world. He is the center of created life, and therefore, being in the image of God, he is the means by which God acts in the creation. It is precisely in this divine image that the cosmic meaning of man is revealed, according to the commentary of St. Gregory of Nyssa. Creation participates in the spiritual life through man.[11] Placed by God

[9]Summarized by G. Florovsky, *Vizantiiskie otssy V-VIII vekov* (Paris, 1933), p. 173.

[10]Ch. 89, *Diadoque de Photice, oeuvres spirituelles* (Sources chrétiennes, Paris, 1955), p. 149.

[11]See G. Florovsky, *Vostochnye otssy IV i V veka* (Paris, 1931), p. 157.

at the head of all visible creatures, man must realize in himself
the union and harmony of everything and unite all the universe
to God, in order to make of it a homogeneous organism where
God would be "all in all," for the final goal of creation is its
deification.

But man did not accomplish his calling. He turned away
from God, and his will power weakened, and the inertia in his
nature prevailed over his impetus toward God. This led to the
disintegration of man, the microcosm, which consequently led
to a cosmic disintegration, a catastrophe in all creation. The
whole visible world fell into disorder, strife, suffering, death
and corruption. This world ceased faithfully to reflect the
divine beauty, because the divine image, man, inscribed at the
center of the universe, was obscured. This was the exact oppo-
site of man's vocation. God's design, however, did not change.
Because man was incapable of re-establishing his nature in its
primitive purity by himself, the task which fallen man could
not longer fulfill was accomplished by the New Adam, Christ.
Here is what St. Simeon the New Theologian says on this sub-
ject: "Man, such as God had created him, ceased to exist in the
world; it was no longer possible for any one to be like Adam
was before his fall. But it was indispensable that such a man
exist. God, therefore, wishing there to be a man such as He
had created with Adam, sent His only Son to earth, who, hav-
ing come, became incarnate, assuming perfect humanity in or-
der to be a perfect God and a perfect Man, and in order that
the divinity could have a man worthy of Him. Here is the Man.
There has never been and will never be one like Him. But why
was Christ like this? To keep the law and the commandments
of God, and to fight and conquer the devil."[12] To save man
from the imprisonment of original sin, it was therefore neces-
sary to have a man such as God had created in the beginning,
that is, a sinless man, because sin is an external thing, super-
imposed on human nature. It is a contrivance of the created
will, according to St. Gregory of Nyssa, a voluntary denial of
the fullness of life by creation.

The incarnation of the Son of God is not only the recreation
of man in his primitive purity. It is also the realization of that

[12]Homilies, *First Oration* (3rd Russian edition, Moscow, 1892), p. 23.

which the first Adam did not know how to achieve. In the words of the Fathers of the Seventh Ecumenical Council: "God re-created man in immortality, thus bestowing upon him a gift which could no longer be taken away from him. This re-creation was more God-like and better than the first creation; it is an eternal gift."[13] This gift of immortality is the possibility of attaining beauty and divine glory: "By uniting it to divine beauty," says the kontakion. By assuming human nature, Christ impregnated it with grace, making it participate in the divine life, and cleared the way to the Kingdom of God for man, the way of deification and transfiguration. The divine image was reinstated in man in the perfect life of Christ. He destroyed the power of original sin by His freely accepted passion and led man to realize the task for which he was created: to achieve the divine likeness. In Christ this likeness is realized to a total, perfect degree, by the deification of human nature. Indeed, the deification represents a perfect harmony, a complete union of humanity and divinity, of human will and divine will. The divine likeness, therefore, is only possible for a renewed man, in whom the image of God is purified and restored. This possibility is realized in certain properties of human nature and particularly in its freedom. The attainment of the divine likeness is not possible without freedom, because it is realized in a living contact between God and man. Man consciously and freely enters into the design of the Holy Trinity and creates in himself the likeness to God to the extent of his possibilities and with the help of the Holy Spirit. Thus the Slavonic word "prepodobny," which literally means "very similar," is applied to the monastic type of holiness.[14] The rebirth of man consists

[13]Sixth session, Mansi 13:2164.

[14]This word, appearing in the time of Sts. Cyril and Methodius to translate the Greek word ὅσιος, indicates the attainment of the divine likeness by man. A corresponding expression does not exist in other languages. The opposite term ("dissimilar"), however, can be traced to a very distant epoch. Plato uses this term in a philosophical sense (ἀνομοιότητος πόντον or τόπον) in his *Politics* to express the "noncorrespondance" of the world to his idea. St. Athanasius the Great already uses it in a Christian sense: "He who created the world, seeing it succumb to the storm and in danger of being swallowed up in the place of dissimilitude, seized the helm of the soul and came to its aid by correcting all of its transgressions." St. Augustine in his *Confessions* says, "I saw myself far from Thee, in a place of dissimilitude" (*et inveni me longe esse a Te in regione dissimilitudinis*, PL 32:742).

in changing "the present humiliated state" of his nature, making it participate in the divine life, because, according to the classical phrase of St. Gregory the Theologian, who echoes St. Basil the Great, "Man is a creature, but he has the order to become God." Henceforth, by following Christ, by integrating himself in His body, man can re-establish in himself the divine likeness and make it shine forth in the universe. In the words of St. Paul, " . . . we all, with unveiled face, beholding the glory of the Lord, are being changed into His likeness from one degree of glory to another" (2 Cor. 3:18). When the human person attains this goal, he participates in the divine life and transforms his very nature. Man becomes the son of God, a temple of the Holy Spirit (1 Cor. 6:19). By increasing the gifts of His grace, he surpasses himself and elevates himself higher than Adam was before his fall, for not only does he return to man's primitive purity, but he is deified, transfigured, "united to divine beauty" in the words of the kontakion of Orthodoxy: He becomes God by grace.

This ascension of man reverses the process of the fall and begins to deliver the universe from disorder and corruption, since the deification attained by the saint constitutes the beginning of the cosmic transfiguration to come.

The image of God is ineffaceable in man. Baptism only re-establishes and purifies it. The likeness to God, however, can increase or decrease. Being free, man can assert himself in God or against God. He can, if he wants, become "a child of perdition." Then the image of God grows obscure in him, and in his nature he can achieve an abject dissimilarity, a "caricature" of God.

The transfiguration to come of the entire human nature, including that of the body, is revealed to us in the transfiguration of the Lord on Mount Tabor: "He was transfigured before them and His face shone like the sun, and His garments became white as light" (Math. 17:2; Mark 9:1-8; Luke 9:27-36). The Lord no longer appeared to His disciples in His "form of a servant" but as God. The whole body of Christ was transfigured, becoming, so to speak, the luminous clothing of His divinity. As Metropolitan Philaret of Moscow says, in His

[15]*Tvorenia*, Hom. 12 (Moscow, 1873), p. 99.

transfiguration "on Mount Tabor, not only the divinity appeared to men, but humanity also appeared in the divine glory." [15] And the Fathers of the Seventh Ecumenical Council explain: "Speaking of the nature of the transfiguration, it took place not in such a way that the Word left the human image, but rather in the illumination of this human image by His glory." [16] In the words of St. Gregory Palamas: "Thus Christ assumes nothing foreign, nor does He take on a new state, but He simply reveals to His disciples what He is." [17] The transfiguration is a manifestation perceptible by the whole human being, of the divine glory of the second person of the Holy Trinity who, in His incarnation, is inseparable from His divine nature, common to both the Father and the Holy Spirit. United hypostatically, the two natures of Christ remain distinct one from the other ("without mixture or confusion," according to the words of the dogma of Chalcedon), but the divine energies penetrate the humanity of Christ and make His human nature resplendent by transfiguring it in a flash of uncreated light. It is "the Kingdom of God (which has come) with power" (Mark 9:1). According to the Fathers, Christ showed "unto His disciples the deified state to which all men are called. Just as the body of our Lord was glorified and transfigured, resplendent with divine glory and infinite light, so also the bodies of the saints are glorified and become luminous, being transfigured by the force of divine grace. St. Seraphim of Sarov not only explained, but directly and visibly revealed this likeness between man and God to Motovilov, [18] by transfiguring himself before his very eyes. Another saint, Simeon the New Theologian, describes his own experience of this divine illumination in the following way: "The man whose soul is all on fire also transmits the glory attained internally to his body, just as a fire transfers its heat to iron." [19]

Just as the iron when it is united with the fire becomes hot and yet remains iron, though it is purified, so also human nature when it comes into contact with grace remains what it is,

[16]Sixth session, Mansi 13:321CD.
[17]PG 150:1232C.
[18]V. Iline, *Serafim Sarovski* (Paris, 1930), p. 125.
[19]*Or.* 83, § 3, *ed. cit.* p. 385.

remains whole: Nothing is lost. On the contrary, it is purified just as the iron is purified when in contact with fire. Grace penetrates this nature, is united with it, and from this point on man begins to live the life of the world to come. This is why one can say that a saint is more fully man than the sinner is. He is free from sin, which is essentially foreign to human nature; he realizes the primordial meaning of his existence; he puts on the incorruptible beauty of the Kingdom of God, in the construction of which he participates with his own life. For this reason beauty, as it is understood by the Orthodox Church, is not the characteristic beauty of a creature. It is a part of the life to come, when God will be all in all: "The Lord reigns, He is clothed with majesty," we hear in the prokeimenon at Vespers (Psalm 92) on Sunday, which is an image of the eternal life to come. The author of the *Areopagitica* calls God "beauty" because, on the one hand, God bestows on every creature a unique beauty, and, on the other hand, He adorns him with another beauty, with the true "divine beauty." Every creature is, so to speak, marked with a seal of its Creator. But this seal is not yet the divine likeness, but only the beauty characteristic of the creature.[20] For man, it can be a path or a means of bringing him closer to God. Indeed, according to St. Paul, "ever since the creation of the world, his invisible nature, namely his eternal power and deity, has been clearly perceived in the things that have been made" (Rom. 1:20). For the Church, however, the value and the beauty of the visible world lie not in the temporary splendor of its present state, but in its potential transfiguration, realized by man. In other words, true beauty is the radiance of the Holy Spirit, the holiness of and the participation in the life of the world to come.

Thus, the second part of the kontakion for the Triumph of Orthodoxy leads us to the patristic understanding of the icon and allows us to grasp the profound meaning of Canon 82 of the Quinisext Council. "We represent on icons the *holy flesh* of the Lord," says Patriarch St. Germanus.[21] St. Theodore of Studios, an intrepid and uncompromising defender of Orthodoxy, explains this even more clearly: "The representation of

[20]Dionysius the Areopagite, *On the divine names*, ch. 4, 7, PG 3:701 C.
[21]PG 98:157 BC.

Christ," he says, "is not in the likeness of a corruptible man, which is disapproved of by the apostles, but as He Himself had said earlier, it is in the likeness of the incorruptible man, but incorruptible precisely because He is not simply a man but God who became Man."[22] These words of St. Theodore explaining the contents of the icon, and the words of the Fathers of the Seventh Ecumenical Council, reflect the christological teaching of St. Gregory the Theologian: "Let us not be deprived of our integral salvation, by attributing only bones, veins and the human exterior to the Savior, . . . let us keep man in his entirety and add the divinity."[23]

By comparing the quoted texts, we see that the task of the New Testament image, as the Fathers understood it, consists precisely in portraying as faithfully and completely as possible the truth of the divine incarnation, insofar as this can be done by art. The image of the man Jesus is the image of God; this is why the Fathers of the Seventh Ecumenical Council, having His icon in mind, say: "In the same Christ, we contemplate both the inexpressible and the represented."[24]

As we see, therefore, the icon is an image not only of a living but also of a deified prototype. It does not represent the corruptible flesh, destined for decomposition, but transfigured flesh, illuminated by grace, the flesh of the world to come (cf. I Cor. 15:35-46). It portrays the divine beauty and glory in material ways which are visible to physical eyes. The icon is venerable and holy precisely because it portrays this deified state of its prototype and bears his name. This is why grace, characteristic of the prototype, is present in the icon. In other words, it is the grace of the Holy Spirit which sustains the holiness both of the represented person and of his icon, and it is in this grace that the relationship between the faithful and the saint is brought about through the intermediary of the icon of the saint. The icon participates in the holiness of its prototype and, through the icon, we in turn participate in this holiness in our prayers.

During the pre-iconoclastic era, as we have said, there

[22]*Seven Chapters against the Iconoclasts*, ch. 1, PG 99:488.
[23]First Letter to Cledonius against Apollinarius, PG 37:184 AB.
[24]Sixth session, Mansi 13:244 B.

were, as there are today, not only authentic icons in the churches but also simple portraits, and also intermediate images, part portrait and part icon. The Fathers of the Seventh Ecumenical Council therefore had to distinguish carefully between an icon and a portrait. The latter represents an ordinary human being, the former a man united to God. The icon is distinguishable from the portrait by its very content, and this content creates specific forms of expression which are characteristic of the icon alone and which distinguish it from all other images. The icon indicates holiness in such a way that it need not be inferred by our thought but is visible to our physical eyes. As the image of the sanctification of man, the icon represents the reality which was revealed in the transfiguration on Mount Tabor, to the extent that the disciples were able to understand it. This is why the liturgical texts, particularly for the feast of the Holy Face (August 16) set up a parallel between the contents of the icon and the transfiguration: "Falling to the ground on the holy mountain, the greatest of the apostles prostrated themselves upon seeing the Lord reveal the dawn of divine brightness, and now we prostrate ourselves before the Holy Face which shines forth brighter than the sun . . ." Or yet again: "Having illuminated the human image which had grown dark, O Creator, Thou didst reveal it on Mount Tabor to Peter and to the Sons of Thunder; and now bless and sanctify us, O Lord who lovest mankind, by the brightness of Thy most pure image."[25] This parallel, which can also be illustrated by other texts, is certainly not the fruit of simple, poetic imagination, but it is rather an indication of the spiritual contents of the icon. The icon of the Lord shows us that which was revealed to the apostles on Mount Tabor. We contemplate not only the face of Jesus Christ, but also His glory, the light of divine Truth made visible to our eyes by the symbolic language of the icon, "the accomplishment made clear to everyone by paintings," as it was put at the Quinisext Council.

This spiritual reality of the icon assumes all its value of

[25]Second and third Sticheras, tone 4.

practical teaching in the last phrase of the kontakion of the Triumph of Orthodoxy: "We confess and proclaim our salvation in word and images." Thus the kontakion ends with man's answer to God, with the acceptance and confession of the divine economy of salvation. It is easy to understand how to confess salvation in words. The confession by deed can be understood as the accomplishment of the commandments of Christ. But there is something more here. We find the clearest explanation of these words in the Synodicon of the Triumph of Orthodoxy, about which we spoke earlier. As we know, this Synodicon[26] contains a series of anathemas against the heretical iconoclasts and a series of proclamations of eternal memory to the confessors of Orthodoxy. Among others, paragraph three proclaims eternal memory "to those who believe and who substantiate their words with writings and *their deeds with representations,* for the propagation and affirmation of the truth by word and images." The representations imply, therefore, that there are deeds which should be represented. But the act of creating images is also a "deed." This word takes on a double meaning in the kontakion: that of internal and external deeds. In other words, it expresses the living experience of the Church, the experience which is expressed in words or in images by the men who attained holiness. On the one hand, man can reestablish in and through the grace of the Holy Spirit his likeness to God. He can transform himself by an internal effort and make of himself a living icon of Christ. This is what the Fathers call "an active life," an internal deed. On the other hand, man can also, for the good of others, translate his inner sanctification into images, either visible or verbal: "We proclaim our salvation in word and images," says the kontakion. Man can therefore also create an external icon, making use of matter which surrounds him and which has been sanctified by the coming of God on earth. Of course, one can express the internal spiritual state by words alone, but this internal state is manifested and visibly confirmed by representations.

All that we have said about the contents of the icon can

[26]The best edition of the entire Synodicon is by J. Gouillard in *Travaux et mémoires* 2 (Paris, 1967).

be compared to a text of the First Epistle of St. Paul to the
Corinthians. This will help us to understand the significance
of the icon, for we all see that this text and the icon express
the same teaching and the same experience. "How are the
dead raised?" asks St. Paul. And he answers, "You foolish
men! What you sow does not come to life unless it dies. And
what you sow is not the body which is to be..." (I Cor.
15:35-38). He compares our mortal body to the grain thrown
to the ground. In the course of this present life, the grain
must germinate, that is, it must to some extent enter the life
to come. Similarly, we must enter the life of the age to come
in order to open ourselves to the general resurrection in that
form which it pleases God to give us. "What is sown is
perishable, what is raised is imperishable. It is sown in dis-
honor, it is raised in glory. It is sown in weakness, it is raised
in power. It is sown a perishable body, it is raised a spiritual
body" (I Cor. 15:42-44). Christ, the new Adam, renewed
and recreated our human nature in immortality.

> The first man Adam became a living being; the last
> Adam became a life-giving spirit. But it is not the
> spiritual which is first but the physical, and then the
> spiritual. The first man was from the earth, a man
> of dust; the second man is from heaven. As was the
> man of dust, so are those who are of heaven. Just
> as we have borne the image of the man of dust, we
> shall also bear the image of the man of heaven. I
> tell you this, brethren: flesh and blood cannot in-
> herit the Kingdom of God, nor does the perishable
> inherit the imperishable (I Cor. 15:45-50).

And a little farther, the apostle says, "for this perishable
nature must put on the imperishable, and this mortal nature
must put on immortality" (I Cor. 15:53). The light of the
transfiguration on Mount Tabor is already the glory of the
world to come. For the power which resurrects the saints
after their death is the Holy Spirit. It is the Holy Spirit who,
during the terrestrial life of the saints, vivifies not only their
souls but also their bodies. This is why we say that the icon

transmits not the everyday, banal face of man, but his glorious and eternal face. For the very meaning of the icon is precisely to depict the heirs of incorruptibility, the heirs of the Kingdom of God, of which they are the first-fruits from the time of their life here on earth. The icon is the image of the man in whom the grace which consumes passions and which sanctifies everything is truly present. This is why his flesh is represented completely differently from ordinary corruptible flesh. The icon is a peaceful transmission, absolutely devoid of all emotional exaltation, of a certain spiritual reality. If grace enlightens the entire man, so that his entire spiritual and physical being is filled by prayer and exists in the divine light, the icon visibly captures this man who has become a living icon, a true likeness of God. The icon does not represent the divinity. Rather, it indicates man's participation in the divine life.[27]

Thus, holiness is the achievement of the possibilities given to man by the divine incarnation. It is an example to us. As for the icon, it portrays this achievement, it "explains" it in an image. The icon is intimately connected with the renewal, the deification of the human nature realized by Christ. On the one hand, the icon bears witness to its result, the deification of man, the experience of the saints. A new image, a reflection of this life, corresponds to the new life in Christ. A saint is a living icon of God. The painted icon is an external expression of this holiness, the representation of a man sanctified by the grace of the Holy Spirit. Thus, there is an organic bond between the veneration of the saints and that of the icons. This is why in those religious communities

[27]It is sometimes said that if the Christian art of the West, that of the Roman Church, leans towards Nestorianism, the Orthodox icon has nuances of monophysitism. What we have already said about the contents of the icon permits us to judge the absurdity of this statement. Though one can say that Western art is really Nestorian because it represents only the human aspect and not the sacred, that is, the terrestrial reality alone, the Orthodox icon has nothing to do with monophysitism because it represents neither the divinity nor man absorbed by it. Rather, it represents man in the fullness of his terrestrial nature, purified from sin and united with the divine life. To accuse Orthodox art of monophysitism is to completely misunderstand its contents. For the very same reasons, one could accuse the Holy Scripture or the Orthodox liturgy of monophysitism, because like the icon they express a double reality: that of the creature and that of grace.

which have renounced the veneration of the saints, the sacred image no longer exists, and where the conception of holiness is false, the image is also false. It is this organic bond between the veneration of the saints and that of icons which St. John of Damascus had in mind when he wrote to Leo III at the outset of iconoclasm, even before the iconoclasts had renounced the veneration of the saints: "It is not against icons that you fight, but it is against the saints."[28]

The analysis of the kontakion of the Triumph of Orthodoxy gives us a clearer understanding of the double realism of the New Testament sacred image, a realism about which we have already spoken. Just as the God-Man, Jesus Christ, "in whom dwelleth all the fullness of the Godhead bodily" (Col. 2:9), so also the Church, the body of Christ, is both a divine and human system. It unites two realities in itself: the historical, earthly reality and the grace of the Holy Spirit, the reality of the world and that of God. The purpose of sacred art is precisely to bear witness visibly to these two realities. It is realistic in these two meanings, and thus the icon is distinguishable from all other images, just as the Holy Scripture is distinguishable from all other literary works.

The Church piously preserves historical reality in the representation of Christ, the saints and the events of the Bible.[29] To follow faithfully the concrete historical fact is the only way we can achieve a personal contact, in the grace of the Holy Spirit, with the person whom the icon represents. Each characteristic trait of a saint, therefore, will be carefully preserved, and only this fidelity to historical truth allows the iconography of the saints to be so stable. Actually, it is not only a matter of transmitting an image consecrated by tradition, but above all of preserving a direct and living link with the person whom the icon represents. This is why it is essential to abide by an image reproducing, to the greatest degree possible, the traits of the person. Obviously, this is not

[28]*First Treatise*, ch. 19, PG 94:1249.

[29]We are not speaking here of "symbolic" icons, like that of Sophia, Divine Wisdom, or of icons of angels, for example. We shall speak of them elsewhere. We note only that the angels are represented as they appeared to men.

always possible. Like the biographies of the saints, the physical traits of the saints are often more or less forgotten, and it is difficult to reconstruct them. The likeness risks, therefore, being imperfect. The unskillfulness of the painter can also lessen it. However, it can never disappear completely. An irreducible minimum always remains which provides a link with the prototype of the icon. As St. Theodore of Studios writes, "The icon is venerated not in its lack of a resemblance to its prototype, but insofar as it does resemble him."[30] In other words, what is essential in this case is not what an icon lacks in resemblance to its prototype, but what it has in common with him. The iconographer can limit himself to a few characteristic traits. In the majority of cases, however, the faithfulness to the original is such that a faithful Orthodox can easily recognize the icons of his most revered saints, not to mention Christ and the Virgin. And even if some saint is unknown to him, he can always say to which order of sainthood the saint belongs, *i.e.* if he is a martyr, a hierarch, a monk, *etc.*

The Orthodox Church has never accepted the painting of icons according to the imagination of the painter or from a living model, which would signify a conscious and total break from the prototype. The name "icon" would no longer correspond to the represented person and this would be a flagrant lie which the Church could not tolerate. (This general rule has been frequently broken or abused in the past few centuries.) In order to avoid a falsehood and a break between the image and its prototype, iconographers use old icons and manuals as models. The ancient iconographers knew the faces of the saints as well as they knew those of their close relatives. They painted them either from memory or by using a sketch or a portrait. Indeed, once a person had acquired a reputation of holiness, an image was made of him to distribute among the faithful immediately after his death, before his official canonization and the discovery of his relics. Thus, all kinds of accounts were preserved on the icons, and particularly sketches and the evidence of contemporaries. When the living tradition began to disappear, or more exactly, when people

[30]*Third Refutation*, ch. 3, § 5, PG 99:421.

began to deviate from it, towards the end of the sixteenth century, the documentation which the iconographers used was systematized. It was then that the manuals appeared with what are called "podlinniks," with and without illustrations. These establish the typical iconography of the saints and the feast days and indicate the principal colors. When they are not illustrated, they contain brief descriptions which characterize the saints and also mention the colors. As documentation, these "podlinniks" are indispensable to iconographers. But in no way can one attribute to them the same significance as to iconographic canons or the holy Tradition.

However, the historical reality alone, even when it is very precise, does not constitute an icon. Since the person depicted is a bearer of divine grace, the icon must portray his holiness to us. If, in representing the human aspect of the incarnate God, the icon portrays only the historical reality, as, for example, a photograph does, this would mean that the Church sees Christ with the eyes of the non-believing crowd which surrounded Him. But according to the commentary of St. Simeon the New Theologian, the words of Christ: "he who has seen Me has seen the Father" (John 14:9), were addressed only to those who, while looking at Jesus the man, simultaneously contemplated His divinity. As St. Simeon also says: "Actually, if one admits that Christ the Lord said this to those who looked merely at His body, it follows that even those who crucified Him saw the Father, for they looked upon Christ in His flesh; and therefore, there would be no difference between the faithful and the unbeliever, and the former would have no advantage over the latter; all would have obtained the desired bliss, all would have seen God."[31] The contemplation of the Church is distinguishable from secular sight precisely by the fact that in the visible, the Church sees the invisible; in the temporal, she sees the eternal, which she reveals to us in her worship. The icon is a part of this worship, and like worship it is a revelation of eternity in time. This is why in sacred art a portrait of a man is only a historical document. It cannot replace the liturgical image, the icon.[32]

[31]Or. 63, § 1, *ed. cit.* p. 111.
[32]N. P. Kondakov notes a characteristic case of the use of the portrait as

But a question arises: On what do we base our contention that the icon expresses the spiritual experience of holiness, that we see in it the same authenticity as in the transmission of historical reality? To confirm this, we "are surrounded by so great a cloud of witnesses," in the words of St. Paul (Heb. 12:1), witnesses who communicate their experience of sanctification to us. The image, as we know, expresses the same thing as the word, and this is why we can say that, just as the saints left us descriptions in verbal images of the Kingdom of God which they carried inside themselves, so also other saints have transmitted the same descriptions to us, but in visible images, by using forms, lines and colors, a language of artistic symbols,[33] and their evidence is just as truthful. It is the same theology, but it is in images instead of in words. The testimony of St. Simeon the New Theologian on the authenticity of the verbal expression of spiritual knowledge can be applied here. "That which is contained in these words," he says, "must not be called concepts (νοήματα) but a contemplation of that which really exists, for we speak of it from experience. Thus, that which we say should rather be called an awareness of contemplated things, and not of an idea (νόημα)."[34] And, indeed, only a personal experience can give rise to the words, forms, colors or lines which truly correspond to what they express. St. Simeon continues a little further on,

> When someone wishes, for example, to relate something about a house, or a field, or a royal palace, or a show, he must first see and examine all of this well and only after that can he know what he is talking about. What could one say alone about some object that he has

a documentary basis for the icon. In 1558, when the relics of St. Nicetas, archbishop of Novgorod, were discovered intact, a posthumous portrait of the saint was made and sent to the ecclesiastical authorities with the following letter: "By the grace of the saint, lord, we have sent you on paper an image of St. Nicetas, bishop . . . to be made." This was followed with details characterizing the outward appearance of St. Nicetas, his vestments, *etc.*, to complete the portrait drawn on paper. *Russkaia Ikona*, vol. 3, part 1, pp. 18-19.

[33]This is why the Orthodox Church has canonized iconographers whose art is considered to be obvious evidence of holiness.

[34]*Or.* 63, § 3, *ed. cit.*, p. 115.

never seen?. . . . Yet, if no one can say anything exact about visible and earthly things without having seen them with one's own eyes, how then can one say or proclaim something about God, about divine things and about the saints of God, that is, about the relationship that the saints have with God and about the knowledge of God that they have inside themselves and which produces ineffable movement in their heart—how could someone who has not been previously enlightened by the light of knowledge say anything about all this?[35]

The transfiguration of Christ occurred before only three witnesses, the three apostles "capable of receiving" this revelation and even they only saw this "dawn of divine light" to the extent that they were able (that is, to the extent of their inner participation in this revelation). We can draw an analogy from the lives of the saints. For example, when St. Seraphim of Sarov was transfigured before Motovilov, to whom he wished to show the aim of Christian life, he explained to him that he would be able to see this transfiguration only because he participated in it himself to a certain extent. He would not have been able to see the light of grace if he himself had not been enlightened. This also explains why Tradition asserts that the Evangelist Luke painted the icons of the Virgin after Pentecost. Without this "light of knowledge" about which St. Simeon the New Theologian speaks, without a direct participation in the sanctification and concrete evidence, no science, no technical perfection, no talent can be of much help. Until the Holy Spirit descended upon them, the apostles themselves (who, however, had constantly seen Christ and believed in Him) had no direct experience of sanctification by the Holy Spirit and consequently they were not able to convey it by word or image. This is why neither Holy Scripture nor a holy image could appear before Pentecost (excluding, of course, the icon which Christ Himself could have made). In the creation of an icon, nothing can replace the concrete and personal experience of grace. Without this personal experience, one can paint icons only by transmitting the experience of those who have

[35]*Ibid.*, p. 116.

had it. This is why the Church, by the voice of its councils and its hierarchs, ordains that icons be painted as they were formerly painted by the holy iconographers. "To represent with colors which conform to Tradition," says St. Simeon of Thessalonica, "is true painting; it is analogous to a faithful copy of the Scriptures; and divine grace rests upon it, since what is represented is holy."[36] It is necessary to "represent with colors which conform to Tradition," because in Tradition we participate in the experience of the holy iconographers, in the living experience of the Church.

These words, like those of the Seventh Ecumenical Council, emphasize the participation of the image in the holiness and glory of its prototype. The grace of God rests on the image, says St. John of Damascus, because "the saints were filled with the Holy Spirit during their lives. Even after their death the grace of the Holy Spirit lives on inexhaustibly in their souls, in their bodies which are in their tombs, in their writings and in their holy images, not because of their nature, but as a result of grace and divine action."[37] The grace of the Holy Spirit lives in the image, which "sanctifies the eyes of the faithful," according to the Synodicon of the Triumph of Orthodoxy (§ 4), and which heals both spiritual and corporal illnesses: "We venerate Thy most pure image, by which Thou hast saved us from the servitude of the enemy," we sing at Matins on the Feast of the Holy Face; "by representation, Thou healest our illnesses."[38]

Sacred art, then, is a realistic art in the strictest sense of the word. According to widespread opinion, sacred art would be "idealistic" in the sense that it expresses a certain grand idea. This opinion represents a total misunderstanding which stems from the fact that the realism in sacred art does not resemble what is usually meant by this word, that is, an image which reflects the present state of the visible world. But in true sacred art, there is no place for idealism or idealization, that is, for the expression of ideas or ideals, just as there is no place for them in the liturgy or in the Scripture. And this is understand-

[36]*Dialogue against heresies*, ch. 23, PG 155:113D.
[37]*First Treatise*, § 19, PG 94: 1249 CD.
[38]Canon of that day, ode 7.

able, since all idealization, even if it is not an illusion or a lie, has a subjective element and is, therefore, limited. It inevitably limits reality, more or less deforming it. Indeed, one can say that an image, once it is marked with idealization, ceases to be an icon. This is obvious, because no one can testify to a historical reality or to divine life by an abstract concept or by basing himself on an individual impression.

Let us now turn to the means by which the icon conveys spiritual reality in practice. How can the "new creature," the deified man, be represented? Here too we shall use texts from the Fathers which will help us to understand our subject better.

It is obvious that divine grace is not expressible by any human means. If we happen to meet a saint, we do not actually see his holiness. As Philaret, Metropolitan of Moscow, says: "The world does not see the saints, just as a blind man does not see light."[39] Consequently, we cannot represent this holiness, which we do not see; it cannot be portrayed by word, by image, or by any human means. In the icon, it can only be portrayed with the help of forms, colors, and symbolical lines, by an artistic language established by the Church and characterized by strict historical realism. This is why an icon is more than an image representing a certain religious subject, because this same subject can be represented in different ways. The specific character of an icon consists more particularly in the *how* of the representation, that is, in the means by which the sanctified state of the represented person is portrayed. Unfortunately, the symbolical language of the Church has not always been understood, and this misunderstanding has often led to the absurd. As an example, we can quote the words of the Russian iconographer of the seventeenth century, Joseph Vladimirov, who played a very important role in the decline of Russian sacred art. Vladimirov was a fervent partisan of western art. He once had a discussion with a Serbian archdeacon, John Pleshkovich, who defended traditional Orthodox art and argued against western innovation. Under the pretext of answering Pleshkovich and criticizing poorly painted icons, Vladimirov wrote a whole treatise explaining his point of view on

[39]*Sermon 57: On the Annunciation, Sermons,* vol. 3 (Moscow, 1873).

sacred art. We can quote here one of the arguments which is characteristic of his point of view and which directly concerns our subject. "Where can one find a rule," wrote Vladimirov, "which says that the faces of the saints must all be represented equally bronzed and darkened? All of the saints did not have thin and dark faces. And if certain saints, during their life, did not have a healthy appearance because they neglected their bodies, then after their death, having received the crowns of the just, they must have changed their appearance to a lighter aspect because a bright countenance befits the just, and a dark one, the sinners. But many saints were distinguishable by an amazing beauty even during their lifetime. Must they, too, be represented with darkened faces?"[40] Even today we can hear similar arguments. To support his arguments, Vladimirov quotes examples from the Scripture: "When the great prophet Moses received the law on Mount Sinai from the Lord," he says, "then the children of Israel could not look at Moses' face because of the brightness which rested on him . . . Must the face of Moses also be represented bronzed and dark, the way that you do, Pleshkovich? . . ." [41] Or further still, he writes: "When the old men saw Susanna and coveted her and slandered her in order to bring her before the tribunal . . . she was beautiful to behold . . . And in our time, . . . you, Pleshkovich, expect iconographers to paint dark images which do not resemble the beauty of their prototypes, and you teach us to lie against the ancient Scriptures."[42] At first glance, this seems to be correct. But, to begin with, we know that the faces in icons were not always dark, nor were they always dark at the time when Vladimirov wrote. But what is totally absurd in the arguments of Vladimirov is that he places a face illuminated by grace on the same level as one illuminated by physical beauty, which he identifies with a bright countenance. He equates the corporal, sensual beauty of Susanna which provoked the covetousness of the old men with the beauty of Moses. In other words, he equates the healthy glow of a youthful face with divine light. Vladimirov sees no difference between these two kinds of

[40]Quoted from N. Pokrovsky, *Pamiatniky* . . . pp. 391-92.
[41]Quoted from T. Buslaev, *Tvorenia*, vol. 2 (St. Petersburg, 1910), p. 431.
[42]*Ibid.*, p. 432.

beauty. According to him, both can be conveyed with light colors, and, more importantly, both should come as close as possible to representing the visible reality. In his work, therefore, he constantly uses examples from western painters who paint in "the imitation of life."

Among the saints, there were certainly people of great physical beauty. However the Church gives us, as an example to follow, the internal life of the saint and not this physical beauty. This is also why the Gospel never gives any physical description, nor does it exalt the beauty or the strength of the human body. Is not the goal of the Holy Scripture, like that of the icon, to lead us towards a state which is the opposite of the one in which the old men found themselves when they saw Susanna?

The liturgy tells us that in the icon of the Holy Face we prostrate ourselves before the face of the Savior which "shines brighter than the sun," that we ask to be "enlightened" by the image of Christ (see the stichera for August 16). We must remember that when the Holy Scripture or the liturgy make comparisons with the perceptible world to teach us of the spiritual realm, these are only images and not adequate descriptions. Therefore, speaking of the evangelists' account of the transfiguration of Christ, St. John of Damascus justifies the inevitably insufficient comparison between divine grace and the light of the sun, emphasizing that it is impossible to represent that which is not created with the same means as created beings.[43] In other words, the material light of the sun can only be an *image* of divine, uncreated light, and nothing more.

On the other hand, however, the icon must correspond to sacred texts which are absolutely explicit, when it is not a matter of a poetic imagery or of an allegory, but of translating concrete reality. But how is spiritual illumination to be depicted in the icon, a light "which shines brighter than the sun," surpassing, therefore, all the means of representation? By colors? But they are not sufficient to portray the natural light

[43]*Sermon on the Transfiguration*, PG 94:545-576; see B. Krivocheine, "L'enseignment ascétique et théologique de Saint Grégoire Palamas," *Seminarium Kondakovianum* (Prague, 1936), p. 135.

of the sun. How then could they represent the light which sur-
passes that of the sun?

In the writings of the Fathers, as well as in the lives of the
saints, we often find evidence of a certain light which made
the faces of the saints shine internally at the moment of their
supreme glorification, just as the face of Moses glowed when
he descended from the mountain, so much so that he had to
cover it because the people could not stand the glare (Ex.
34:30, 2 Cor. 3:7-8). The icon conveys this phenomenon of
light by a halo, which is a precise sign, in an image, of a well-
defined event in the spiritual world. The light which shines
from the glorified faces of the saints and which surrounds their
heads, as well as the upper part of their bodies, naturally has a
spherical shape. As Motovilov says, when speaking of the
transfiguration of St. Seraphim: "Imagine, in the very center
of the sun, in the most brilliant burst of its rays, the face of the
man who speaks to you." Since it is obviously impossible to
represent this light as such, the only way to convey it by paint-
ing is to imagine a disk of this luminous sphere (Fig. 17). It is
not a matter of placing a crown above the head of the saint, as
is sometimes done in the West, where this crown remains in a
way external (Fig. 18), but rather of portraying the radiance
of the face. The halo is not an allegory, but the symbolical ex-
pression of an authentic and concrete reality. It is an indispens-
able part of the icon—indispensable yet insufficient. Indeed,
it expresses other things besides Christian holiness. The pagans
also frequently represented their gods with halos, as well as
their emperors, undoubtedly to emphasize the divine nature of
the latter.[44] It is not, therefore, this halo alone which distin-
guishes an icon from other images: It is only an iconographic
device, an outward expression of holiness, a witness of the
light.[45] For even if the halo should be effaced and no longer

[44]We can not say what this light symbolizes for the pagans. On the one
hand, the Church recognizes a partial revelation outside of itself, and one may
conclude then, that the mystery of uncreated light could have been revealed
to the pagans to a certain extent. In any case, they knew that divinity was
connected with light. On the other hand, the writings of the Fathers reveal
to us that the phenomenon of light can have a demonic origin as well, be-
cause the devil himself occasionally takes on the traits of an angel of light.

[45]It is something completely different from the square halo which can be

be visible, an icon still remains an icon, and is clearly distin-
guishable from all other images. By its forms and by all its
colors, it shows us, in a symbolical manner of course, the inner
state of the man whose face "shines brighter than the sun."
This state of inner perfection is so inexpressible that the Fa-
thers and ascetic writers characterize it only as an absolute si-
lence. The effect of this illumination on human nature and par-
ticularly on the body can, however, be described to a certain
extent and indirectly represented. St. Simeon the New Theolo-
gian referred to the image of the fire united with iron. Other
ascetics left us more concrete descriptions. "When prayer is
sanctified by divine grace," writes Bishop Ignatius Brianchani-
nov (nineteenth century), for example, "the entire soul is
drawn towards God by an unknowable force, which pulls the
body with it . . . In the man born to the new life, it is not only
the soul, nor the heart alone, but also the flesh which is filled
with spiritual consolation and bliss, with the the joy of the liv-
ing God . . ." [46] And further on he writes: "Incessant prayer and
the teaching of the divine Scripture open the spiritual eyes of
the heart which see the King of powers and there is great joy,
and the desire of God burns strongly in the soul; then the flesh
is also carried away by the effect of the Spirit and the whole
man becomes spiritual . . ." [47]

In other words, when the usual state of dissipation, "the
thoughts and sensations of the fallen nature," are replaced in
man by silent prayer, and man is illuminated by the grace of
the Holy Spirit, the entire human being flows like molten lava
in a single burst toward God. The entire human nature is
spiritually exalted and, according to Pseudo-Dionysius, "every-
thing in him which was chaos, is put right; that which was
shapeless, takes form, and his life . . . radiates a bright light." [48]
Thus "the peace of God, which passes all understanding"
(Phil. 4:7) lives in man, this peace which characterizes the

seen on certain images. Formerly, this was a way to indicate that the person
was painted when still alive.

[46]*Asketitchesky opyt*, vol. 1.

[47]*Very Useful Account of Abbas Philemon*, § 3, Russian Philokalia, vol. 3,
p. 397.

[48]*Ecclesiastical Hierarchy*, ch. 2, 3, 8.

presence of the Lord Himself. "In the time of Moses and Elias," says St. Macarius the Great, "when God appeared to them, a multitude of trumpets and powers preceded Him and served the majesty of the Lord; but the coming of the Lord Himself was different, manifested by peace, silence and calm. For it is said: 'and after the earthquake a fire; but the Lord was not in the fire; and after the fire a still small voice' (I Kings 19:12). This shows that the presence of the Lord is made manifest by peace and harmony."[49] Man becomes God according to grace yet remains a man, just as our Lord remained God while becoming man.

The body of man, as well as his soul, participates in the divine life. This participation does not change him physically: "What we see does not change," says St. Gregory of Nyssa. "An old man does not become an adolescent, wrinkles do not disappear. What is renewed is the inner being, soiled by sin and grown old in bad habits. This being returns to its child-like innocence."[50] In other words, the body retains its structure, its biological properties and the characteristic traits of the outward appearance of man. Nothing is lost. Rather, everything is changed, and the body entirely united with grace is illuminated by its union with God. "The (Holy) Spirit, uniting with the intellect," says St. Anthony the Great, " . . . teaches it to keep the entire body, from head to toe, in order—the eyes, so that they can see purely, the ears so that they can hear in peace . . . , the tongue, so that it can speak only good, the hands, so that they are put into movement only to be lifted in prayer or to perform works of charity . . . , the stomach, so that it may keep eating and drinking in the appropriate limits . . . , the feet, so that they may walk aright in the will of God . . . Thus, the entire body becomes accustomed to goodness and is transformed, by submitting itself to the power of the Holy Spirit, so that it finishes by participating to a certain extent in the characteristics of the spiritual body that it will receive at the resurrection of the just."[51]

The effect of divine grace on the human body and in par-

[49]Russian Philokalia, vol. 1, p. 192.
[50]Quoted from G. Florovsky, *Otssy IV-V vekov*, p. 171.
[51]Russian Philokalia, vol. 1, p. 21.

ticular on the senses, as it is described in words by St. Anthony, is shown to us by the icon. The analogy between the verbal description and the image is so obvious that it leads us to a very clear conclusion: There is an ontological unity between the ascetic experience of Orthodoxy and the Orthodox icon. It is precisely this experience and its outcome which is described by the Orthodox ascetics who are shown to us in the icons and conveyed by them. With the help of colors, forms and lines, with the help of symbolical realism, an artistic language unique in its genre, the spiritual world of the man who has become a temple of God is revealed to us. The order and inner peace to which the Holy Fathers testify are conveyed in the icon by outward peace and harmony: The entire body of the saint, in every detail, even the hair and the wrinkles, even the garments and all that surrounds him, is unified and restored to a supreme harmony. It is a visible expression of the victory over the inner division and chaos in man and, as we shall see, a victory by man over the division and chaos in humanity and the world.

The unusual details of appearance which we see in the icon—in particular in the sense organs: the eyes without brilliance, the ears which are sometimes strangely shaped—are represented in a non-naturalistic manner not because the iconographer was unable to do otherwise, but because their natural state was not what he wanted to represent. The icon's role is not to bring us closer to what we see in nature, but to show us a body which perceives what usually escapes man's perception, *i.e.* the perception of the spiritual world. The questions which St. Seraphim of Sarov insistently asked Motovilov as he was transfigured before him illustrate this well: "What do you see?", "What do you feel?", *etc.* For the light which Motovilov saw, the scent which he smelled, the heat which he felt, were not of the physical order. At that moment, his senses were perceiving the effect that grace has on the physical world which surrounded him. The non-naturalistic manner of representing the sense organs in icons conveys deafness, impassiveness, detachment from all excitation and, conversely, the receptiveness to the spiritual world by those who have attained holiness. The Orthodox icon is the expression in an image of this hymn of Holy Saturday: "Let all mortal flesh keep silent

... pondering nothing earthly-minded." Everything here is subordinate to the general harmony which expresses peace, order and inner harmony. For there is no disorder in the Kingdom of the Holy Spirit. God is "the God of peace and order," says St. Simeon the New Theologian, paraphrasing St. Paul.[52]

If we compare the faces of the holy apostles Peter and Paul in an icon to their portraits in the Roman medallion, we will see that, in spite of the similarity, there is a great difference between the portrait and the icon (Fig. 19-21). This difference is characteristic of the change which a portrait undergoes in becoming an icon. While preserving the characteristic traits of St. Paul, for example, the icon portrays a certain sickly look in his face (2 Cor. 7:9) which is also very apparent in the medallion. But the icon conveys this face in its union with the divine reality: It represents the human flesh entirely enlightened by the sanctifying grace of the Holy Spirit. This contact with grace makes the physical heaviness, the outward appearance of corruptible flesh which is so apparent in the medallion, disappear from the face of the apostle. The traits of the face, the hair, the wrinkles—all are restored to a harmonious order, exempt from all sensual quality. The spiritualized face reflects the Kingdom of God which the apostle Paul carries in himself. These eyes "see in purity," these ears "hear in peace." The inner life in God finds its expression in the glorified face conveyed by the icon. The everyday face of the apostle which we see on the medallion is transformed into his eternally transfigured face.

Let us take another example (Fig. 22). This appears to be the face of an angel, but it is the head of a man, "a celestial man and a terrestial angel," the martyr St. George. He draws attention because of a kind of "immovable" calmness, yet his eyes convey a forward motion. The face and the eyes, that is, those elements which express the spiritual life of man best of all, portray the complete power of the spirit over the body, a trait particularly characteristic of Russian icons. "Let the flesh nurture no earthly thought"; the face of St. George radiates because of the absence of earthly thought in the flesh which is enlightened by the Holy Spirit. Devoid of all physical heavi-

[52]Sermon 15, § 2, *ed. cit.* p. 143.

ness, it is full of peace and spiritual serenity. Nothing human, however, is lacking from this face: It is humanly viril, full of strength and will. If one has the impression of seeing an angel, it is because of its purity and its truly celestial calm.[53]

In other words, just as we represent the God-Man as similar to us in everything except sin, so also we represent the saint as a person free from sin. As St. Maximus the Confessor puts it: "Like the flesh of Christ, our flesh also becomes free from the corruption of sin," because, just as Christ was without sin in His flesh and in His soul, so are we who believe in Him and who have put Him on by the Holy Spirit; we can, by our will, be free from sin in Him.[54] The icon shows us precisely the body of a holy man, a body free of the corruption of sin, which "to a certain extent participates in the properties of the spiritual body which it will receive at the resurrection of the just."

As a manifestation of the ascetic experience of Orthodoxy by the image, the icon is an important educational source. Herein lies the essential goal of sacred art. Its constructive role does not lie only in the teaching of the truths of the Christian faith, but in the education of the entire man. This is why the Fathers of the Seventh Ecumenical Council say that the teaching of iconography depends on the holy Fathers. The contents of the icon is, therefore, a true spiritual guide for Christian life and, in particular, for prayer. The icon shows us the attitude which we should have in our prayer, towards God on the one hand, and towards the world which surrounds us on the other. "Prayer is a *conversation* with God," says St. Nilus of Mount Sinai. "This is why it requires the absence of passions, deafness and the rejection of external, worldly excitement." This is exactly what the icon manifests. A correct guide for our senses is indispensable, because evil enters the human soul through them: "The purity of man's heart is disturbed by the disordered movement of images which enter and leave by the senses of sight, hearing, touch, taste and smell, as well as by the spoken word," says St. Anthony the Great.[55] This

[53]For more detailed study of the icons of St. Paul and St. George, see *The Meaning of Icons*, pp. 112 and 129.
[54]*Active and Contemplative Chapters*, ch. 67, Russian *Philokalia*, vol. 3, p. 263.
[55]Russian *Philokalia*, vol. 1, p. 122.

is why the Fathers speak of the five senses as the "doors" of the soul: "Close all the doors of your soul, that is, your senses," St. Isaiah teaches, "and guard them carefully, so that your soul does not accidentally go wandering through them, or so that neither the cares nor the words of the world drown out the soul." Praying before an icon or simply looking at it, we are constantly reminded of what St. Isaiah speaks of: "He who believes that his body will be resurrected on the judgment day must keep it without sin and free from all stain and all vice."[56] We must do this so that, in our prayer at least, we close the doors of our soul and strive to teach our body (as the saint in the icon taught his body) to keep itself aright in and by the grace of the Holy Spirit, so that our eyes may "see with purity," so that "our ears may hear in peace," and so that our "heart does not nurture evil thoughts." In other words, by the image, the Church endeavors to help us redeem our nature which has been tainted by sin.

Thus, the icon is both a means and a path to follow. It is itself a prayer. Visibly and directly, it reveals to us this freedom from passion about which the Fathers speak. It teaches us "to fast with our eyes," in the words of St. Dorotheus.[57] And indeed, it is impossible "to fast with our eyes" before just any image, be it abstract, or even an ordinary painting. Only the icon can portray what it means "to fast with our eyes" and what this allows us to attain.

After what has been said, it is obvious that the goal of the icon is neither to provoke nor to exalt a natural human feeling. Its goal is to orient all of our feelings, as well as our intellect and all the other aspects of our nature, towards the transfiguration, stripping them of all emotional exaltation. It works like the Gospel, to which it corresponds. Like the deification that it depicts, it suppresses nothing that is human, neither the psychological element, nor the diverse characteristics of man in the world. The icon of the Virgin which is called Our Lady of Tenderness (*Umilenie*) shows us a completely maternal tenderness; the icon of a saint does not fail to portray precisely his

[56]Abbot Isaiah, *Homily 15*, Russian Philokalia, vol. 1, p. 33.
[57]*Teachings and Useful Messages for the Soul* (7th ed., Optina Pustyn, 1895), p. 186.

earthly activity, which he knew how to transform into a spiritu-
al deed, be it an ecclesiastical activity, like that of a bishop or
a monk, or a worldly one, like that of a prince, a soldier or a
doctor. But, as in the Gospel, this entire burden of actions,
thoughts, knowledge and human feelings is represented in its
contact with the divine world, and this contact purifies every-
thing and consumes that which cannot be purified. Each mani-
festation of human nature, each phenomenon of our life is
illuminated, attaining its true meaning and place.

But let us return briefly to the representation of the human
body in Orthodox iconography. We have said already that the
Orthodox icon is in a sense an expression in an image of the
hymn of Holy Saturday: "Let all mortal flesh keep silent."
This comparison takes on an almost literal significance if we
consider the depiction of the naked body in the icon. Let us
take, for example, an icon of St. Basil the Blessed (Fig. 23).
We see that the body of St. Basil is natural but not naturalistic,
whether in its general shape or in its details. Looking at it, one
does not notice if he is dressed or naked. It is as if he were truly
dressed in "the first garment" (Luke 15:22), the robe of grace.
This is the nudity that Adam and Eve did not notice or feel
ashamed of. "The inner renewal which makes man return to
child-like innocence" is conveyed in such a way that all carnal
sensuality is absent from the body. Nothing is present that
might awaken impure thoughts or sensations in the viewer.
Expressing a complete submission to God, this body truly "pon-
ders nothing earthly-minded." The nudity of St. Basil is a
part of his asceticism. It allows us to recognize in the icon his
kind of holiness, just as a garment permits us to recognize
other kinds, *i.e.* that of the ascetic, the bishop, the apostle, *etc.*
We never find in Orthodox iconography this "savoring" of
the flesh that we find in secular art on religious subjects, be it
a "savoring" of healthy and prosperous flesh or, on the con-
trary, that of a suffering, bruised body. Indeed, as we know,
even the ordinary physical quality is contrary to the meaning of
the sacred image.

The question of nudity in art, therefore, never arises in the
Orthodox Church, as it has in the West. In 1563, the Council
of Trent in its twenty-fifth session reached the following de-

cision: "The Holy Council wishes that all impurity be avoided, that images not be given provocative charms . . . " What did the Roman authorities do in response to this order? We can find a striking account of the situation in E. Mâle's *L'Art religieux après le Concile de Trente*.[58] The "impurity" that had to be avoided was the human body. This is why the first thing that the Roman ecclesiastical authorities did was to prohibit the representation of the naked body in religious art. A real purge against nudity began. By order of Pope Paul IV, the figures of Michaelangelo's Last Judgement were veiled. Pope Clement VIII, renouncing half-measures, decided to have the whole fresco obliterated, and was only stopped by the entreaties of the Academy of St. Luke. Charles Borromeo, who firmly believed in the decisions of the Council of Trent, had the nude obliterated wherever he found it. Paintings and statues were destroyed. Even painters themselves burned their own works. In the Orthodox Church, the very character of its sacred art would have made such a situation impossible. The representation of St. Basil the Blessed, when placed next to a Western image, is a sufficiently eloquent demonstration of this. But nudity is only a special case. Actually, it is not only a nude body which can have "provocative charms." To be convinced of this, one need only compare two images on an analogous subject. Take, for example, two representations of holy women: a painting of St. Agnes by Ribera (Fig. 24), and an Orthodox fresco representing St. Mary of Egypt (Fig. 25). Even though the angel partly hides St. Agnes, it is obvious that if one had to pray before such an image, one could do so only with closed eyes.

This essential difference between the Western and the Orthodox sacred art is not the result of the initiative of the painters, nor is it a unique result of a decadence of faith or theology, as is thought by certain Roman Catholic authors.[59] It seems to us that there is a more profound and serious reason for this difference, and this is deviation, not decadence. We have seen that the icon represents the human person, the bearer of a nature which has been deified and restored in its primitive

[58] *Op. cit.* p. 2.
[59] See E. Mâle, *op. cit.* p. 14.

purity. In other words, art, by its appropriate means, portrays the communion of this person with the divinity, his deification. But according to the doctrine of the late Thomism generally taught in the Roman Church (although not officially), human nature as such was not changed by the fall of Adam. Man remained as God had created him. He was only deprived of the supernatural gifts of grace—natural justice and control over nature—after which he evolved toward evil in his soul as well as in his body. This privation of the supernatural gifts, imposed by God, is the punishment inflicted on Adam and Eve and all their posterity. Man is compared to a dignitary of the imperial court, at first favored by the sovereign and placed in a high position, then punished and lowered to his primitive condition. The divine incarnaiton restores to human nature the gift which had been taken away from it, and man can, once again, receive grace. But this grace is a created effect, just like that which Adam possessed before his fall: it is an effect created by God in the human soul and superimposed, so to speak, on human nature, just as it was added to Adam's nature in the beginning. Being created, grace, just as the "light of glory" contemplated after death by the blessed, does not transform saints into truly deified men, into "partakers of the divine nature" (2 Peter 1:4), into gods through grace. This is why deification in the West is not understood literally, but as a metaphor. It is true that Roman theologians also speak of uncreated grace. However, if they understand created grace as a created effect on the human soul by the Holy Spirit, uncreated grace is understood as the very person of the Holy Spirit (*ipsissima persona Spiritus Sancti*) who accompanies His Gifts.[60] God is present in the human soul but is not united with man's entire nature; man "in a state of grace" is a God-bearing vessel. Deification, for the Roman Church, does not mean an ontological change in the life of the creature; it is only a change of its actions. The very nature of man remains unchanged. The texts of the mystics of the Roman Church on the presence of God in the soul are very characteristic in this sense. Most often, they compare the sanctified soul to heaven, to paradise, to the dwelling place of God, to the liturgical chalice, to the taber-

[60]Raoul Plus, S.J., *Dieu en nous* (Toulouse, 1931), p. 142.

nacle which holds the Host, to the manger in Bethlehem which received the Christ child. What is particularly striking in these comparisons is their static character. Between created nature and divine life, a "created supernature" always is interposed. There is no penetration of created being by the uncreated. The somewhat crude expression of Bernard of Clairvaux is very significant: An ass remains an ass even if it carries Christ on its back.

According to Orthodox teaching, it is human nature itself which is tainted by Adam's sin. There is not the loss of the supernatural gifts of grace but rather a corruption of human nature. God is life, and this is why sin is a fall of man out of divine eternal life, an inner defect in human nature at its very source. The divine incarnation heals this soiled and sick nature, and if the fall of Adam was both a physical and a spiritual catastrophe, the renewal of our nature in the incarnation is also both spiritual and corporal. Man has the capacity to change, and this is his vital principle, this dynamic principle which allows him to attain grace and to be transformed "from one degree of glory to another" (2 Cor. 3:18). An infinite perspective of perfection is opened before man, to the point of union with God, when man becomes god through grace. Orthodox theology insists on the uncreated character of grace and defines it as natural processions, as the energy characteristic of the common nature of the three divine persons. By these energies, man surpasses the limits of the creature and becomes "a partaker of the divine nature." This is why, in the Orthodox Church, human nature enlightened by grace is often compared to iron reddened by fire, to air entirely penetrated with light, etc. If the analogies used by Roman theology are for the most part static, the comparisons used by the Orthodox theologians emphasize, on the contrary, the dynamism of relations between nature and grace, of the penetration of the divinity in the creature, the real deification of man by uncreated divine grace.

Thus, as we see, the difference between Orthodox sacred art and Western religious art corresponds to a difference between the Orthodox and Western conceptions of holiness, and is not simply a result of a decadence of faith and of West-

ern theology. Two different dogmatic concepts are involved, corresponding to two experiences, to two ways of sanctification which hardly resemble one another.[61] The representation of man in Western art corresponds to the theoretical impossibility of deifying human nature, of transfiguring it radically, its corporal reality included. It is no longer man who is represented in the image and in the likeness of God. Rather, God Himself is represented in the image and likeness of fallen man. The contact with the divinity does not transform all of human nature. This is why the image of a holy man in Western art is more of an allusion to holiness than a representation of it. The saint is represented in the same way as we are, in the image of "earthly Adam," that is, in his corruptible aspect. The real transfiguration of his nature is not portrayed because this transfiguration is also not accepted in theory. The only indication of holiness is the halo placed above the head of the saint like a sort of luminous crown. (It is true that the halo is not always represented in the same way and is sometimes not represented at all.) The radiance of his face is not an expression of the sanctified state of man, but it is precisely a sign of an external gift of grace, a kind of reward or coronation.

Orthodox sacred art is a visible expression of the dogma of the transfiguration. The transfiguration of man is understood and transmitted here as a well-defined objective reality, in full accordance with Orthodox teaching. What is shown to us is not an individual interpretation or an abstract or more or less deteriorated understanding, but a truth taught by the Church (Fig. 26-27). When we tolerate icons "of the Italian style" in our churches, we also introduce a teaching foreign to Orthodoxy and a falsified understanding of spiritual experience, of holiness. In other words, we unconsciously and ignorantly follow the deviation of others. On the purely intellectual level, this borrowed art may maintain certain external aspects of correct teaching, but it does not have and cannot have any true educative value. All deviation, even partial, from the Orthodox iconographic tradition diminishes or alters ecclesiastical doctrine, thereby weakening the con-

[61]See V. Lossky, *Mystical Theology*, p. 227.

structive role of the image. A further point, interesting from a psychological point of view, is illustrated if we look closely at the Christ painted by Simon Ushakov (Fig. 28),[62] and at the Christ of the Cathedral of the Assumption (Fig. 29). It would seem that the image painted by Ushakov, because it is more "human," should be more understandable and more accessible. But in reality the contrary is true. Its carnal character (although minimal) and a certain psychological content are an obstacle to direct contact. Its spiritual content is hidden by the carnal image, as though by a veil. Before such an image, one feels as though he is before a portrait of a living person, which is to say, before an enigma. One feels nothing of the sort, however, when one is looking at the Christ of the Cathedral of the Assumption. Here, the spiritual content is in the foreground and not veiled either by psychology or by carnal characteristics. Thus in spite of the severity of this face, which should, it seems, put us off, the image of God is completely open to us. We feel no obstacle to a direct contact with the sacred. This psychological and carnal obstacle is felt even more in the image of Christ by Carlo Dolci (Fig. 30). Generally speaking, all naturalism and all psychology in the icon not only falsifies Orthodox teaching, but also obstructs our contact with the sacred.

We say, therefore, that the question goes much deeper than the natural color of flesh, than that of representing man "in the imitation of life" as, formerly, the painter Joseph Vladimirov contended in support of a position which still tempts many today. "Imitation of life" would mean a reversal of the effort of the saint who precisely liberates himself from the shackles of this life and of corruptible beauty. The colors of the icon convey the color of the human body, but not of the natural flesh tint of the skin. Much more is involved than depicting the physical beauty of the human body. The beauty in the icon is spiritual purity, inner beauty and, in the words of St. Peter, "let it be the hidden person of the heart, with the imperishable jewel of a gentle and quiet spirit, which in God's sight is very precious" (1 Pet. 3:4). It is the beauty of

[62]Simon Ushakov, a famous iconographer of the seventeenth century, was the father of secular Russian painting.

the communion of the terrestrial with the celestial. It is this beauty-holiness, this divine likeness attained by man, that the icon portrays. In its own language, the icon conveys the work of grace which, according to St. Gregory Palamas, "paints in us, so to speak, on what is the image of God that which is in the divine likeness, in such a way that . . . we are transformed into His likeness."[63]

The justification and the value of the icon do not, therefore, lie in its beauty as an object, but in that which it represents: an image of beauty in the divine likeness. The demands of the Council of the Hundred Chapters (Moscow, sixteenth century) and of the manuals (*podlinniks*) which require that icons be painted "in the image and likeness" are to be understood in this sense.

It is understandable that the light of the icon which enlightens us is not the natural brightness of faces depicted by color, but rather the divine grace which purifies man, the light of purified and sinless flesh. This light of the sanctified flesh must not be understood only as a spiritual phenomenon or as a uniquely physical phenomenon, but as the two together, a revelation of the spiritual flesh to come.

Let us also say a few words about the way in which the clothing of the saints should be represented in an icon. Clothing, like the flesh, is not represented in a naturalistic fashion (Fig. 31). While respecting man's particularities and covering his body in a perfectly logical way, it is represented in such a way so as not to conceal the glorified state of the saint. It emphasizes the work of the man and becomes in some way the image of his vestment of glory, of his "robe of incorruptibility." The ascetic experience, or rather its result, also finds here its outward expression in the severity of the often geometrical forms, in the lighting and in the lines of the folds. They cease to be disordered. They change their appearance and acquire a rhythm and an order which is subordinate to the general harmony of the image. In effect, the sanctification of the human body is communicated to its clothing. We know that touching the clothing of Christ, the

[63]Russian Philokalia, vol. 5, pp. 300-301: *To the nun Xenia, about virtues and passions*, § 38.

Virgin, the apostles and the saints brought healing to the faithful. One need only recall the Gospel story of the hemorrhaging woman or that of the veil of the Virgin.

The inner order of the man represented in the icon is naturally reflected in his posture and his movements. The saints do not gesticulate. They are in prayer before the face of God, and each of their movements and the very posture of their bodies take on a hieratic, sacramental aspect. Usually, they are fully turned towards the spectator, or at least partially turned. This trait characterizes Christian art from its birth, as we have seen when we studied the art of the catacombs. The saint is present before us and not somewhere in space. Addressing our prayer to him, we must see him face to face and converse with him. This is without a doubt the reason why the saints are almost never represented in profile, except in very rare cases when they are turned towards the center in complicated works. A profile does not allow direct contact; it is, as it were, the beginning of absence. This is why only persons who have not yet attained holiness are represented in profile, such as the wise men and the shepherds in the icon of the nativity, for example.[64]

Up to now, we have spoken of the holiness of man and the means by which the icon portrays his sanctified state. But the nature of holiness is to sanctify that which surrounds it; the deification of man is communicated to his surroundings. This is the beginning of the transfiguration of the world. The deification of human nature results in the liberation of the world from its chaotic division, in a return to unity, the reconstruction of the divided universe into a single living whole. This process reverses the fall of Adam and the cosmic catastrophe which ensued. It is in man and through man that the participation of all creatures in the divine eternal life is realized and manifested. Just as creation fell with the fall of man, it is saved by the deification of man, for "creation was subjected to futility, not of its own will, but by the will of Him who subjected it in hope; because creation itself will be set free from its bondage to decay and obtain the glorious

[64]An exception: the lives of saints depicted in images on the margins of icons.

liberty of the children of God" (Rom. 8:20-21). We have
a sign which marks the beginning of the restoration of the
unity of the entire fallen creation. This is the sojourn of
Christ in the desert: "He was ... with the wild beasts; and
the angels ministered to Him," says St. Mark the Evangelist
(1:3). The celestial and terrestrial creatures destined to be-
come the new creation in the God-Man Jesus Christ are as-
sembled around Him. This thought of the unification in
peace of the entire universe clearly permeates all Orthodox
iconography; it is most particularly emphasized in certain icons
which reveal the cosmic meaning of creation, as for example,
"Let everything that breathes praise the Lord" or "All crea-
tion rejoices in you" and others. The entire universe is as-
sembled around Christ and the Mother of God. It is united in
a single Church of God: the angelic powers and mankind,
animals, birds, plants and the stars. This union of all creatures
in God, beginning with the angels and including the inferior
beings, is the restored universe to come, as opposed to the
general strife and the internal struggle inside creation. Peace
and harmony in creation, one Church embracing the entire
world—this is the essential impulse of Orthodox sacred art,
an impulse which prevails in architecture as well as in paint-
ing.[65] This explains why, in the icon, we find that everything
which surrounds a saint changes its aspect. The world sur-
rounding man—the bearer and announcer of the divine revela-
tion—becomes an image of the world to come, transfigured
and renewed. Everything loses its usual aspect of disorder,
everything acquires a harmonious order—men, landscape,
animals and architecture. Everything which surrounds the
saint yields with him into a rhythmic order. Everything re-
flects the divine presence and is drawn—and draws us also—
towards God. The earth, the vegetable world and the animal
world are represented in the icon, not to bring us close to
that which we always see around us, *i.e.* the fallen world in
its corruptible state, but to show us the participation of this
world in the deification of man. The effect of holiness on
the entire created world, particularly on the wild animals, is a

[65]E. Trubetskoi, *Smysl Zhizni* (Berlin, 1922), pp. 71-72.

trait which often characterizes the lives of the saints.[66] Epiphanius, a disciple and biographer of St. Sergius of Radonezh, comments as follows on the attitude of ferocious beasts toward the saint: "Let no one be astonished, for you know that when God dwells in a man and when the Holy Spirit rests in him, everything submits to him as unto Adam before his fall, when Adam lived alone in the desert." The life of St. Isaac the Syrian states that the animals who came to him smelled in him the odor which Adam exhaled before his fall. This is why, when animals are represented in an icon, they have an unusual appearance. While preserving the characteristic traits of their species, they lose their usual appearance. This may seem to be odd or awkward if we did not understand the profound language of the iconographers, who allude here to the mystery of paradise which is, at the moment, inaccessible to us.

Thus the universe which is represented in an icon does not reflect the disorder of our world corrupted by sin, but divine order and perfect peace reestablished in the universe. Divine grace, and not the rational categories of the earth, not human morality, reigns in the icon. From this arises the hieratism of the icon, its simplicity, its majesty, its calm. From this arises the rhythm of its lines and the joy of its colors. It reflects the efforts of asceticism and the joy of victory. This is pain transformed into "the joy at the living God." This is the new order of the new creation.

Let us take, as examples, two representations of the nativity of Christ. One of these is an Orthodox icon, the other is a religious image (Fig. 32-33). We shall not speak of the dogmatic contents of the feast which they depict, but rather we shall limit ourselves to the aspect of the image which concerns the subject which we are discussing at this moment. As we can see, the painting by Ribera represents a touching family scene in a purely earthly setting. What strikes us first of all is the state of the souls of the represented persons. The men, the animals and the landscape—this is the world in its usual state. It states a fact and could represent the birth of

[66]For example, those of St. Isaac the Syrian, St. Mary of Egypt, St. Sergius of Radonezh, St. Seraphim of Sarov, St. Paul of Obnorsk and many others.

any child. The icon, on the other hand, rigorously expresses
the teaching of the Church on the incarnation. It shows us,
first of all, the fact itself with much more faithfulness than
the religious image, because it follows Tradition and the
evangelical account much more closely. Thus, the Child is
shown in a cave and not in a stable. He is covered in swaddling
clothes, according to the sign which the angels had indicated
to the shepherds: "And this will be a sign for you: you will
find a babe wrapped in swaddling clothes and lying in a
manger" (Luke 2:12). Furthermore, the icon shows the par-
ticipation of the entire universe in the birth of its Creator, in
accordance with the liturgy of the feast. Clarifying the mean-
ing of the event, it shows that which is visible only to the
eyes of the faith, that which the world does not see but which
is evident to the Church: the spiritual triumph of creation.
"Let heaven and earth rejoice prophetically today! Let angels
and men be spiritually triumphant!"[67] "Prophetically" means
foreseeing and foretelling the transfiguration to come. A
specific language, not elaborated in a painter's workshop but
in the profound wisdom of the Church, serves to reveal to us
the image of the future holiness of the world, the future trans-
figuration of man at the head of all creation. Not only does
all of nature participate in the nativity of the Lord, but it al-
ready bears a mark of its future glory. The mountains, the
trees, the beasts, all change their appearance and take on an
ordered, rhythmic, harmonious character.

The world which we see here no longer reflects its daily
banality. The divine light penetrates everything and this is
why the persons and the objects are not illuminated from one
side or another by a source of light; they do not project shad-
ows, because there are no shadows in the Kingdom of God,
where everything bathes in light. In the technical language
of iconographers, "light" is called the background of the icon.

As for architecture in the icon, while being subordinate to
the general harmony, it plays a particular role. Like the
landscape, it identifies the place where the event takes
place: a church, a house, a town. But the building (just like
the cave of the nativity or that of the resurrection) never

[67]Sticheron for the lité.

shuts off the scene. It only acts as a background, so that the event does not occur in the building, but in front of it. This is because the very meaning of the events that the icons represent is not limited to their historical place, just as, while having taken place in time, they surpass the moment when they occurred. It is only since the beginning of the seventeenth century that Russian iconographers, under the influence of Western art, have begun representing scenes which take place within a building. The architecture is linked with the human figures in the general meaning of the image and in its composition, but the logical connection is often completely missing. If we compare the way in which architecture is represented, we will see a great difference. The human body, although represented in a manner which is not naturalistic, is, however, with very rare exceptions completely logical: Everything is in its place. The same is true of clothing: The way in which garments are treated, in which the folds fall, is quite logical. But the architecture frequently defies all human logic, both in its forms and in its details (Fig. 34-34). Proportions are absolutely neglected, the doors and windows are not in their proper place and, besides, are completely useless because of their dimensions, etc. Contemporary opinion sees many Byzantine and antique forms in the icon, due to a blind attachment of the iconographers to forms which have become incomprehensible. But the true meaning of this phenomenon is that the action represented in the icon transcends the rationalistic logic of men and the laws of earthly life. Architecture, be it antique, Byzantine or Russian, is the element which best permits the icon to portray this. It is arranged with a certain pictorial "foolishness for the sake of Christ," in complete contradiction with the rational categories. This architectural fantasy systematically baffles reason, putting it back in its place and emphasizing the metalogical character of faith. This a-logical character of architecture continued to exist in Russian iconography until its decline, particularly at the end of the sixteenth and the beginning of the seventeenth centuries, when the understanding of the iconographic languages began to disappear. From this time on, architecture becomes logical and proportioned. And curiously enough, it is exactly at this

time that we discover many truly fantastic architectural forms in actual Russian construction.

From all that we have said, it follows that the icon does not at all attempt to create an illusion of the object which it represents, to represent it "as if it were real." Actually, being an image by its very nature, it is the opposite of an illusion. While looking at it, we not only know, but we also clearly see that we are not before the object itself, but before its image. From the time of the catacombs, Christian art has not tolerated any attempt to create the illusion of space and apparent volume. But one must not conclude that the icon, like the painting of the non-Christian East, is only two-dimensional. The composition of the icon always conveys space and depth. Volume is marked in the way of treating bodies, faces, clothing and buildings. The icon reflects the third dimension, but in such a way that it cannot break through the surface of the board. Space and volume are limited by this surface and must not create an illusion of surpassing it. All breaks, even the minimal, deprive the icon of part of its meaning, distract the eye from the essential and lead it off into the represented space (Fig. 36). The harmony between the painted surface and its depth is to a great degree maintained by what is called inverse perspective. According to the laws of optics, the dimensions of objects decrease with distance and the lines of perspective cross each other at the horizon. But the icon shows us the opposite. Indeed, the point of departure of its perspective is not found in the illusory depth of the image which attempts to reproduce visible space, but *before* the image, in the spectator himself.

Superficial critics have often claimed that inverse perspective reflects an ignorance of ordinary perspective or the inability to use it. To be assured of the contrary, one only needs to look closely at the icons. We will then see that the iconographers knew how to combine ordinary perspective with inverse perspective very well, as Andrei Rublev did, for example, in his famous icon of the Holy Trinity, where the house of Abraham and the opening in the table are represented in an ordinary perspective, and the table, the steps, and the heads of the angels are in inverse perspective (Fig. 37).

This is the best proof that it is not a matter of ignorance but of conscious symbolism, of willful rejection of normal perspective. We have seen that the Seventh Ecumenical Council emphasized the perfect correspondence between the icon and the Holy Scripture and that the icon calls us to the life which the Gospel reveals. But in the Gospel everything is, so to speak, in inverse perspective: "The first shall be the last," the meek and not the violent shall inherit the earth, and the supreme humiliation of the cross is truly the supreme victory. Thus the life of the Christian is placed in this same perspective: the death of the martyr is his victory, his coronation, and the privations of the ascetic struggle are transformed into an incomparable joy. If we consider the inverse perspective of the icon from this point of view, we will be able to understand its meaning. The inverse perspective is not an "optical illusion." It does not fascinate the spectator and lead him in to a futile game of appearances. On the contrary, it calms him, makes him concentrate and makes him attentive to the message of the icon. It is as if man were standing before a path which, instead of losing itself in space, opens on to infinite fullness. A door which leads to divine life, therefore, is opened before the Christian. But "the gate is narrow ... that leads to life," according to the Gospel (Matt. 7:14). Here too, the analogy with the spiritual experience of Orthodox saints is evident. Thus St. Macarius the Great, like many other ascetic writers, uses the image of the door precisely when speaking of spiritual progress: "Doors are opened ... and man enters the interior of many abodes; and as he enters, still other doors are opened before him, and he is enriched; and to the degree that he is enriched, new marvels are shown to him"[68] Once embarked on the path to which the narrow gate leads, man sees endless possibilities and perspectives opening before him, and his path, far from becoming narrow, becomes wider. But in the beginning, it is but a simple point in our hearts, from which our whole perspective must be reversed. This is the authentic and literal meaning of the Greek word μετάνοια, which means "the reversal of the intellect."

We have seen that everything is strange and unusual in

[68]Russian Philokalia, vol. 1, p. 230.

the icon: the men, the animals, the landscape and the architecture. We have attempted to show that this is not a matter of the artist's fantasy, and even less of his unskillfulness, but a pictorial translation of a certain spiritual experience, the very same about which the great saints of Orthodoxy speak. We have examined the ways in which the image expresses that to which the Church calls us. The icons which we have used as examples date from different periods, so as to demonstrate more clearly the actual principle of the icon and not the style of this or that period. For this principle is not connected with any particular moment in history. It is characteristic of the Church of all ages, just as the spiritual experience of the saints whose writings we have quoted to show the spiritual world of the icon and who have lived in the Church from the beginning of Christianity. This is why the Orthodox image of worship, the icon, is uniquely defined by its aim, which is as universal as Orthodoxy itself, that is, the teaching of the salvation which the Church brings to the world.

The strange and unusual character of the icon is the same as that of the Gospel. For the Gospel is a true challenge to every order, to all the wisdom of the world. "I will destroy the wisdom of the wise, and the cleverness of the clever I will thwart," says the Lord by the mouth of His prophets whom St. Paul quotes (I Cor. 1:21). And just as the evangelical preaching is foolishness for the wisdom of the world, the icon which corresponds to it is also foolishness. It offends the so-called "normal" eye, for which the fallen state of the world seems normal. The iconographic forms sometimes border on deformities which shock man. But in the Gospel as well, many elements shock the superficial reader by their "immoral" and "unjust" character, as when, for example, Christ in the parable of the unfaithful steward recommends making friends with the help of profits unjustly gained (Luke 16:1-9) or when He damns the fig tree which bore no fruit because it was not its season (Mark 11:13). Such things obviously can be understood only in the proper perspective and not from a rationalistic point of view. The Gospel calls us to life in Christ, and the icon represents this life. This is why it sometimes uses abnormal and shocking forms, just as holiness sometimes tol-

erates extreme forms which seem like madness in the eyes of
the world, like the holiness of the fools in Christ. "They say
that I am mad," said one of them, "but without madness one
does not enter into the Kingdom of God . . . To live according
to the Gospel one must be mad. As long as men are reasonable
and of sober mind, the Kingdom of God will not come to
earth."[69] Madness for the sake of Christ and the sometimes
provocative forms of icons express the same evangelical reality.

In this study, we have tried to show that, just as the sym-
bolism of the first centuries of Christianity was a language
common to the entire Church, so also the icon is a language
common to the entire Church because it expresses the common
Orthodox teaching, the common Orthodox ascetic experience
and the common Orthodox liturgy. The sacred image has al-
ways expressed the revelation of the Church, bearing it in a
visible form to the faithful, placing it before their eyes as an
answer to their questions, a teaching and a guide, as a task
to accomplish, as a prefiguration and the first-fruits of the
Kingdom of God. Divine revelation and its acceptance by
man are the same action in two ways, so to speak. Apoc-
alypse and gnosis, the path of revelation and that of
knowledge correspond to each other. God descends and re-
veals Himself to man; man responds to God by lifting himself,
by harmonizing his life with the attained revelation. In the
image he receives the revelation, and by the image he responds
to this revelation to the degree that he participates in it. In
other words, the icon is a visible testimony to the descent of
God to man as well as to the impetus of man towards God.
If the word and the song of the Church sanctify our soul by
means of hearing, the image sanctifies by means of sight,
which is, according to the Fathers, the most important of the
senses. "The eyes are the light of the body. So, if your eye
is sound, your whole body will be full of light" (Matt. 6:
22). By word and by image the liturgy sanctifies our senses.
Being an expression of the image and likeness of God restored
in man, the icon is a dynamic and constructive element of
worship. This is why the Church, by the decision of the Sev-

[69]Archimandrite Spiridon, *Mes missions en Siberie* (trans. P. Pascal, Ed. du
Cerf, 1950), pp. 39-40.

enth Ecumenical Council, orders that icons be placed "on the
same level as the images of the life-giving cross, in all of the
churches of God, on vases and sacred vestments, on the walls,
on wooden boards, in homes and in the streets." In the icon,
it recognizes one of the means which can and must allow us
to realize our calling, that is, to attain the likeness of our
divine prototype, to accomplish in our life that which was re-
vealed and transmitted to us by the God-Man. The saints are
very few in number, but holiness is a task assigned to all men,
and icons are placed everywhere to serve as examples of holi-
ness, as a revelation of the holiness of the world to come, a
plan and a project of the cosmic transfiguration. Furthermore,
since the grace attained by the saints during their lives con-
tinues to dwell in their image,[70] these images are placed every-
where for the sanctification of the world by the grace which
belongs to them. Icons are like the markers on our path to the
new creation, so that, according to St. Paul, in contemplating
"the glory of the Lord, [we] are being changed into His like-
ness" (2 Cor. 3:18).

Men who have known sanctification by experience have
created images which correspond to it and which truly con-
stitute a "revelation and demonstration of that which is
hidden," according to the words of St. John of Damascus, just
as the tabernacle does, following the directions of Moses,
revealing what had been shown to him on the mountain. These
images not only reveal a transfigured universe to man, but
they also allow him to participate in it. It can be said that
the icon is painted according to nature but with the help of
symbols, because the nature which it represents is not directly
representable. It is the world which will only be fully re-
vealed at the second coming of the Lord. An icon, therefore,
cannot be contrived. No artistic imagination, no technical per-
fection, no talent can replace definite knowledge. Only a
true image, by its obvious authenticity, can show us the way
and lead us toward God.

Therefore, the icon opens up to us an immense vision
which embraces both the past and the future of the universe.

[70]St. John of Damascus, *First Treatise*, ch. 19, PG 94:129 CD.

It is simultaneously a teaching and a guide in all the days of our life. Thus, human creation, poor as its possibilities may be, is used by the Church as a way to reveal to the world the mystery of the age to come.

Select Bibliography

Alpatov, Mikhail V., *Vseobshchaia istoriia iskusstv*, Moscow, Leningrad, 1948.

Bréhier, Louis, *L'art chrétien*, Paris, 1928.

Buslaev, Fedor, *Tvoreniia*, St. Petersburg, 1910.

Cabrol, Fernand, and H. Leclercq, *Dictionnaire d'archéologie chrétienne et de liturgie*, Paris, 1907-53.

Debolsky, Grigorii S., *Dni bogosluzheniia pravoslavnoi kafolicheskoi vostochnoi Tserkvi*, St. Petersburg, 1901.

Diehl, Charles, *History of the Byzantine Empire*, New York, AMS Press, 1969

————, *Manuel d'art byzantin*, 2nd edit., Paris, 1925-26.

Dobschütz, Ernst von, *Christusbilder* (Texte und Untersuchungen zur Geschichte der altchristlichen Literatur, n.f., vol. 3), Leipzig, 1899.

Florovsky, Georges, *Puti russkogo bogosloviia*, Paris, 1937.

————, *Vostochnye otssy IV i V veka* (Bogoslovic ottscv Tserkvi), Paris, 1931.

————, *Vizantiiskie ottsy V-VIII vekov* (Bogoslovie ottsev tserkvi), Paris, 1933.

Grabar, André, *La peinture byzantine*, Geneva, 1933.

————, *La sainte face de Laon* (Zographica 3), Prague, 1931.

Hefele, Karl Joseph von, and H. Leclercq, *Histoire des Conciles*, Paris, 1907 ff.

Khomiakov, Aleksei S., *Izbrannye sochineniia*, New York, 1955.

Kondakov, Nikodim P., *Ikonografiia Bogomateri*, St. Petersburg, 1914-15.

————, *Ikonografiia Gospoda Boga i Spasa nashego Iisusa Khrista*, St. Petersburg, 1905.

————, *The Russian icon*, Prague, 1931.

Lazarev, Viktor N., *Iskusstvo Novgoroda*, Moscow, 1947.

————, *Istoriia vizantiiskoi zhivopisi*, Moscow, 1947-48.

Lebedev, Aleksei P., *Istoriia vselenskikh soborov*, St. Petersburg, 1904.

Leclercq, Henri, *Manuel d'archéologie chrétienne depuis les origines jusqu'au VIII° siècle*, Paris, 1907.

Lossky, Vladimir N., *The Mystical Theology of the Eastern Church*, London, 1957.

Mâle, Emile, *L'art religieux après le Concile de Trente*, Paris, 1932.

Michel, André, *Histoire de l'art*, Paris, 1905-29.

Ostrogorsky, Georg, *Les debuts de la querelle des images*, Paris, 1930.

_____, "Gnoseologicheskie osnovy vizantiiskogo spora o sviatykh ikonakh," *Seminarium Kondakovianum* II (Prague, 1928), pp. 48-52.

_____, *History of the Byzantine State*, New Brunswick, N. J., Rutgers University Press, 1969.

_____, "Rom und Byzanz im Kampfe um die Bilderverehrung," *Seminarium Kondakovianum* VI (Prague, 1933), pp. 73-87.

_____, "Soedinenie voprosa o sv. ikonakh s khristologicheskoi dogmatikoi v sochineniiakh pravoslavnykh apologetov ranniago period ikonoborchestva," *Seminarium Kondakovianum* I (Prague, 1927), pp. 35-48.

_____, *Studien zur Geschichte des byzantinischen Bilderstreites* (Historische Untersuchungen 5), Breslau, 1929.

Ouspensky, Léonide, *L'Icone*, Paris, 1948.

_____, and V. Lossky, *The Meaning of Icons*, Olten, Switzerland, 1952.

Pokrovsky, Nikolai V., *Pamiatniki khristianskoi ikonografii i iskusstva*, St. Petersburg, 1900.

Scaglia, Sisto, *Manuel d'archéologie chrétienne*, Turin, 1916.

Schmemann, Alexander, *The Historical Road of Eastern Orthodoxy*, New York, 1963.

Trubetskoi, Eugene N., *Icons: Theology in Color*, Crestwood, N. Y., St. Vladimir's Seminary Press, 1973.

_____, *Smysl' zhizni*, Berlin, 1922.

Uspensky, Fedor I., *Ocherki po istorii vizantiiskoi obrazovannosti*, St. Petersburg, 1891.

Uvarov, Aleksei S., *Khristianskaia simvolika*, Moscow, 1908.

Vasiliev, Alexander A., *History of the Byzantine Empire, 324-1453*, 2nd Eng. edit., Madison, University of Wisconsin Press, 1952.